John and Joy Kasson
1972

The Pictorial Mode

*"For, after all, the style is
a part of the thought,
and a bad style is a
distortion of the thought."*

Bryant

The
Pictorial Mode

Space & Time in the Art of
Bryant, Irving & Cooper

Donald A. Ringe

The University Press of Kentucky

ISBN: 0–8131–1250–8

Library of Congress Catalog Card Number: 71–147859

Copyright © 1971 by The University Press of Kentucky

A statewide cooperative scholarly publishing agency
serving Berea College, Centre College of Kentucky,
Eastern Kentucky University, Kentucky State College,
Morehead State University, Murray State University,
University of Kentucky, University of Louisville,
and Western Kentucky University.

Editorial and Sales Offices: Lexington, Kentucky 40506

In memory of my parents

Contents

Preface

Interest in the paintings of the Hudson River school and their relation to the works of William Cullen Bryant, Washington Irving, and James Fenimore Cooper is by no means new. As long ago as 1940, Walter L. Nathan had pointed out the relation in the chapter on Thomas Cole he contributed to a symposium called *Romanticism in America*, and five years later Frederick A. Sweet amply demonstrated the relation of literature to American romantic painting in the catalog he prepared for an important exhibition of the Hudson River school shown at The Art Institute of Chicago and the Whitney Museum of American Art in New York. Shortly thereafter, two important articles appeared on the relation of Cooper's novels to the fine arts. James Franklin Beard discussed the subject in the paper he read at the centennial observation of Cooper's death in 1951, and Howard Mumford Jones developed the philosophical implications of the relation in an article published the following year in *Tulane Studies in English*. Since that time, other studies, including a number of my own, have appeared, but no one has yet developed in detail the stylistic implications of the many affinities that exist between the works of the writers and painters.

Such a study presupposes that literature and painting are analogous arts, that the understanding of one may throw important light on the other. This book frankly makes that assumption. It accepts as generally true for literature and art what Henry James wrote more specifically of novels and paintings in "The Art of Fiction": "Their inspiration is the same, their process (allowing for the different quality of the vehicle) is the same, their success is the same. They may learn from each other, they may explain and sustain each other." If James is right, and I think that he is, a study of the works of Bryant, Irving, and Cooper in relation to the paintings of a school of artists whose aesthetic views they shared should prove illuminating, especially since so much of their work is developed through the pictorial mode, a style of writing that bears

close affinities to the art of the landscape painter. In this book, I intend to discuss that style at length, to demonstrate its relation to the techniques of the painters, and to show how it functions for the expression of theme. Admittedly, my purpose is restrictive, and I have had to leave out of consideration a number of important elements—like characterization or prosody—that a complete study of any one of these writers would demand. What is gained from the limited focus, however, will, I hope, at least partially compensate for whatever omissions that focus entails.

Because I am concerned with the question of style as a means for thematic expression, I have concentrated most strongly on the more purely literary works of all three men, and I have, where possible, drawn my examples from what is generally their best work. I have tried, in addition, to honor the artistic integrity of the novels, poems, tales, and sketches that have been my primary focus of attention. When the writers employ a persona, for example, I have attempted to maintain the distinction between the real and ostensible authors. In Bryant's and Cooper's works, the persona presents no serious difficulties, for it is easy enough to distinguish the Indian at the burial place of his fathers or Corny Littlepage from Bryant and Cooper. In Irving's works, however, the problem can become quite difficult, especially in those books that appeared under the name of Geoffrey Crayon. By and large, I have followed the practice of William L. Hedges in his recent study of Irving. I have treated Crayon as the narrative voice in the earlier works, like *The Sketch Book* and *Bracebridge Hall*, that bear his name. But beginning with the first edition of *The Alhambra*, I have considered the narrative voice to be Irving's own.

In the course of this study, I have incurred a number of debts that should be acknowledged here: to Howard Mumford Jones, who first introduced me to the Hudson River painters and directed the study of Bryant of which this book is the remote descendant; and to my colleague Kenneth R. Ball, who kindly read an early version of the manuscript and made a number of good suggestions. The University of Michigan granted me a summer fellowship and a sabbatical leave to study Cooper and Irving, and the University of Kentucky awarded me a summer fellowship to begin the writing. Parts of three chapters have appeared in articles published in

PMLA (1963), *American Literature* (1958, 1967), and the *Papers of the Michigan Academy of Science, Arts, and Letters* (1956). To the editors of the journals and to the Modern Language Association of America, I am grateful for permission to reprint this material. Finally, the person who contributed most is, as usual, mentioned last: my wife, who, despite previous experience, cheerfully helped me to see yet another book through the press.

I. Introduction

That nineteenth-century American literature from Washington Irving to Walt Whitman contains a strong emphasis on the visual—on "seeing" the world described in the various works—is so evident from the essays, poems, and tales of the writers themselves as hardly to need comment here. Wherever one turns in the literature of the period, he is likely to find a recurring strain of the pictorial, a stress on images of sight, and a deep concern with the need for close and accurate observation of the physical world in order to discern its meaning. In different works the practice took different forms, with Emerson's *Nature* and Melville's *Moby Dick* standing above the rest as significant landmarks in a developing theory of symbolism that both explains and justifies the overriding emphasis on the visual to be found in many contemporary works.[1] But if the major writers of the American Renaissance transformed their concern with the visual into highly sophisticated art, their predecessors in American literature were no less aware of the need to find and explain the meaning of physical nature, and they too developed a descriptive style through which to express their view of the world in their prose and verse.

Most readers are well aware of the large amount of description to be found in the works of Bryant, Irving, and Cooper. To begin any one of the Leatherstocking tales is to confront at once the broad descriptions of nature that figure so largely in most of Cooper's novels, and the reader of his fiction soon comes to expect that a considerable part of each book will be presented through the pictorial mode. To turn to *The Sketch Book* or *The Alhambra* is to find a similar emphasis on the visual in the works of Washington Irving, for many of his sketches and stories—including such famous tales as "Rip Van Winkle" and "The Legend of Sleepy Hollow"—contain a large amount of highly effective description. And to read the verse of William Cullen Bryant is to encounter whole poems—the simple lyrics as well as the long philosophic ones—de-

veloped through close delineation of the external scene. In all these works, the description is simply *there*, occupying what may seem to the twentieth-century reader to be an inordinately large part of the poems and tales.

Conditioned by later books in which physical description plays a relatively minor role, the general reader today is likely to become impatient with the large amounts of it to be found in the works of Bryant, Irving, and Cooper. Failing to perceive immediately the thematic and artistic reasons for its presence, he is likely to dismiss the pictorial element as merely nonfunctional backdrop to the action of the tales and novels, or as so much romantic decoration, serving no significant purpose in the prose and verse. Readers who are aware of the development of romantic imagery in eighteenth-century Europe will recognize the close affinity of this description to the cult of the picturesque and, impelled perhaps by a misguided sense of nationalism, may seek to dismiss the pictorial mode as simply derivative of European models and not to be taken as serious art. This attitude, combined with lingering memories of mistaken nineteenth-century criticism that would make Bryant an American Wordsworth, Irving an American Goldsmith, and Cooper an American Scott, has probably stood in the way of sound evaluation of their works on their merits alone.

In a sense, these latter critics are right. The pictorial style does derive from aesthetic theories popular in England at the end of the eighteenth century. The writers themselves consistently use the vocabulary of the picturesque mode, and their descriptions of external nature strongly resemble the delineation of the natural scene that had appeared on canvas in Europe since the time of Claude Lorrain. Yet it is a mistake to assume that similarity is merely sameness, that to derive a style is to fail to adapt it to one's own artistic purposes. The basic question to be decided is not the source of the style, but whether or not the artist can mold it into a suitable vehicle for expressing his own individual themes. If the pictorial mode were simply imposed upon the work without concern for what is being expressed, it would have to be dismissed as nonfunctional decoration. If, on the other hand, it can be shown that "the style is a part of the thought,"[2] that the pictorial mode embodies the central core of meaning in the works of Bryant, Irving, and

Cooper, it will have to be accepted—derivative though it may sometimes seem to be—as their proper mode of expression.

The mere presence of so much description should prompt us to seek the reasons for its inclusion. The authors' concern with describing the physical world derives from the philosophic stance of the late eighteenth century, a stance that had a profound effect on all romantic art. Fundamentally, the question is epistemological. It involves a theory of knowledge. Living in the post-Lockean age, these writers believed as a matter of course that knowledge of the external world came only through sensation, that there could be nothing in the mind that was not first in the senses. Knowledge does not, however, come equally from each of the senses. Taste, touch, and smell yield only a relatively small part of one's knowledge of external reality. Hearing yields more, but it is through sight that one acquires most knowledge of his environment. Small wonder, then, that perception becomes a matter of primary interest to the philosophers and, as a natural consequence, to those writers who were deeply concerned with communicating to their readers the truth as they perceived it through their experience in the external world.

These concepts came to American writers primarily through the Scottish Common Sense school of philosophy, which, as a number of scholars have shown, was a dominant force in American philosophic thought in the early nineteenth century.[3] The influence of such men as Thomas Reid, Dugald Stewart, and Archibald Alison was all-pervasive throughout the period and strongly affected both the thought and the style of the first generation of American romantic artists. Bryant had read all three while preparing to enter Williams College in 1810,[4] and Irving was reading Dugald Stewart in the same year.[5] Of the three philosophers, however, Alison seems to have had the greatest influence on American art; his important work, *Essays on the Nature and Principles of Taste*, first published in Edinburgh in 1790, was widely read. An edition of this work was printed in Boston as early as 1812, and Alison and his ideas were noticed in some detail in early volumes of the *North American Review*.[6] Both Bryant and Thomas Cole reflect his views in their critical writing,[7] and the influence of his ideas is everywhere apparent in the prose and verse of the period.

Basic to the thought of the Common Sense philosophers is the sensationalist concept of knowledge. In his *Elements of the Philosophy of the Human Mind*, for example, Dugald Stewart sees "the impressions made on our senses by external objects" as furnishing "the occasions on which the mind, by the laws of its constitution, is led to perceive the qualities of the material world, and to exert all the different modifications of thought of which it is capable."[8] And Archibald Alison observes, in his *Essays on Taste*, that "the various qualities of matter are known to us only by means of our external senses."[9] This principle was, of course, only one of the bases for the philosophic system, the ramifications of which cannot be summarized here. Suffice it to say that the operation of the mind on the data derived from experience leads the observer to the acquisition of knowledge.

What is more important from our point of view is that this mental process can lead to an aesthetic response on the part of the sensitive observer. In Common Sense aesthetics, perception plays an important role, for the mind must perceive the objects of sublimity and beauty—the basic aesthetic categories of this philosophy—before it can respond to them with the proper emotion. The relation between the object perceived and the aesthetic response, however, is not a simple or an inevitable one, for it depends on a number of factors that have no necessary connection with the external object itself. Indeed, as Alison writes in the opening pages of his *Essays on Taste*, the simple perception of the object alone is frequently insufficient to arouse the emotions of taste. Although the effect such an object will have on the senses will be the same for every person who possesses normal sensation, not everyone will experience the emotions of sublimity or beauty. Though some may be deeply affected by what they perceive, others may feel no emotion at all.

One person may perceive but little beauty in a scene that another person might view with delight. Similarly, a single individual may respond quite differently to a given scene on separate occasions. If he should be in pain or grief, he will attend only to his present suffering and, even when viewing the most sublime or beautiful scene, will feel nothing of the admiration he might have had for it on another, happier occasion.[10] In the light of such evidence, Alison can only conclude that the objects of external nature

are in themselves incapable of producing the emotions of taste, that the beauty and sublimity of the external world reside not in the objects themselves, but are derived instead from mind.[11]

That there is nonetheless an important relation between the objects of sublimity and beauty and the response of the sensitive viewer is a basic tenet of the aesthetic system. These objects, however, affect the imagination of the observer only when trains of thought "analogous to the character or expression of the original object" are aroused in the imagination. Alison thought that the youthful mind, for example, when viewing a beautiful scene, is likely to experience a series of pleasing ideas: "of peace and innocence, and rural joy, and all the unblemished delights of solitude and contemplation." These "trains of imagery . . . rise spontaneously in the mind, upon the prospect of any object to which they bear the slightest resemblance, and they lead it almost insensibly along, in a kind of bewitching reverie, through all its store of pleasing or interesting conceptions." Whereas the man of business may associate ideas of value with the natural prospect and the philosopher may speculate "upon the causes of the beauty that was ascribed to [the scene]," the youth will experience a train of associations—aroused by the scene, but little dependent upon it—which will enable him to feel "an emotion of delight."[12]

Through the operation of mind, therefore, certain mental qualities or ideas are associated by the sensitive observer with various objects in the external world, and these associations are aroused in the mind when the object is presented to the senses. In the human body, in works of art, and in the objects of external nature, Alison writes, certain forms, sounds, and colors become signs of nonmaterial qualities: "of particular passions or affections" in the human body; of dexterity, taste, convenience, or utility in objects of art; or of peace, danger, plenty, or desolation in the external scene. "In such cases," he goes on to say, "the constant connexion we discover between the sign and the thing signified, between the material quality and the quality productive of emotion, renders at last the one expressive to us of the other, and very often disposes us to attribute to the sign, that effect which is produced only by the quality signified." In essence, the objects of the external world become signs of nonmaterial qualities, and "like all other signs," they

affect the observer by leading his imagination "to the qualities they signify."[13]

These objects are presented to the imagination primarily through the avenue of sight. Although Alison, like Stewart, may refuse to limit "the objects of sublimity or beauty, to the sole class of visible objects," he is quick to add "that by far the greatest number of these objects are such as we discover by means of [sight]." Through the rest of the senses, Alison writes, we are able to discern only single qualities of objects, and these when the objects are in close proximity to us. Through sight, on the other hand, we can perceive the multiple qualities of objects even when they are at a considerable distance.

> It is natural, therefore, that the greater power of this sense should dispose us to greater confidence in it, and that the qualities of bodies which we discover by means of it, should more powerfully impress themselves upon our imagination and memory, than those single qualities which we discover by the means of our other senses. The visible qualities of objects, accordingly, become to us not only the distinguished characteristics of external bodies, but they become also in a great measure the signs of all their other qualities; and by recalling to our minds the qualities signified, affect us in some degree with the same emotion which the objects themselves can excite.[14]

No stronger reason could be given for the predominance of the visual in this aesthetic system.

The effect of such a theory on the various branches of art should be immediately obvious. If the objects of external nature can arouse in the mind a train of associations that may lead the observer to experience the emotions of sublimity and beauty, so too will the images of those same objects affect the imagination of the reader or spectator when they are presented to his mind through the medium of art. Indeed, if it is properly done, the artistic representation of the external scene will be superior to the original from which it is taken. In exerting his creative powers, the artist can project a more unified view than any to be found in nature. He can create a landscape, for example, that eliminates those elements which in the natural scene would detract from its total

effect. In viewing the natural world, Alison writes, we often find the sublimest scenes "disfigured by objects that we feel unworthy of them," and "the loveliest scenes, in the same manner, are frequently disturbed by unaccording circumstances."[15] The artist, however, in composing his landscape, can leave out the discordant details and present such a unified impression that the emotion of sublimity or beauty is felt by the observer with the fullest and purest force.

Not all the arts, however, are equally successful in arousing the imagination to the proper pitch of activity. Though landscape gardening, in Alison's view, is superior to the natural landscape in that it can present a greater unity of effect, it is inferior to landscape painting because of the limitations that unwieldy natural objects place on the gardener. The painter has greater freedom to select the details of his compositions from a thousand different scenes, can give them a unity forever beyond the scope of the gardener, and can perpetuate on canvas those transient elements of the landscape—the effect of light and shadow, for example—that quickly pass from the natural scene. Superior to both, however, is the composition of the poet, for the gardener and painter are too limited to the strictly visual. The appeal they make to the eye is, of course, of the greatest importance, but they do not have the poet's means to appeal more directly through the medium of language to the imagination itself. "The painter can represent no other qualities of nature, but those which we discern by the sense of sight. The poet can blend with those, all the qualities which we perceive by means of our other senses."[16]

The advantage that the poet enjoys is therefore enormous. The painting is frozen in time and can represent a scene only as it appears at a given moment. The poet can range through time to show both the growth and decay of the things he describes, as well as "the powerful effects which are produced by the contrast of these different aspects or expressions." The painter must leave the interpretation of his view "to the imagination of the spectator; but the poet can give animation to whatever he describes."

All the sublimity and beauty of the moral and intellectual world are at his disposal; and, by bestowing on the inanimate objects of his scenery the characters and affections of mind,

he can produce at once an expression which every capacity may understand, and every heart may feel. Whatever may be the advantage which painting enjoys, from the greater clearness and precision of its images, it is much more than balanced by the unbounded powers which the instrument of language affords to the poet, both in the selection of the objects of his description, and in the decision of their expression.[17]

Granted the basic tenets of this philosophy, it was only to be expected that American writers of the early nineteenth century, whose aesthetic sensibilities had been strongly influenced by Common Sense thought, should lay great stress on the pictorial element in their prose and verse. The visual image, they had learned, was the basic means by which they could reach the minds of their readers, and the descriptive style they developed takes full advantage of the device. Because the visual image could serve approximately the same purpose as the corresponding object in the external world, the writers could use such images in their prose and verse to elicit from their readers a response fundamentally the same as that aroused by the physical objects themselves. Thus, if rugged mountain peaks or the broad expanse of sea observed in external nature suggest to the sensitive mind the concept of human freedom, the corresponding verbal image will do the same. In a similar fashion, if the beauty or sublimity of the physical world is suggested by sun-drenched landscape or dark abyss, so also will the verbal depiction of such views arouse the appropriate emotion in the sensitive reader.

Nowhere is the practice of these writers better illustrated than in a little book of essays and engravings published in New York in 1852, *The Home Book of the Picturesque,* a cooperative effort of both artists and writers in which, among others, Bryant, Irving, and Cooper all took part. The general theory is reflected in a long introductory essay by E. L. Magoon, called "Scenery and Mind," where the influence of natural objects is detailed at length. The practice, on the other hand, is amply illustrated in the little essays that accompany the various engravings of native scenes that are reproduced in the book, for each author describes the scenery he knows in such a way as to create the appropriate effect on the mind of the reader, who has probably not been able to view such scenes him-

self. Cooper compares European and American scenery for those who have not had the opportunity "to extend their personal observations beyond the limits of their own homes,"[18] and other writers, it may be assumed, describe the native landscape for much the same purpose. Irving depicts the Catskill mountains, Bryant describes the valley of the Housatonic, and other writers, like Bayard Taylor, N. P. Willis, and Henry T. Tuckerman, present a number of other parts of the native scene.

The purpose of the writers, however, is not to describe photographically, but to suggest to the minds of their readers those qualities of the various landscapes which give them their basic character. "All landscapes," Taylor writes, "whatever may be their features, have a distinct individuality, and express a sentiment of their own,"[19] a view that is amply illustrated by the other essays in the book. Cooper, for example, sets out to depict "the leading peculiarities of the scenery of various nations, and to direct the attention of the reader to the minor circumstances which give character to the landscape." He presents a number of typical scenes of various countries in Europe and ends with a general contrast of European and American scenery that reveals the basic difference between the two. He stresses the effect of "time and association," of the "impress of the past" that is reflected in European landscape, while he sees in American scenery "the freshness of a most promising youth, and a species of natural radiance that carries the mind with reverence to the source of all that is glorious around us."[20] The landscapes are described, not for themselves alone, but for their highly suggestive power.

The other writers see markedly different qualities in the external scene. Irving presents the Catskill mountains as having a fanciful character, owing perhaps to the "beautiful atmospherical effects" that have helped to arouse the romantic traditions with which, in his mind, they have long been associated. He acquired, he tells us, "a host of fanciful notions" when, as a boy, he watched the shifting play of light and shadow move across them while he listened to the marvelous legends told by an Indian trader who had taken passage on the same sloop with him.[21] Bryant, on the other hand, describes the Housatonic River in more serious intellectual terms, for he sees the course of the stream as analogous to human

life. It passes from childhood to youth as it grows in volume and strength, sweeping along in the majesty of manhood, turning the mills of the various towns, and slipping at last "like an aged man" into the sea.[22]

If the writers differ sharply in the suggested meanings they see in the natural landscape, they all attempt to elicit an aesthetic response from their readers. Tuckerman, for example, describes American mountains in such a way as to support his general conclusion that American scenery strikes the imagination as sublime,[23] while Susan Fenimore Cooper, the novelist's daughter, depicts a peaceful landscape lying beneath "the softening haze of the Indian summer" as a scene of strange and fanciful beauty.[24] Her father describes the mountain villages of southern Europe in a manner that reveals the "character of peculiar beauty" that they possess,[25] while Irving contrasts the sublimity of the wild depths of the Catskills with the "bland and beautiful" slopes, "softened by cultivation," that descend toward the Hudson.[26] Bryant, on his part, pauses in his essay to describe the sublime effect of a violent thunderstorm, the lightning "appearing like rivulets of molten gold" as it flashes through clouds made crimson by the light of a setting sun.[27] In passages like these, the writers are using the descriptive mode not only to express thematic meaning, but to arouse as well the emotional response of the beautiful or the sublime.

The Home Book of the Picturesque is an essentially simple volume, the whole purpose of which was to present rather graceful pieces of description for the amusement and general edification of its readers. A curious period piece, it is in itself a thing of small intrinsic value. Yet it remains a significant document in the history of American taste and provides a convenient means of entry into the study of those more significant works of Bryant, Irving, and Cooper which still may justly claim our serious critical attention a century and more after the descriptive style has gone out of fashion: works that rely as heavily on the pictorial mode for the expression of their themes, but which use the descriptive technique for serious artistic ends. To read these works in terms of their visual elements, however, is not an easy task, for it requires us to "see" the descriptive effects in something of the same way that a contemporary audience might have viewed them; to recapture, in

other words—insofar as it is possible—the aesthetic sensibility of the first half of the nineteenth century in America.

The authors themselves provide us with certain clues, for they sometimes suggest the train of associations that their descriptions should elicit. By presenting the visual image and including as well the reaction that one might appropriately have toward the object, the writer reveals the function that the pictorial style was intended to serve. In *Bracebridge Hall* and *The Sketch Book*, for example, both of which are told from the point of view of Geoffrey Crayon, the persona describes the effect of the rural scene in England. It has about it, he observes, "a serene and settled majesty . . . that enters into the soul, and dilates and elevates it, and fills it with noble inclinations." The "planted groves, and stately avenues, and cultivated parks" to be found in the English countryside in- fluence the sensitive observer because of the "moral associations" with which they teem.[28] English scenery, in Crayon's view, pos- sesses "great charm" derived from "the moral feeling that seems to pervade it. It is associated in the mind with ideas of order, of quiet, of sober well-established principles, of hoary usage and reverend custom" (2: 83). Irving employs in these passages the prerogative of the writer, mentioned by Alison, of providing both the visual images and the moral associations that can be inspired by them. He shows us in effect how we might "read" this type of imagery.

Cooper, too, occasionally includes in his works both the visual image and the associations it is designed to elicit. In *The Heiden- mauer*, for example, he writes of the "pleasing melancholy" aroused in the "man of reflection and proper feeling" who ap- proaches so striking an object as the remains of the ancient wall that gives the book its title. "The certainty that he has before his eyes the remains of a work, raised by the hands of beings who existed so many centuries before him in that great chain of events which unites the past with the present, and that his feet tread earth that has been trodden equally by the Roman and the Hun, is suffi- cient of itself to raise a train of thought allied to the wonderful and grand."[29] In *Home as Found*, moreover, he includes an ancient tree that so fills the minds of his characters with thoughts of the distant past as to influence them—and the reader as well—to experience the emotion of the sublime (pp. 201–3).

Similar examples can be found in Bryant's verse, where natural objects are frequently used to suggest thematic meaning. The sight of the little stream in "The Rivulet," for example, arouses in the poet a chain of associations reaching back to the past, when, as a small boy, he had played along its banks. The change he perceives in himself after the lapse of time in contrast to the unchanged aspect of the stream leads him to thoughts of the mutability of human life, thoughts that, presumably, the reader will be influenced to share with him.[30] In much the same fashion, Bryant suggests in "A Forest Hymn" the meaning to be perceived in the untouched woods. He imagines the effect that "stilly twilight," "gray old trunks," and sighing boughs must have had on primitive man in leading his mind to thoughts "of boundless power / And inaccessible majesty" (p. 79). His own experience in an "aged wood" has led him to feel a similar sense of awe, and his description of the scene is designed to have a like influence on the reader. By suggesting such objects in his verse, therefore, he guides the imagination of his reader to both the thematic meaning to be derived from them and to the emotional response that they might appropriately raise.

Although passages like these are helpful to the twentieth-century reader in enabling him to understand selected visual images and short descriptive passages in the works of Bryant, Irving, and Cooper, he cannot rely on them entirely in interpreting their poems and tales. The writers pause only infrequently to provide such explicit guides, and they sometimes include long and complex descriptions, frequently running to considerable length, that cannot be simply tagged in this way. To interpret such extended descriptions and to understand the artistic function served by the broad descriptive patterns that may dominate the whole of even so long a work as a novel by Cooper, the modern reader requires another means for analyzing the pictorial style. In this matter, he is helped most by the close analogies to be found in the works of contemporary landscape painters, who resemble this group of writers in both temperament and thought. Because of the many similarities in both theme and technique in the verbal and graphic landscapes of the period—similarities that have already been noted by a number of scholars[31]—we can turn from one medium to the other, using what we learn from one as a gloss to the meaning of the sister art.

There are dangers in this method, for a painting is not a description. An image expressed in language is not precisely the same as the painted representation of even the same object depicted on canvas, a fact well known to the associationist philosophers and those whom they influenced. Yet despite the obvious differences in the verbal and graphic delineations of the external scene, there is an area in which they are very much alike. Both depict the objects of external nature, and both attempt to suggest by the manner of their presentation those ideas and qualities of which the external world is only the sign. At the simplest level, the painting and the description may merely present related images, which, if not exactly the same, can nonetheless arouse similar associations in the mind of both reader and viewer. At a much more complex level, however, the verbal and graphic landscapes may combine their various parts in such a manner as to suggest related wholes, the form and tone of which may excite the imagination of the reader and viewer to a perception of related meanings and the enjoyment of a similar emotional response.

The intellectual basis for this relation had been firmly established in the Common Sense thought of the time, for the Scottish philosophers believed that painting and poetry could achieve analogous effects. Although Archibald Alison might argue for the superiority of poetry to painting because of the greater suggestive power of language, both he and Dugald Stewart agreed that painting could transcend the merely imitative and approach the suggestiveness of poetry. The landscape painter, in Alison's view, can employ a "language" that appeals not only to the eye, but also to "the imagination and the heart," and the sensitive viewer, recalling perhaps the effects he has learned to appreciate in poetic compositions, may come to value the expressive landscape over the merely imitative.[32] In a similar fashion, Stewart writes in his essay "On the Beautiful" that certain details in a landscape painting may have "the power of conveying to the fancy more than the pencil of the artist has delineated." They exist, therefore, not for any intrinsic merit they may have in the landscape, but serve instead "as hints to the imagination." The effect of such an element is much like that of language. "It does not denote what is actually represented; but what sets the imagination at work, in forming pictures of its own."[33]

Because the painter can use his graphic images in much the same way that the poet employs language, he can offer the sensitive spectator landscapes that rival poetry in their suggestive power. By no means content, as Stewart puts it, "to deceive the eye by accurate representations of particular forms," the superior landscape artist speaks "by the touches of an expressive pencil . . . to the imaginations of others." He employs his professional skill "to convey the ideas in his mind," and, by departing from strict imitation and "forming new combinations of his own, he vies with the poet in the noblest exertion of the poetical art."[34] Though one may doubt that anyone ever achieved with paint and canvas the highly imaginative effects that can be suggested through language, the theory is nonetheless important in that it placed the work of the landscape painter on a level more nearly approaching that of poetry. It encouraged the view in both painters and writers, moreover, that literature and painting are closely related arts in which similar techniques may be used to express related meanings.

American writers and painters agreed, for example, that landscape painting could rise above the merely imitative to achieve poetic suggestiveness. In discussing the principles of art in his *Lectures on Art*, Washington Allston writes that every work of genius is suggestive, that "only when it excites to or awakens congenial thoughts and emotions, filling the imagination with corresponding images, does it attain its proper end,"[35] and Thomas Cole, in a letter to Daniel Wadsworth, views the mission of the artist as "a great and serious one. His work ought not to be a dead imitation of things, without the power to impress a sentiment, or enforce a truth."[36] The writers, on their part, were perfectly willing to concede that the landscape painter could indeed achieve poetic effects in his art. To Bryant and Cooper, some of the paintings of Thomas Cole were quite literally poems, and his work as a whole, in Cooper's view, exhibits "high poetical feeling."[37] As Bryant expressed it in his eulogy of Cole in 1848, the artist had "copied the forms of nature, . . . blended them with the profoundest human sympathies, and made them the vehicle, as God has made them, of great truths and great lessons."[38]

If painter could rival poet in the suggestiveness of his art, the writer, in turn, could vie with the landscape artist in his depiction

of external nature. Through the use of the verbal image, he could suggest to the sensitive reader the kind of scene he might find in the works of a graphic artist. Thus, in his *Tales of a Traveller*, Irving describes an Italian landscape as if viewed by a painterly eye (7: 322), and Cooper uses the language of art to describe a scene he presents in *The Headsman* (p. 298). At times, they explicitly state that the scene resembles in tone the works of such well-known artists as Salvator Rosa or Claude Lorrain. At others, they simply compose their landscapes in such a way as to suggest the typical view to be found in the works of their painter friends. In either event, all three writers clearly expected their readers to see the relation, to read the descriptive passages as one might view a painting, above all to *visualize* the scene described and discern its thematic significance. Twentieth-century readers may take a cue from this perception and turn to the graphic arts as an aid in recapturing the sense of the pictorial that the writers instilled in their work and through which they expressed a significant part of its meaning.

II. Space

Forced by the nature of their aesthetic beliefs to appeal to the "eye" of their readers, the writers were confronted with much the same problem as that which faced their painter friends: to construct a visual world in which meaning could be expressed through the depiction of objects in space. For both writer and painter, this spatial arrangement was crucial. Whatever the natural object involved in either mode of expression, it could assume a number of meanings depending upon the spatial context in which it was placed. Tiny human figures completely dwarfed by a vast expanse of mountain and sky necessarily suggest a different thematic meaning from similar human forms, which, by their size and position, dominate a more restricted landscape. In a similar fashion, a pleasant rural scene will suggest quite different interpretations if viewed, on the one hand, from a point of observation in the plane of the landscape itself, or, on the other, from a reference point placed high above it on an adjoining mountain or hill. The second aspect increases the reach of space in the surrounding scene and suggests a much more expansive view of the natural world. Similar differences can be achieved by adding or subtracting details from a given landscape, or by changing the pattern of light and dark in the scene.

To say this much is not to ignore the obvious distinction that must be made between verbal and graphic depictions of space. However much alike the landscapes of writers and painters may seem to be, the nature of the media themselves entail some important differences. Literature, after all, is not fundamentally a spatial art, but painting clearly is. In viewing a painted landscape, the eye may perceive the broadest spatial patterns with almost a single glance, but in reading an extended description in a poem, sketch, or novel, it can perceive even the most general spatial relations only as the passage unfolds in time through the sequence of words. To be sure, after the initial impact made by the painting, the eye of the viewer must move in a similar way across the canvas to read

the details of the picture in a more leisurely fashion. Yet even here a difference is still apparent, for the whole of the painting remains before the view, as the whole of the description does not. The effect of a landscape painting must therefore always be more immediate than that of a scene described in a poem or novel.

These differences aside, however—and for our purposes they are not crucial ones—there remains a fundamental core of similarity in the way that the writers and painters handled their spatial relationships. Both were concerned with the meaning that their depictions of nature might suggest, and both used much the same elements in their verbal and graphic landscapes in order to suggest it. At least three can be clearly discerned. Because they envision a natural world that is vast and expansive, they lay particular stress on the immensity of the external scene. Their views are spatially arranged to suggest this attribute of the physical world and to express the significance of that view to men who must live and act with a consciousness of its immensity. Within the spacious landscape, however, they commonly include two other basic elements that contribute to both the aesthetic effect and the thematic meaning. All make use of closely observed and accurate detail in their depicted scenes, and all employ rather striking patterns of light and shadow in composing their landscapes. Taken separately, each of these elements performs a significant function in the verbal and graphic views. Taken together, they help to create the characteristic mode of expression that Bryant, Irving, and Cooper shared with their artistic contemporaries.

1. The Expanse of Nature

That American writers and artists of the generation of Bryant, Irving, and Cooper should have been concerned with the depiction of an expansive nature was only to be expected. The whole cultural tradition to which they belonged and the natural landscape that presented itself to their senses both encouraged and justified the attempt. As heirs of the aesthetic views of the eighteenth century, they were well aware of the relation of vast space to the theories of the sublime developed by eighteenth-century writers

and critics, and much of the American practice in both literature and painting during the early nineteenth century derives, in part at least, from that source. Critic after critic in eighteenth-century England had listed among the qualities that produced the sublime such elements as vastness, great distance, height, depth, and infinity, and had mentioned such specific natural phenomena as the ocean, stars, and mountains as contributing to its effect. Indeed, so commonplace were these concepts in such writers as John Baillie, Edmund Burke, Hugh Blair, and others that it would be cause for wonder if men like Bryant, Irving, and Cooper had not been influenced by them.[1]

Throughout the eighteenth century, too, the practice of British poets had provided ample precedent for the use of such concepts in literary art. In "Summer," for example, the second part of *The Seasons*, James Thomson evokes the sublime in the vision of cosmic space he includes in the early part of the poem (ll. 32–34), and he presents a landscape of vastness and solitude in his description of a tropic scene (ll. 690–715). Edward Young writes of "boundless space" and "boundless time" in his *Night Thoughts* (9: 1172–74), and William Cowper includes a set view from an eminence in the vast panorama he describes in the first book of *The Task* (ll. 154–80). Contemporary British writers also evoked a sense of sublimity in their works. Poets like Wordsworth, Byron, and Shelley develop the suggestions of infinitude as they perceive them in mountain and sea,[2] and Sir Walter Scott, among writers of prose, depicts sublime landscapes in the views he draws of highland scenery in such romances as *Waverley* and *Rob Roy*.[3] Since much of this work was available to Bryant, Irving, and Cooper by the time they began to write, we can never discount the influence of British example on their art.

But if British critical theory and practice had taught generations of Englishmen and Americans how to look at external nature, the physical environment in which the Americans lived undoubtedly contributed its part too. The immensity of space as opposed to the smallness of man had been a primary condition of American life for two hundred years,[4] and even at the beginning of the nineteenth century a spacious continent waited to be filled. It was only natural, then, that Americans should have been deeply moved by

the perception of almost limitless space, and that writers from Bryant to Frank Norris and painters from Cole to Albert Bierstadt should have deliberately sought to express in their writings and paintings the spaciousness they perceived in the external landscape. The concept of extensive space was so deeply ingrained in the American consciousness that writers and painters could assume that their audiences would understand the themes they expressed through the depiction of an expansive landscape.

One need only turn to the travel literature written and published from the closing years of the eighteenth century on, to perceive that the art of Bryant, Irving, and Cooper was based upon an aesthetic and philosophic attitude toward nature that had thoroughly permeated American life. The travel literature is particularly useful for this purpose, for in these narratives one finds the personal reactions to the natural scene of a great many individuals of varied types and backgrounds. Yet even though these books were written by quite different personalities over a rather long period of time and describe a large number of quite varied scenes, there is a remarkable similarity in the way the different writers describe the external landscape, so much so, in fact, that they must surely be reflecting—or perhaps even catering to—a taste in landscape already well established in the popular mind. No other conclusion is possible when one finds Alexander Mackenzie in Canada in 1789, William Bartram in the southern colonies in the 1770s, and other travelers in the Ohio and Missouri valleys after the turn of the century all describing the natural landscape in much the same way.[5]

Indeed, wherever one turns in the travel literature of the times, he is likely to find one or more set descriptions of a vast landscape, almost invariably seen from an eminence and suggesting not only the expansiveness of the view but, perhaps, a philosophic thought or two as well. In even so unliterary a book as John Filson's *Discovery, Settlement, and Present State of Kentucke* (1784), the author includes such views. In a section of the book supposedly written by Daniel Boone, Filson has the frontiersman ascend "the summit of a commanding ridge" and look "round with astonishing delight" on ample plain and beautiful river, while "at a vast distance . . . the mountains lift their venerable brows, and penetrate

the clouds." One may doubt that Boone experienced a sophisticated aesthetic reaction as he passed through the wilderness, or that he felt a Burkean feeling of terror as he contemplated "wild and horrid" cliffs, the remains of "some violent convulsion, . . . the ruins, not of Persepolis or Palmyra, but of the world!"⁶ Nevertheless, such passages are significant in that they indicate what Filson could probably assume was in the cultural possession of his audience.

Example after example can be multiplied from the many frontier narratives that appeared as the West was opened. In his *Topographical Description of the Western Territory of North America* (1792), Gilbert Imlay, in describing the Falls of the Ohio, comments upon the sublimity of the river's breadth and describes "the rising hills of Silver creek, which, stretching obliquely to the north-west, proudly rise higher and higher as they extend, until their illumined summits imperceptibly vanish";⁷ while Thaddeus Mason Harris, in his *Journal of a Tour into the Territory Northwest of the Alleghany Mountains* (1805), describes from an eminence a view "crowded with mountains upon mountains in every direction; between and beyond which were seen the blue tops of others more distant, mellowed down to the softest shades, till all was lost in unison with the clouds."⁸ And Fortescue Cuming, in his *Sketches of a Tour to the Western Country* (1810), describes his ascent of a high pinnacle, "from whence there is a most extensive view in every direction, of ridges beyond ridges covered with forests, to the most distant horizon."⁹

The mere appearance of such landscapes is not their main significance, for to describe a scene from an eminence is a perfectly natural thing to do, and with some of the writers, one may suppose, the carefully drawn panoramic view might have been little more than a fashion to be followed in giving a literary gloss to their materials. What is important is the meaning ascribed by some of the writers to their expansive scenes, for it helps to establish the relation of these men to the creative writers and painters, who used similar techniques to develop a philosophic theme and elicit an aesthetic response from their audience. Once again the basic source is the aestheticians of the eighteenth century, who wrote of the natural scene as serving to stimulate the emotions of the beholder,

or to reveal to him certain qualities of the Deity, who reveals himself in his creation. Both the psychological and religious aspects of the sublime had been developed at length throughout the eighteenth century and had achieved full expression in the works of Archibald Alison, who saw the highest function of the natural scene as leading the mind of the beholder to contemplation of the Almighty.[10]

Such ideas, closely associated with the description of an expansive nature, appear in some of the travel literature we have been considering. Harris, for example, writes at length of the psychological effect of "the majestic features of the uncultivated wilderness, and the extensive views of nature gained from the brows of a lofty mountain." They "produce an expansion of fancy and an elevation of thought [that are] dignified and noble. When these great scenes of creation open upon the view, they rouse an admiration exalting as it is delightful: and while the eye surveys at a glance the immensity of heaven and earth, the mind is rendered conscious of its innate dignity, and recognizes those great and comprehensive powers with which it is endowed. THE SUBLIME IN NATURE, which, in its effect is equally solemn and pleasing, captivates while it awes, and charms while it elevates and expands the soul."[11] "Ideas of immensity" swell and exalt his mind as he contemplates a prospect which suggests the idea of infinitude, and he feels "some wonderful relations to an universe without boundary or end."[12] Cuming feels "wonderfully cheered" when he comes upon an extensive prospect and experiences "an expansion of the whole system" when he emerges from the restriction of "thick forests and cane brakes,"[13] an idea that was shared by H. M. Brackenridge, who, in his *Journal of a Voyage up the River Missouri* (1814), comments upon the different feelings aroused by the "romantic scenery" of the extensive plains and "those experienced in the close forests of the Ohio."[14]

It is but a step from this kind of attitude to that which would stress the religious aspects of the expansive landscape, for if the natural scene suggests the concept of infinitude to the mind, it may also lead it eventually to the contemplation of God. Thus, Harris mentions the awe which the spectator feels in "mountainous scenes" where "nature exhibits her boldest features" and "every

object is extended upon a vast scale"; and he writes of a "something which impresses the mind with awe in the shade and silence of . . . vast forests. In deep solitude, alone with nature, we converse with God."[15] Estwick Evans, moreover, whose *Pedestrious Tour of Four Thousand Miles* appeared in 1819, sees religion "in the very name of wilderness, which charms the ear, and soothes the spirit of man," and he perceives in "the expansive calmness" of a prospect "great and deep things, too sublime for human utterance.—Things which point to the future development of mind, to the high destinies of virtue, and to the nameless peace of heaven." The "grand in nature," he believes, "withdraws the human mind from the trifling concerns of time, and points it to its primeval dignity, and lofty destinies."[16]

Such descriptions and interpretations of the external landscape were not limited to the travel literature of the time. They had already appeared a generation earlier in American writings that have some claim to literary merit. The set depiction of an extensive landscape so common in these volumes had achieved a kind of classic expression in Thomas Jefferson's famous description of the confluence of the Shenandoah and Potomac rivers in *Notes on the State of Virginia* (1784–1785),[17] and the religious meaning that some of the travelers read into the landscape had already appeared, expressed with an artistry that few could match, in William Bartram's *Travels* (1791). Both Jefferson and Bartram draw their expansive landscapes with a painterly eye, and Bartram provides the philosophic meaning that gives his book a coherence not often found in such volumes. The whole of his work is animated by a vision of the world "as a glorious apartment of the boundless palace of the sovereign Creator," and his mind is filled with awe when he sees in the external landscape "an amazing display of the wisdom and power of the supreme author of nature."[18]

Bartram does not append so explicit a statement of his religious response to nature with every scene he describes. Indeed, he shows considerable artistic restraint in keeping such comments to a minimum. Yet his book is filled with the same spirit of wonder at the glories of external nature even in those passages in which the religious theme is not overtly expressed. Thus, when he describes a scene, the "ridges of hills rising grand and sublimely one above and

beyond another, some boldly and majestically advancing into the verdant plain, their feet bathed with the silver flood of the Tanase, whilst others far distant, veiled in blue mists, sublimely mount aloft, with yet greater majesty lift up their pompous crests and overlook vast regions,"[19] the reader knows the context in which the description is to be interpreted. The panoramic views are designed to suggest the boundless majesty of God as it is revealed in his creation. One might even argue that any explicit comment on the author's part would be not only superfluous, but detrimental to his effect, for Bartram constructs his descriptions so well that, once we are aware of his thematic purpose, they are in themselves fully capable of suggesting the philosophic meaning that he wishes to convey.

All the ideas we have been treating here and the means by which the writers gave them expression appear as well in the works of Bryant, Irving, and Cooper and have their graphic counterparts in the paintings of the Hudson River school, for they are the early expression in America of a romantic vision of the world that many writers and painters of the early nineteenth century shared. Since a number of the passages cited, moreover, were written and published before the major works of Bryant, Irving, and Cooper began to appear, there can be no doubt that the writings of the first generation of romantic artists grew out of an intellectual and artistic matrix that had been forming for at least a generation or more. We can find analogues to their spacious descriptions of the panoramic landscape in books that go well back into the latter years of the preceding century, and we can trace their sources even further in the aesthetic theories of eighteenth-century England and the practice of English prospect poets of yet earlier times. The view from an eminence had obviously become a rather standard convention by the time they began to write, and its effect upon the perception of a wide horizon was well understood.[20]

To say this much, however, is not to detract from the artistic accomplishment of a Cooper or Bryant, a Cole or Durand, for writers and painters have always derived part at least of their themes and techniques from their predecessors, yet the true artist has always been able to place his unmistakable stamp upon them. Nor should we conclude that the response these writers and

painters made to the natural setting was not personal and real be-
cause it was based on English aesthetic theories and reflected Euro-
pean practices. One need only read Bartram's *Travels* to under-
stand that a valid response to the external scene may be expressed
in terms of a rather stylized artistic convention. One might just as
well conclude, indeed, that the American landscape gave added life
to the aesthetic views because they seemed to explain so well an
imaginative response to the natural scene that was both native and
sincere. What the passages from the travel volumes indicate, there-
fore, is simply that Bryant, Irving, Cooper, and their painter
friends based their work on a view of nature widely current in
their own day and used a mode of expression that would have
been readily understood and appreciated by their contempo-
raries.

One of the basic elements of that mode—the panoramic view
seen from an eminence—has become so well known that we need
hardly pause to enumerate examples here. The relation of such
landscapes as Cooper's view of Fort William Henry in Chapter 14
of *The Last of the Mohicans* to the canvases of the Hudson River
painters has been demonstrated by Howard Mumford Jones,[21] and
I have written elsewhere of the affinity between the panoramic
views in Bryant's verse and the paintings of Thomas Cole.[22] We
need only note that Irving too would on occasion describe a sim-
ilarly expansive scene, and we may point to the vast panorama
he describes from the Tower of Comares in *The Alhambra*
(15: 105–10), or to the magnificent landscape he draws when
Captain Bonneville stands on the Great Divide and views the
mountain peaks and streams spread out before him (10: 217–19),
as noteworthy examples of the technique. To be sure, the latter
description is drawn on the continental scale that reminds us more
of Bierstadt than of Cole, but passages like these demonstrate his
kinship to Bryant and Cooper in this basic technique of landscape
description.

Typically, the landscape is described from an eminence over-
looking a valley or broad plain. The point of view is thus elevated
above the level of the landscape, a vantage point that necessarily
lengthens the sweep of horizontal space and widens the field of
vision on each side. A river wanders through the middle distance

tying the parts of the landscape together, and trees and, at times, men and their artifacts establish the scale of the scene. The view is circumscribed by a range of hills or mountains, but distant peaks or ridges sometimes rise beyond them to suggest an even greater distance. The infinite reach of space, finally, is suggested either by the way the distant mountains blend into the heavens or by a highlight placed in the limitless expanse of sky. The scene may be varied in a number of ways and may express any of several moods, but the effect of unlimited space is always present and may suggest the religious feeling associated with ideas of infinity.

Such formal descriptions of the external scene, however, have only a limited artistic value. Varied though they may be, there is a certain sameness about them that precludes their frequent use, and a writer, after all, must necessarily find only a very few occasions when such panoramic views can appropriately be introduced. One would expect, therefore, as is indeed the case, that such set pieces of nature description should appear rather infrequently in the works of these three writers. The striking nature of the descriptions and their relation to the canvases of the Hudson River painters have drawn much attention to them, but undue emphasis on them alone will blind the critic to other means the writers used to suggest the sense of vast space which all three perceived in the external landscape and wished to express in their works. Several elements in the natural scene could, of course, be used for a similar purpose, and these are the ones we should consider in most detail, for they have the greatest and, at their best, the subtlest effect on the individual writer's style. It is in them that we are most likely to perceive the fundamental artistry of the pictorial mode.

The elements most commonly used are not hard to enumerate, for any aspect of the external landscape that would suggest either great size or vast power was a suitable object for their purpose. Mountains, stars, sea, forest, prairie—all offered themselves to the imagination of the artist as means through which he might project his vision of a spacious world. But although all these elements appear in the works of Bryant, Irving, and Cooper, it must not be assumed that they always serve the same intellectual purpose for all three men. The function of a symbol in romantic art is to suggest—an idea to which these writers fully subscribed and which

had become a commonplace in the aesthetic theory of the times.[23] But what is suggested by the symbol—or for that matter by the object in external nature—is determined to a considerable extent by the sensibility that observes it, because the observer is likely to interpret the symbol or the view in terms of his own individual associations.

This concept is best illustrated from the works of the men themselves. Consider, for example, their use of the mountains. Here were natural objects perfectly suited to suggest the expanse of space, but what that space might mean was determined to a considerable degree by the attitude of the writer and the context in which he placed his symbol. In some of Bryant's poems, for example, the mountains become the vehicle for expressing the poet's liberal views. In "William Tell," "they proclaim / The everlasting creed of liberty" (p. 118); in "To the Apennines," they become an image of the freedom sought by those in political bondage (p. 160). One can argue that open space may appropriately express the concept of freedom, an idea that Bryant repeats in terms of the prairies in his poem "The Hunter of the Prairies," but one wonders if it would necessarily mean the same thing to one who, unlike Bryant, was not already committed to the principle of liberty and would therefore be less likely to read his own predilection into the landscape.

Such is the conclusion we must certainly draw if we examine Irving's use of similar material. Though struck, like Bryant, with the sublimity of the mountain landscape, he makes no attempt to view the mountains as symbols of freedom. Rather, he stresses the vast upheavals of the earth by which the mountains had been formed, and he even views them once as a kind of chaos. Thus, in *Astoria*, the mountains of the West, with their "precipitous cliffs and yawning ravines" appear to be, in words that remind us of the passage in Filson, "the ruins of a world" (8: 217). In *The Adventures of Captain Bonneville*, they call to mind the "past convulsions of nature" (10: 290) that thrust them into their present form.[24] Through a number of these descriptions, the concept of change recurs—albeit change that has taken place in the distant past—and the suggestion is strong that even the mountains themselves share in the transience of all things in nature. Hence, one is

tempted to see this attitude on Irving's part as related to his life-long obsession with the theme of mutability.

The sea, like the mountains, is also capable of multiple inter-pretations and can serve at times a rather conventional purpose. It occasionally appears as a stereotyped image of eternity into which the stream of life flows, a function which it serves not only in Cole's vast allegorical series of paintings *The Voyage of Life*[25] but also in Bryant's poem "The Unknown Way" (p. 213), and in at least two of Cooper's novels, *Mercedes of Castile* (p. 508) and *The Sea Lions* (p. 121). Like the mountains, too, the sea can be used to represent the idea of freedom, of escape from the trou-bles and restraints of the civilized world. This concept, as Thomas Philbrick points out in his discussion of Cooper's sea fiction, in-forms two of the early maritime novels that Cooper wrote.[26] In both *The Red Rover* and *The Water-Witch*, Cooper's use of the sea suggests a theme of unrestrained freedom, the like of which is not to be found in his later tales, where the ocean serves a very different purpose. The meaning of the sea changes when the writer invests it with different associations.

Cooper himself made use of this concept of multiple meanings in at least two of his novels. At one point in *The Headsman*, a group of characters just embarked on Lake Geneva are struck with awe and "reverence" by the sublime view as the setting sun gilds the tops of the Alps that rise above them (pp. 67–69), yet, a short time later, as a gathering storm forms around these peaks, the same view takes on an ominous tone, derived in part from "the very sublimity of the scale on which Nature had here thrown together her elements." The same qualities that the observer "had dwelt upon with rapture, were now converted into dreary crags that seemed to beetle above the helpless bark, giving unpleasant admonitions" of the danger that threatened it (pp. 77–78). It is not the space alone, therefore, that controls the meaning of the scene, but the emotional interplay between the observers and the external landscape. The shifting aspect of the natural scene and its influence upon their mood determine the meaning and the signifi-cance of the symbol used.

A similar concept is illustrated in *The Red Rover*, where, as Philbrick has observed, three characters come upon the same scene

and each reacts in a highly individual manner.[27] It is night on board the *Caroline* when Gertrude, Mrs. Wyllys, and Wilder all gaze at a strange seascape, the full moon playing across the waves, which, reflecting the light, give "a character of the wildest loneliness to the view." Gertrude is both frightened and delighted by the sight, while Mrs. Wyllys is impressed "with a deep conviction that she [is] now entirely in the hands of the Being who had created the waters and the land" and thus reads a religious significance into the scene. Wilder, on the other hand, the professional seaman, views it with none of these feelings, for "to him the view possessed neither novelty, nor dread, nor charm" (pp. 197–98). Each responds to the external scene as his mood, or background, or professional training dictates. There would seem to be nothing in the landscape, therefore, to determine a particular meaning: everything is in the mind of the beholder.[28]

Such a view of nature and art, although perfectly consistent with the associationist philosophy on which their aesthetic theories were based, posed a serious problem to the philosophic writer or painter who perceived an absolute truth of God, man, and nature in the external scene and wished to communicate it in his works. If the meaning of a scene or symbol was merely relative to the mood or background of the individual who responded to it, the artist would be hard pressed to communicate his themes to his audience with the reasonable assurance that they would be generally understood. Not all associations, of course, were individual, and contemporary philosophy allowed for group or national associations that large numbers of people might share, a fact which the writers and painters made good use of in their works. Yet the theory did introduce a large degree of relativism into the interpretation and appreciation of a landscape or a work of art and created a serious problem for the writers and painters that they had to solve.

Most of the writers and artists of the generation of Bryant, Irving, and Cooper shared, to a greater or less degree, a great religious vision of the world similar to that noted in the works of William Bartram and others among the writers of travels. Basic to this view was the belief that God revealed himself in the works of his creation and that man could learn the truths of his own being—

both physical and moral—from careful observation of the natural world. To those who shared this belief—as Bryant, Cole, and Cooper in particular did—the truths that man perceived in the external landscape were not relative to the individual observer, but were valid for all men in all times and places. Hence, when writer and painter sought to impress upon their audience the truths of the universe as they saw them, they had to find less equivocal means than any we have yet noted for the expression of their great moral theme. What they needed, in short, was a symbolic device that would compel the interpretation they wished.

It was precisely here that the concept of a spacious world served them best, for although a reader or viewer might not be willing to concede a specific moral meaning in a particular land-scape, few would be disposed to deny the immensity of earth, sea, or sky when seen from the point of view of the individual human being. For poet, painter, and novelist, this was the essential mean-ing of a spacious world: the universe is vast and man is small. To perceive this relation, they believed, is to acquire a proper sense of one's own limitations in an immense and powerful world and to develop thereby a healthy spirit of humility with which to face the world, other men, and God. In expressing this theme, there-fore, the literary or graphic artist strove to instill in his works so deep a sense of a vastly spacious world that the reader or viewer would at once apprehend its meaning. And to insure its effective-ness, he would present it most frequently in terms of human char-acters who, living and working within the frame of an expansive nature, clearly illustrate the limitations of man.

On canvas this theme could most easily be expressed through the conventional means of depicting a vast scene as if viewed from an eminence with tiny men or their possessions firmly subordinated to the general view. The small figures in the middle distance of Cole's *View of the White Mountains* or the houses and farms that are all but engulfed by the surrounding space in *The Oxbow* clearly serve this purpose.[29] In poems and prose works, too, the same technique could be used, so long as the writer was willing to limit himself to the standard device of the prospect described from an eminence. Thus, Bryant includes "white villages, and tilth, and herds" in the view he presents in the opening lines of "Monument

Mountain" (p. 63). Cooper depicts Fort William Henry and the tents of the French army in the panoramic scene he draws in *The Last of the Mohicans* (pp. 163–65) and describes Abercrombie's fleet ascending Lake George in the view he presents in *Satanstoe* (pp. 354–55). And Irving, too, in the vast panorama he draws in *The Alhambra*, includes towers, walls, and battlements in the distant mountains, the city of Santa Fe in the vast expanse of the Vega, and even "a long train of mules" moving among the arid hills (15: 108–9).

The writers, of course, had more resources available to them than did the painters and could use more varied means to suggest an expansive landscape. Through the use of language, they were able to suggest relations between man and nature that could not easily be represented on canvas. The writers were well aware of this advantage, and Bryant, in his "Lectures on Poetry," discusses it at length. Since the purpose of art is suggestive—to arouse the proper associations in the mind of the reader or viewer—the art form with the greatest power of suggestion is obviously the most versatile. Because, by its very nature, language is not so definitive in its representation of physical reality as forms painted on canvas, it allows for a greater imaginative power to work in the mind of the reader. Indeed, Bryant even goes so far as to argue that this very limitation of language, its inability to express precisely the physical reality it attempts to describe, works to the advantage of the literary artist, for what he loses in exactness of representation, he gains in the power of suggestion.[30]

Through this suggestive power of language, therefore, the writer can escape the physical limitations of graphic art. He can suggest a kind of landscape that can never be depicted on canvas. Thus, the literary artists were able to portray the whole breadth of native wilderness or the wide expanse of the sea while still maintaining a rather close focus on individual characters. In a similar fashion, they could make use of the vast reaches of cosmic space in a way that was forever denied the painter. To be sure, Cole was quite adept at creating an impression of infinity in the highlights of his brilliant skies, but there was a limit beyond which he could not go in reducing the size of his human figures in relation to cosmic space. The physical proportions of his paintings necessarily

imposed a restriction upon him. The poet or prose writer, however, feels no such limitation. Free from the landscape painter's bondage to physical representation, he can use his language and figures to work upon the imagination of his audience and so suggest what the painter cannot portray. He can make the suggestion of space as great as he pleases.

The freedom enjoyed by the literary artist is immediately apparent in the works of Bryant, Irving, and Cooper, for all three attempt to suggest the vastness of physical space through other than painterly means. Not all are equally successful, nor do all attempt to express precisely the same theme. Washington Irving, for example, differs from his contemporaries in that he does not develop the thematic implications of the material so thoroughly as do Bryant and Cooper, and he always stops short of expressing a deeply moral theme. With Bryant and Cooper, too, there are certain differences. The poet, if he wishes, may make his poem a purely descriptive one, the suggestion of space expressing the moral theme he wishes to convey. The novelist, on the other hand, is primarily concerned with detailing a narrative action, so that his use of space is likely to be a more subtle one, subordinated as the setting must be to the characters who act in it. Nevertheless, despite these differences, all three may be treated together to illustrate the literary use of this basically pictorial technique.

Since the moral theme in Bryant and Cooper hinges upon the physical contrast between the smallness of man and the vast expanse of the universe, those aspects of the natural scene which most clearly reveal the contrast can express the theme with the least danger of misinterpretation. From this point of view, it is well to consider first the use that Bryant and Cooper make of cosmic space, for no other element in the external world can suggest so well the smallness of the human being. In Bryant, the device appears quite early, for it is one of the means he used to develop the theme of "Thanatopsis." In the central section of the poem among a group of images designed to expand the context in both space and time, he includes the lines:

> The golden sun,
> The planets, all the infinite host of heaven,

> Are shining on the sad abodes of death,
> Through the still lapse of ages. [p. 22]

Like most of the figures in the poem, the image is well designed to place the concept of death in so broad a framework that the idea of one's physical end shrinks almost to insignificance by comparison.

In other poems, too, the endless reaches of space are designed to illuminate the contrast. Thus, in "To a Waterfowl," the poet develops a large part of his poem through images that connote the expanse of limitless space. The flight of the bird "far, through [the] rosy depths" of the evening sky, the vast distance he is to cover as he makes his way through "the desert and illimitable air," and his final disappearance into "the abyss of heaven"—all suggest so great a sense of space that man, in gazing into it, should become aware of the greatness of the God who created the world and who cares for its creatures (pp. 26–27). Perception of this relation, then, should fill him with faith and help him put aside all petty cares for self and worry over the future. In a similar fashion, the "beautiful, boundless" sky, "bright vault, and sapphire wall" in "The Firmament" connote the vastness, grandeur, and beauty of God's creation, toward which one should turn, when tired of the empty mirth of men, to find a place "of innocence and rest" (pp. 86–88). It is only through a perception of one's true relation to the boundless universe, the poet seems to say, that one can maintain his sense of proportion in life—a conclusion that the imagery of these poems is designed to encourage.

A related idea is expressed, but more obliquely, in "A Song of the Stars." In this highly imaginative poem, Bryant envisions the stars coming into being in the first dawn of creation when

> the world in the smile of God awoke,
> And the empty realms of darkness and death
> Were moved through their depths by his mighty breath,
> And orbs of beauty and spheres of flame
> From the void abyss by the myriads came. [p. 77]

The succeeding stanzas, quoting the stars' song, are consistently developed through numerous images of light and space to suggest the size and grandeur of the newly created cosmos, and the lines

move with a joyous sweep well suited to the idea the poet is expressing. But in the concluding stanza, he reminds the reader that, boundless and beautiful though the stars may be, they are, in comparison with their Creator, but dim lamps. The effect that this reversal of the image is intended to have is obvious. If the stars shrink to such insignificance when seen in relation to God, how much more the human being who can hardly comprehend the distant reaches of cosmic space!

Similar ideas expressed through the same device appear in the novels of Fenimore Cooper. In a highly effective scene in *The Bravo*, for example, he places the glittering city of Venice in so broad a context of nighttime splendor—"the firmament, gemmed with worlds, and sublime in immensity"—that even the magnificence of that jewel of cities pales in contrast to the immense beauty of sea and sky (pp. 192–93). In *Mercedes of Castile*, he draws an even broader image of space when he contrasts the turbulent ocean on which Columbus sails for home with the ordered cosmos. "Whatever disturbances occur on its surface," he writes, "the earth continues its daily revolutions in the sublimity of its vastness, affording, at each change, to the mites on its surface, the indubitable proofs that an omnipotent power reigns over all its movements" (p. 412). A related image appears, moreover, at the end of *The Crater*, for Cooper closes that book with a vision of the earth, "a point" floating in space, controlled by the hand that placed it there and that will one day strike it from its orbit to utter destruction (p. 482). Cooper is obviously seeking as broad a suggestion of infinite space as he can, and with the usual purpose of impressing on men a sense of their own insignificance.

In a number of his late novels, moreover, Cooper uses the material as a plot device, his characters changing their attitudes as a result of this perception. In *The Wing-and-Wing*, the starlit sky over the Mediterranean provides the means for Ghita Caraccioli's attempt to bring her atheist lover, Raoul Yvard, back to faith, and his gazing upon a single star on the night of his death does indeed lead him closer to God (pp. 173, 462). In a similar fashion, Mark Woolston, the hero of *The Crater*, shipwrecked on a reef in the South Pacific, is "impressed . . . with the deepest sense of the power and wisdom of the Deity" and better understands "his

own position in the scale of created beings" because he has studied the stars (p. 144). Indeed, in his next-to-last novel, *The Sea Lions*, Cooper uses the device at the climactic point in the book. Trapped by the ice of an antarctic winter, Roswell Gardiner, a Unitarian sea captain, regains his faith in the Trinity when he muses alone under the stars of the antarctic night. "Each and all of these sublime emblems of the power of God," Cooper writes, "were twinkling like bright torches glowing in space; and the mind had only to endow each with its probable or known dimensions, its conjectural and reasonable uses, to form a picture of the truest sublimity, in which man is made to occupy his real position" (p. 378).

Cooper does not, of course, make the stars alone productive of the change in Woolston and Gardiner, but includes as well other elements in the spacious landscape to affect his heroes. In *The Crater*, it is an earthquake that raises the reef on which Mark Woolston is living and opens a whole new world to his view. This earthquake and the one that destroys Mark's colony at the end of the book, after it has fallen on evil days, demonstrate unequivocally the power of God who controls the natural forces. In a similar fashion, the long and bitter winter that Roswell Gardiner spends in the antarctic places him in a position where he can do little more than survive. His own limitations thus dramatically impressed upon him, he begins to develop the humility he needs for his return to orthodox faith. In each case, Cooper uses a device which, in its relation to man, rivals in spaciousness the view of the starlit sky in which the characters also perceive their own insignificance. For Cooper, as for Bryant, the cosmic forces of nature provided an appropriate means through which they could convey their great moral themes.

But although the suggestion of cosmic space was admirably suited to their intellectual purpose, the device itself has some serious artistic limitations. So strong is the contrast between human beings and the size and might of cosmic forces, and so obvious is its meaning, that poems and novels in which it plays a major role may seem much too theme-ridden for the modern taste. This charge can certainly be made against several of Cooper's late novels, for the author, increasingly concerned with moral and religious questions, sought ever more explicit means for expressing

his themes and turned to the more striking and extraordinary aspects of nature for their presentation. Much better from the artistic point of view are other materials, drawn from the more immediate environment, which all three writers used. The sea, the forest, the prairie—all appear in the works of Bryant, Irving, and Cooper and serve a similar function. The scale of each is extensive enough to bear the burden of a serious theme, but each represents as well a normal environment for men. In each, moreover, man can acquire an illusion of control over nature—a fact which permits at times a great deal more subtlety in the development of the theme.

Of the three, the sea was perhaps the most difficult to use, for it required a special knowledge not readily available to all three writers. Bryant and Irving crossed the Atlantic a number of times and thus had some firsthand knowledge of the sea, but only Cooper had the professional understanding of ships and sailing men to make the most effective use of the material. The central action of a work should take place at sea or be seen from shipboard if the full effect of the sublime sea is to be felt, and this requires a direct experience with men's struggles against the sea that few creative writers possess. Yet despite the fact that their knowledge of the sea was severely limited, Bryant and Irving do use the material in at least a few of their works for a serious thematic purpose not very different from what we find in Cooper. The novelist, however, drawing upon his superior experience at sea, turned it to good effect in fully a third of his many novels and created a whole new kind of fiction in the process.

The aspects of the sea most frequently stressed are the most sublime ones—the vast expanse of the empty waters and the awesome power of the ocean storm—for these are the elements that are likely to have the most important effect on men. Thus, when Bryant describes the ocean in "A Hymn of the Sea," he includes suggestions of both vastness and might. Much of the imagery of the poem is designed to connote the broad expanse of the ocean, for Bryant, taking a long view of the sea, describes such things as the cycle of rain that forms when the moisture, rising in clouds from the ocean, moves inland to make green "a hundred realms," or the far-reaching patterns of commerce that join land to land and link the Old World with the New. He looks forth

> Over the boundless blue, where joyously
> The bright crests of innumerable waves
> Glance to the sun at once, as when the hands
> Of a great multitude are upward flung
> In acclamation [p. 203]

and he describes, toward the end of the poem, a "long wave rolling from the southern pole / To break upon Japan" (p. 204). The latter image, indeed, serves well to reinforce the vision of almost global vastness that Bryant obviously wishes to suggest in his verse.[31]

The force of the sea, however, also receives due emphasis, a force that Bryant interprets as being derived from God. "The sea is mighty," he writes in the opening lines of the poem, "but a mightier sways / His restless billows." Thus, when "the fierce tornado" falls upon "the armèd fleet" that sails to attack "some thoughtless realm," it is simply the instrument of God's justice that smites the aggressor with such destructive power as to make "the world turn pale" and nations "pause, / A moment from the bloody work of war" (pp. 203–4). Similar ideas appear in other of Bryant's poems. In "A Forest Hymn," the sea arises at the command of God to fling itself upon the continent and overwhelm the cities (p. 81); in "The Winds," we learn that "men grow pale, and pray" in the face of the tempest at sea (p. 189). As the poet concludes in the former poem, these violent storms—the "tremendous tokens of [God's] power"—should teach proud men to lay their "strifes and follies by" and form their lives in accordance with the will of him who orders and controls the elements (pp. 81–82).

Although never so explicitly religious as Bryant is in these poems, Irving too occasionally uses the sea to create a related effect of both size and power. In "The Voyage," the first chapter in *The Sketch Book,* he not only mentions the "vacancy" and "surrounding expanse" of the ocean (2: 14–15), but, by including the account of a wreck and by describing with evocative detail an especially violent storm, he manages to suggest how helpless and fearful Crayon feels when buffeted by the elements. "The creaking of the masts, the straining and groaning of bulk-heads, as the ship labored in the weltering sea, were frightful. As I heard the waves rushing along the sides of the ship, and roaring in my very ear, it

seemed as if Death were raging round this floating prison, seeking for his prey: the mere starting of a nail, the yawning of a seam, might give him entrance" (2: 18). This passage, coming upon the heels of an account in which a ship is run down at night with all hands lost, suggests much of the feeling of awe that we find expressed in Bryant's poems.[32]

The use that Irving makes of the device, however, is very limited, and only in his biography of Columbus does he explicitly introduce the idea that the storm at sea may be the instrument of God in humbling the proud (3: 251).[33] Bryant, too, uses the material only occasionally, and, although one may recognize the appropriateness of the visual elements he includes to the exposition of his theme, the modern reader will, very likely, object to his explicit statement of meaning. More acceptable to the modern taste, perhaps, is Cooper's use of the material, especially in his more realistic maritime novels where the portrayal of the sea is firmly subordinated to a believable action in a recognizable world and the spatial elements may be more subtly presented. In a number of his books, Cooper uses the sea for a thematic purpose similar to that which we have seen in Bryant and Irving—most notably, his late works, *The Crater*, *Jack Tier*, and *The Sea Lions*. Since none of these books, not even *Jack Tier*, approaches the realistic view of the workaday world so well presented in *Afloat and Ashore* and *Miles Wallingford*, this double novel will serve as the best example of Cooper's use of the expansive sea for a serious artistic purpose.

As the title of the first volume implies, this longest of Cooper's novels develops a double action. Life at sea is contrasted with life ashore, and the relation between the two series of events contributes much to the meaning of the book. The circumscribed stability of Clawbonny, Miles Wallingford's ancestral home on the banks of the Hudson where he might marry Lucy Hardinge and live content as a gentleman farmer, is set against an ocean world of immense size and awful danger—a world that can serve as a proving ground for men, but which also can bring them down to utter destruction. At first Miles succeeds at sea. His experience afloat develops his talents so well that he is capable of accomplishing much with a ship on the open ocean, as the number of severe trials

he successfully meets as mate and master of ships clearly illustrates. Indeed, it is the very fact that he can do so much which requires that Cooper use the sea for a further educative purpose. Like several of Cooper's seamen in his late novels, Miles must learn the lesson of his own limitations.

To express this meaning, Cooper draws his seascapes on a vast scale. Even the initial voyages that Miles makes are global in extent. On the first, a year-long voyage in the *John*, he sails from New York to Canton, and, in addition to the threats that pirates and privateers pose to the ship, he endures shipwreck off the coast of Madagascar, life at sea in an open boat, and a violent storm off the coast of the United States, in which the master of the *John*, Captain Robbins, is drowned within sight of land. Miles's second voyage, in the *Crisis*, takes him over an even broader expanse of ocean, for he embarks on a three-year cruise around the world. He is swept through the Straits of Magellan in a violent storm, is almost destroyed by Indians off the Pacific Northwest—where his second master, Captain Williams, is killed—struggles with a French privateer across half the expanse of the Pacific, and fights pirates a second time off the Straits of Sunda. Cooper, it may fairly be inferred, has deliberately cast his action in as vast an arena as he can find, nothing less than the whole earth being large enough to serve as a stage for his drama of the perils of a world in which little can be foreseen or controlled.

In addition, Cooper frequently reminds the reader of the relative size of ships and sea, for many of his descriptions stress the expanse of ocean and wideness of the world. Like Bryant, he uses the waves to express the immensity of space in which his characters move. As the Captain of the *John*, in *Afloat and Ashore*, attempts to anchor his vessel off the coast of Madagascar, Cooper writes of "the long, heavy rollers, that came undulating from the southwestern Atlantic, [and which] broke with a sullen violence that betrayed how powerful was the ocean, even in its moments of slumbering peacefulness. The rising and falling of its surface was like that of some monster's chest, as he respired heavily in sleep" (p. 72). Or again, in the same book, after the *Crisis* is swept through the Straits of Magellan, Miles observes: "There lay the vast Pacific, its long, regular waves rolling in toward the coast, in mountain-like ridges, it is true, but under a radiant sun, and in a

bright atmosphere" (p. 188). One need not cite the many occasions in which Cooper suggests the vastness of the ocean. They appear frequently enough to keep the sense of space before his readers.

The immense power of the ocean, moreover, is also stressed in the novel, and here Cooper's experience at sea stood him in good stead, for he can describe it with an intensity and a sharpness of detail that we do not find in Bryant's more generalized descriptions. Thus, in *Afloat and Ashore*, the storm that drives the *Crisis* through the Straits of Magellan is the worst that Miles has ever seen. "The seas seemed crushed, the pressure of the swooping atmosphere, as the currents of the air went howling over the surface of the ocean, fairly prevented them from rising; or, where a mound of water did appear, it was scooped up and borne off in spray, as the axe dubs inequalities from the log" (p. 177). In *Miles Wallingford*, during the storm in which Miles's own ship, the *Dawn*, is destroyed, he and Moses Marble, his mate, can hardly speak, "the howling of the wind through the rigging converting the hamper into a sort of tremendous Aeolian harp, while the roar of the water kept up a species of bass accompaniment to this music of the ocean" (p. 302).

Cooper is less explicit than Bryant, however, in drawing a specific moral, nor does he imply, as Bryant seems to in some of his poems, that the force of the storm falls on the evil alone. Rather, he leaves the meaning of his characters' experience at least ambiguous throughout most of the novel. If sea currents destroy the *John* on Miles's first voyage, they carry the *Crisis* through a dangerous passage on his second, and although both Captain Robbins and Captain Williams suffer because of their faulty judgment, neither is so evil a man as to deserve to die for his errors. Indeed, in the second volume of the novel, all sense of justice seems to disappear when Miles, escaping from the cupidity of a British naval officer and a French corsair—belligerents who wish to seize his cargo on the flimsiest of pretenses—sees the *Dawn*, in which all his wealth is invested, destroyed by a raging storm as he attempts to make his way through the Irish Sea. It is not the guilty, but the innocent, who, on the face of it, seem to be punished by the tempest, for the British frigate survives to cause Miles additional trouble even after his ship is lost and he has become a ruined man.

Yet Miles, for all his relative innocence in his struggles with the British and French, is also afflicted with a degree of pride and needs to have his own insufficiency brought home to him—his inability to accomplish all that he wishes. It is for this reason, therefore, that Miles is stripped of his power and professional pride when, in *Miles Wallingford*, the storm smashes his ship in the Irish Sea. His crew gone—either captured by the British or swept away by the storm—Miles finds himself alone on the broad Atlantic, his ship and all his possessions lost—even Clawbonny, which he mortgaged to gain investment funds for his voyage. As the *Dawn* is sinking, Miles can see "not an object of any sort . . . on the surface of the wide ocean," even the birds and fishes appearing to have abandoned him to his loneliness (p. 315). Shortly thereafter, he fancies he sees the smile of his Creator in the beautiful scene as the sun sets over the waters (p. 317), and several times he kneels and prays "to that dread Being, with whom, it now appeared to me, I stood alone, in the centre of the universe" (p. 321).

The sense of enormous space that Miles perceives in the surrounding ocean stays with him in the ensuing episodes. When Miles, now on a raft he has made to escape the sinking ship, awakes one morning to find that the *Dawn* has foundered, he cannot describe the sensations he feels as he gazes around and finds himself "on the broad ocean, floating on a little deck that was only ten feet square, and which was raised less than two feet above the surface of the waters." The frailty of his position is brought home to him as it had not been before, and he suffers "from the intense heat of a summer's sun beating directly on a boundless expanse of water" (pp. 326–27). When Miles is reunited with Marble, his mate, and Neb, a black servant, his situation is considerably improved. Since these two had survived the wreck in a launch, the three of them are better able to ride out the violent squalls that ensue than Miles would have been on the raft. The spatial scale, however, is undiminished, for Miles, Marble, and Neb in their launch are likened to "a bubble in the midst of the raging waters of the Atlantic" (p. 337).

Miles eventually escapes from the dangers that beset him, but he becomes a changed man. His pride has been humbled, he comes to recognize his own insufficiency to achieve his ends, he prays to

God in the proper spirit of humility, and, when he returns home, he finds that all he had thought lost has been restored to him—and much more besides. Clawbonny eventually becomes his once again, and his faithful Lucy is there to help him in his time of need. His loss of the *Dawn*, therefore, is not to be read as a sign of the injustice of the universe, but rather as a providential occurrence that in the long run does Miles more good than the success of his voyage could have done. He was seeking wealth that he did not really need and courting the danger of losing personal relations more valuable than wealth, for he ran the serious risk of losing Lucy and a happy life at Clawbonny while he was off at sea. As a result of his experience on the vast and mighty ocean, Miles has learned where the true values of life reside. In this sense, therefore, his terrible affliction has been a source of good to him.

One can argue that the might of a storm at sea is, like that of an earthquake, too greatly disproportioned to the powers of men for the symbol to be artistically a completely satisfactory one. And, in a sense, this charge is true. Though men, through their efforts, can indeed survive such storms and thus do not appear to be so vastly overwhelmed as they are by the grander aspects of cosmic nature, still the modern reader might wish to see the problem presented in a less overpowering context—one in which even wider choice is left to the protagonist, who is not simply brought to his knees by the force of the tempest. From this point of view, the forest and prairie provided an aesthetically more satisfying means for expressing the theme. Although both of these types of landscape can obviously suggest much the same meaning as that expressed by the expanse of the sea, the forest and prairie, as Thomas Philbrick has shown, can also function in a somewhat different way. When men confront the sea, their adversary is at the very least a great nonhuman—or, seen in another light, a superhuman—force. In the forest and on the prairie, however, the antagonists are always men.[34]

This difference has a great effect upon the way the material is used and the kind of theme presented. Though the expanse of trees or the sweep of rolling hills may suggest the sea—and all three writers use metaphors drawn from the ocean to describe their scenes[35]—yet man has a much greater opportunity to impose

his will on the natural environment and, indeed, on other men. He can transform the physical landscape so as to make it appear an almost entirely different world, and he does not face the seaman's constant danger: that the very surface on which he lives and acts will rise up with enormous power against him. To be sure, the stage he moves upon is vast and should indeed suggest to him—no less than the sea—the power and glory of God, but man may, if he wishes, completely ignore this lesson and strive relentlessly for selfish ends. With the power of nature, therefore, by no means so explicitly ranged against them, the characters may engage in a more dramatically balanced conflict.

Certain aspects of the use of space do not vary with the change in subject matter. The same scale of size that was maintained in the poems and stories of the sea appears when the writers make use of the forest, and the meaning is generally quite similar. Thus Bryant in "A Forest Hymn" seems to be "almost annihilated" by the "mighty oak" beside whose trunk he stands (p. 80), and Geoffrey Crayon feels reduced to pigmy size by the "avenues of stately oaks" that he sees in England (6: 90). Both Bryant and Irving, too, were struck with a feeling of religious awe by great stands of lofty trees. "The groves were God's first temples," Bryant writes in the opening line of "A Forest Hymn" (p. 79), and the whole poem is designed to suggest a kind of analogy between forest and church. Irving is equally explicit in pointing up the relation. In a letter from Spain in 1828, he compares his reaction to the cathedral in Seville with the expansive feeling he experiences on "a walk in one of our great American forests,"[36] while in *A Tour of the Prairies* he suggests through associations of light and sound the "grandeur and solemnity" which the forest, like a great cathedral, can arouse in the mind of the observer (9: 42).

Similar ideas can be found in almost any of Cooper's frontier tales. In the opening pages of *The Pathfinder*, for example, Cooper describes a vast panorama of trees, that, viewed across their tops from an eminence, seems like "an ocean of leaves," the vastness of which, "the nearly unbroken surface of verdure," fills the scene with grandeur. Moved by feelings of "admiration and awe"— much like those instilled in men by "the depths of the illimitable

void," the "expanse of the ocean," or the "obscurity of night"—
the characters gaze upon the sublime scene and are deeply affected
by it (pp. 1–4). The scale on which Cooper draws his landscape
establishes the relation of man to nature for the whole book, a
relation whose meaning is explicitly stated by Leatherstocking, or
Pathfinder, as he is called in this novel. To him, the forest is "a
temple" in which "one is every day called upon to worship God"
(p. 20), and he experiences "solemn feelings and true affection"
when he is "alone with God in the forest" (p. 92). Not all the
characters react in this way, but the scout expresses the point of
view in terms of which the expanse of the forest wilderness is
to be seen and interpreted. Indeed, it may well be considered a con-
stant in Cooper's tales of the woods.

The meaning of the forest, however, does not impress itself on
the mind of the observer with the same compelling force as the
maritime storm, and men are free to ignore, if they wish, the mean-
ing which all these writers saw in the forested landscape. In the
hands of the novelist, in particular, this fact could be put to ex-
cellent artistic use, for it gave him a means to present his theme
more obliquely than did sea, storm, or stars. *The Last of the Mohi-
cans* provides an excellent example. In this novel, the vast expanse
of forest wilderness is constantly held before the reader's attention,
and Leatherstocking, here called Hawkeye, who sees the hand of
God in all aspects of the external scene, explicitly states its mean-
ing. Yet for most of the characters in the book, the breadth and
depth of the forest bear little symbolic import. Intent on pursuing
their own ends, they move through the wilderness completely
oblivious to its broader significance. It is only the reader, therefore,
who, fully apprised of the vastness of the physical scene and its
meaning, can perceive the stunning contrast between the scale of
the natural setting and the attitudes of the characters that reveals
the novel's theme.

In *The Last of the Mohicans*, the physical setting is drawn upon
an immense scale—one that Thomas Cole well illustrated in the
two views he painted of a scene from the novel, for in both book
and paintings the humans are dwarfed by the natural environ-
ment.[37] From the very first pages of the novel, Cooper under-
scores the vastness of the scene. A wide boundary of forest sepa-

rates the provinces of France and England, and "interminable forests" stretch to the west. In such a setting, whole armies disappear into the wilderness, returning only as "skeleton bands, . . . haggard with care, or dejected by defeat" (pp. 3–4). Indeed, when the column of troops leaves Fort Edward for Fort William Henry in the opening chapter, the forest appears "to swallow up the living mass which had slowly entered its bosom" (p. 7). Throughout the entire first half of the novel, the same scale is consistently, but unobtrusively, maintained, as Cooper describes "the depths of the forest," "the boundless woods," the "vast range of country," or the "wide tract of wilderness" through which his characters move (pp. 33, 110, 156). The great expanse of the woods is always before the reader as a physical presence. It is constantly there, defining the terms in which the central action is to be interpreted.

But instead of feeling the awe or humility that one might expect them to derive from the setting, most of the characters are bent on selfish ends of war and destruction. Far from being an area of peace and contentment, the forest is filled with martial music and the harsh sounds of discord and contention. The woods may belong to God, as Cooper always insists, but in this tale of violence, they have been transformed by men into the abode of demons. Throughout the novel, Cooper frequently uses images of devils and hell in describing the action. The shouts of the Hurons sound like the cries of devils exulting "at the fall of some Christian soul" (p. 84), their camp at one point resembles "some unhallowed and supernatural arena, in which malicious demons had assembled to act their bloody and lawless rites" (p. 286), and Magua, their subtle chief, looks in one scene like "the Prince of Darkness, brooding on his own fancied wrongs, and plotting evil" (p. 342). Though we may perhaps object to one band of Indians being presented in such melodramatic terms, the effect that Cooper intends is clear. God's wilderness should be an area of peace, a place for worship of the Being who created it. Instead, it has been turned into a kind of hell, not only by the Indians but also by the white armies who have unleashed their savage allies.

The main characters of the novel, who make their way through this area of violence and discord, are mainly concerned with sur-

vival, and the first half of the book depicts their struggle against the savage enemy in the dense forest. Once he has established the meaning of the woods, however, Cooper shifts his point of view and presents the reader with other significant contrasts. In Chapter 14 of the novel, he suddenly expands the horizon to suggest an unlimited space. In doing so, he reveals the attitude he wishes the reader to take toward the contending armies of British and French. Seen from the vantage point of a high eminence, they are dwarfed by the expanse of water, woods, and sky that surrounds them. If the action of the novel has not yet brought home to the reader the absurdity of armies hacking their way through a wilderness to contend for mastery of a vast tract of forest that they cannot really control, the view from the eminence and the succeeding events should certainly do so. For great as the armies are, their might seems as nothing when seen in relation to the stage on which they are acting, and the principles that they follow, the code of honor and personal loyalty to foreign kings, are completely irrelevant in that wilderness context.

To point up this meaning, Cooper narrows his focus in the central chapters of the book. The forest recedes into the background, and the physical scale shrinks to that of the fort and the opposing armies. The frontier scout all but disappears from the action, and the Hurons are pictured as viewing the scene, ominously, from the edges of the surrounding forest. The tone of the writing also changes. Duncan Heyward, who has shown himself incompetent to act in the wilderness, is described as a chivalric knight, and he becomes a principal actor in the scene as he serves as a negotiator between the French and English commanders. Highly stylized formalities become the major concern of the characters, and Colonel Munro is even preoccupied at times with the newness of the Marquis de Montcalm's title of nobility. This white man's world is so vastly different from and completely irrelevant to that of the wilderness in which it is imbedded that Cooper's meaning is unmistakable. The whites may seem to dominate for the moment and have everything under control, but their minuetlike actions are totally divorced from the reality, both physical and moral, that surrounds them and which they can ignore only at their great peril.

This reality breaks in on them with a vengeance in the form of the horrible massacre that occurs after the formal surrender of the fort. Once more the forest world intrudes as two thousand Hurons swarm in from its borders to murder and scalp with impunity. This "jubilee of the devils," as one of the characters calls it (p. 209), goes on unchecked until the Hurons are sated with killing and turn to looting the dead. At this point, Cooper once again broadens his scene, for Magua, capturing the daughters of the English commander, Colonel Munro, drags them off to the eminence from which the earlier view was presented, and Cooper draws a contrasting scene to the broad panorama he had previously depicted. In the ensuing chapter, moreover, he describes the view near the fort after several days have passed. A change in the weather has brought a chill and dreary sky so that "the whole landscape, which, seen by a favoring light, and in a genial temperature, had been found so lovely, appeared now like some pictured allegory of life, in which objects were arrayed in their harshest but truest colors, and without the relief of any shadowing" (pp. 214–15). This is the reality that the make-believe world of the fort had failed to recognize.

It is the reality, too, in which the characters must act in the latter half of the book, for the scene is once again restored to its original scale, and Hawkeye and his companions—Duncan Heyward, Colonel Munro, and the Mohican warriors—plunge directly into it in pursuit of Magua and the Munro sisters. The wilderness they enter is even more dense and trackless than that which they had traversed in making their way toward Fort William Henry, and Cooper pauses to stress its wild and impenetrable aspect. But Hawkeye and the Mohicans, the characters most fully aware of their relation to the wilderness, have been through it before and do not hesitate to enter. From this point on, they are completely dominated by the wilderness world. The white man's ways can do them no good in this place, and they are able to extricate themselves from an extremely perilous situation only by appealing to the Canada Delawares for help. That they succeed is owing in large measure to the passions and enmities of the opposing tribes of Indians—Delaware and Huron—whose conflict, though certainly better suited to the physical realities of the wilderness setting, is surely no more sensible than that of the whites.

This struggle also stands in strong contrast to the landscape in which it takes place. To point up the relation, Cooper pauses before the final battle begins to describe the scene in which it occurs.

> The eye could range, in every direction, through the long and shadowed vistas of the trees; but nowhere was any object to be seen that did not properly belong to the peaceful and slumbering scenery. Here and there a bird was heard fluttering among the branches of the beeches, and occasionally a squirrel dropped a nut, drawing the startled looks of the party, for a moment, to the place; but the instant the casual interruption ceased, the passing air was heard murmuring above their heads, along that verdant and undulating surface of forest, which spread itself unbroken, unless by stream or lake, over such a vast region of country. Across the tract of wilderness, which lay between the Delawares and the village of their enemies, it seemed as if the foot of man had never trodden, so breathing and deep was the silence in which it lay. [p. 393]

The peace is deceptive, for concealed beneath the protective cover of the woods are violent men who will soon turn it into a scene of bloody carnage.

Part of the folly of these struggles, of course, is their utter futility. France and England contend over what, in the long run, they will never control, and Indian fights against Indian, destroying each other and leaving the land for the whites who will eventually dispossess them. Leatherstocking himself, though loyal to his Delaware friends and deeply affected by the religious influence he feels in nature, is the very one who opens the path for the whites, who drive off the Indian owners and finally despoil the land he loves. And the passions of men are forever at war with those principles of peace and order that one perceives in the expansive landscape. Though little of this is explicitly stated in the book —Cooper simply drops an occasional clue to the meaning—the whole action of the novel, when seen against the immense background that Cooper consistently stresses, certainly points to this interpretation. *The Last of the Mohicans* is thus an excellent example of the artistry of Cooper's descriptive technique, for the spatial relations he so carefully maintains throughout the novel are of the greatest importance in the development of his theme.

The prairies, the third of the great expansive landscapes that the writers used, bear certain similarities to forest and sea. Like the sea, the prairies could suggest an almost infinite reach of space, for in both, the view of the observer is limited only by the horizon, and he feels himself naturally dwarfed by the unbroken rolling surface that stretches away in every direction. Some such reaction was certainly experienced by Bryant when he stood on the Illinois prairies in 1832, for he was so deeply affected by his experience that he could not describe it in prose, but reserved it for poetry, "the only form of expression in which it can be properly uttered."[38] When he wrote the poem, moreover, he filled the opening lines with images designed to suggest to the reader the expansiveness of the scene.

> These are the gardens of the Desert, these
> The unshorn fields, boundless and beautiful,
> For which the speech of England has no name—
> The Prairies. I behold them for the first,
> And my heart swells, while the dilated sight
> Takes in the encircling vastness. Lo! they stretch,
> In airy undulations, far away,
> As if the ocean, in his gentlest swell,
> Stood still, with all his rounded billows fixed,
> And motionless forever. [p. 130]

The winds that blow across the grassy hills sweep in from far away:

> ye have played
> Among the palms of Mexico and vines
> Of Texas, and have crisped the limpid brooks
> That from the fountains of Sonora glide
> Into the calm Pacific. [p. 131]

The scene is drawn on a continental scale.

Irving, too, experienced a similar feeling when he made his tour of the Oklahoma prairies in 1832. To be sure, he viewed them with "infinite delight" when he first caught sight of them, for "the landscape was vast and beautiful," and, he adds, "there is always an expansion of feeling in looking upon these boundless and

fertile wastes; but I was doubly conscious of it after emerging from our 'close dungeon of innumerous boughs' " (9: 158). Yet shortly thereafter, he feels an inexpressible loneliness when, after a buffalo hunt, he finds himself alone in the solitude of the prairies. It is "an immense extent of landscape without a sign of human existence," and he has "the consciousness of being far, far beyond the bounds of human habitation." He feels as if he were "moving in the midst of a desert world" (9: 162–63). Like Bryant, Irving is obviously deeply impressed with the expansiveness of the prairie landscape, and, as the poet expressed it in the closing lines of his poem, he has a strong feeling of aloneness amidst the vast sweep of prairie and sky.

Bryant, however, reads a specific religious meaning into his experience, for immediately after describing the vast and unbroken landscape, he writes:

> Man hath no power in all this glorious work:
> The hand that built the firmament hath heaved
> And smoothed these verdant swells, and sown their slopes
> With herbage, planted them with island groves,
> And hedged them round with forests. Fitting floor
> For this magnificent temple of the sky. [p. 131]

Such an interpretation of the landscape is fundamentally no different from that which Bryant made in his poems of forest and sea, nor does it differ in any important respect from the view we find expressed in Cooper's tales, for both poet and novelist always stress the moral aspects of the landscape. Indeed, like the poet, Cooper used the vast and empty expanse of western plains for much the same purpose. In *The Prairie*, a novel that describes a landscape far to the west of Bryant's and more closely akin to Irving's, he depicts an empty waste as vast as theirs. And Leatherstocking, consistently the spokesman for a moral view of nature, sees the hand of God in everything around him, once even describing a herd of buffalo as "ten thousand oxen in one drove, without keeper or master, except Him who made them, and gave them these open plains for their pasture" (p. 233).

But although the prairies, like forest and sea, were well adapted to suggest the general moral view of nature so often expressed in

Bryant and Cooper, they were especially suited to present a cor-
ollary to that theme. Their very nature was different from that of
the forest and suggested a somewhat different interpretation.
American settlers of the eastern half of the country were used to
forested land, and the empty, grass-grown, rolling hills of prairie
and plain seemed strange and unusual to them. Such a view is
clearly reflected by Bryant, who, after traveling some hundred
miles on horseback across the Illinois prairies, wrote his friend
Richard Henry Dana that they "perpetually brought to [his]
mind the idea of their having been once cultivated. They looked
. . . like the fields of a race which had passed away, whose en-
closures and habitations had decayed, but on whose vast and rich
plains, smoothed and levelled by tillage, the forest had not yet en-
croached."[39] This highly imaginative view of the landscape found
expression in his poem, where he pictures a whole civilization of
mound builders that had flourished in the past, but which had
since been swept away from the prairies.

This idea is developed at length in Cooper's *Prairie*, for
Leatherstocking, here called the trapper, takes precisely the same
view of the naked landscape. A man of the forests throughout
most of his long life, Leatherstocking believes that the woods are
the particularly favored spot of the Lord. Thus, in discussing the
Creation with Doctor Bat, a scientific rationalist, the old trapper
maintains that the Garden of Eden must have been simply the un-
touched woods, for, he states, "the garden of the Lord was the
forest then, and is the forest now, where the fruits do grow and
the birds do sing, according to his own wise ordering" (p. 232).
But although the woods belong to God, men are free to use them
wisely or to waste them at will, an idea that Cooper had developed
a few years earlier in *The Pioneers*. The fact that men have chosen
to waste—to cut the trees and destroy the natural woodland—has
driven the old frontiersman from the settlements. As he tells
Mahtoree, a Sioux chief, he bore the noise of the choppers as long
as was necessary, but as soon as he could, he got "beyond the
accursed sounds" (p. 250).

In Leatherstocking's view, the settlers are laying the wilderness
waste, and they seem insatiable in their wish to destroy. Thus, he
tells Hardheart, a Pawnee chief, that a "band of choppers and

loggers" will follow on the heels of Lewis and Clark "to humble the wilderness which lies so broad and rich on the western banks of the Mississippi, and then the land will be a peopled desert, from the shores of the main sea to the foot of the Rocky Mountains" (p. 219). Bryant had expressed a similar concept in "An Indian at the Burial-Place of His Fathers." The Indian persona who speaks that poem laments the cutting of the trees and tilling of the soil, for a denuded land brings the serious consequence of dried-up springs and falling rivers. Hence, he concludes, "The realm our tribes are crushed to get / May be a barren desert yet" (p. 60). Both poet and novelist express the same vision of a despoiled nature, one that must eventually result if the onset of civilization means the wanton and wasteful cutting of the trees without thought of the consequences.

It is but a step from this picture of a ruined landscape to a view of the prairie as a foretaste of the kind of earth Americans may leave to their children if they do not change their wasteful practices. The concept of the prairie as a warning to men is announced early in *The Prairie*, for the trapper tells Ishmael Bush, a squatter, in the opening chapter, "I often think the Lord has placed this barren belt of prairie behind the States, to warn men to what their folly may yet bring the land" (p. 19). This idea recurs at intervals throughout the book, for the trapper believes that the hand of God "which can lay the 'arth bare at a blow, has been here and swept the country, in very mockery of their wickedness" (p. 83). Indeed, in the extended debate that he engages in with Doctor Bat in Chapter 22 of the novel, the trapper concludes that the desolation of the landscape has been caused by an ancient civilization that has been swept away without leaving a trace.

But although the natural landscape in *The Prairie* bears a somewhat different meaning from that of Cooper's other expansive views, it serves a similar artistic function in the novel. As he had done in *The Last of the Mohicans*, Cooper establishes the setting through careful description in the early pages of the book, for as Ishmael Bush and his tribe of squatters make their way across the plains, he depicts a scene of vast proportions. "In their front were stretched those broad plains, which extend, with so little diversity of character, to the bases of the Rocky Mountains; and many long

and dreary miles in their rear, foamed the swift and turbid waters of La Platte" (p. 4). Throughout the novel, Cooper continually reminds us of the scale of his landscape, for hardly a chapter passes without some mention of "the seemingly interminable waste of the prairie," the "vast distance" that a river winds, or "the broad tract of waste" through which the characters move (pp. 81, 95, 166). Indeed, he even likens the rolling hills to the waves of the sea to connote to the reader the imaginative view he must maintain to understand fully the thematic meaning that the sheer spaciousness of the landscape is designed to convey.

The human characters who move through the prairies are as dwarfed by the immensity of the setting as were those in *The Last of the Mohicans*, and they are no more ready to recognize their own insignificance than were those in the earlier novel. Even in a landscape as awe-inspiring as this, men remain passionately concerned with their own selfish wants. Ishmael Bush and his family care little for the destruction they wreak in the landscape, despite the fact that the consequences of their acts are clearly foretold in the desolate landscape they are crossing, and Doctor Bat persists in his belief that "triumphant man" (p. 119) can gain complete dominance over nature through reason and science in the very environment that ought to instruct him in his own insufficiency. Even Paul Hover, the Kentuckian who is generally presented as a sympathetic character, is willing to kill more than he needs for his sustenance merely to gratify himself with only the choicest parts of an animal. Only the trapper, who, by a trick of light, looms, quite appropriately, larger than life when we first meet him in the book, maintains a due awareness of his own limitations and has a proper regard for the power of God, who reveals himself in the vast and forbidding landscape.

The world of *The Prairie* is as violent a place as that of *The Last of the Mohicans*—a world that is characterized not only by the vast and sterile landscape held up as a warning to men but also by the violent gusts and low ominous clouds that threaten in the prairie sky—clouds that contrast sharply with the brighter sphere that can be seen beyond them. Indians ride demonlike across the nighttime landscape, a man murders his sister's son in cold blood, another takes the law into his own hands and executes his brother-

in-law for the murder of his son. It is not a pretty world that Cooper draws here. Indeed, as in all his tales that we have considered, it is a harsh and forbidding one. It has its brighter aspects, of course, as the character of Leatherstocking amply illustrates, and the ideal of moral good is always firmly held before the reader in the sublimity of the natural landscape, the grandeur of which is designed to suggest the power of God. But the perversity of human beings leads most of them to ignore the positive lesson. Careless of the consequences, they simply pursue their purely selfish ends.

In his tales of forest and prairie, Cooper made what is probably his best use of the expansive landscape, for in these novels the spatial dimension itself bears the full weight of the theme. It defines the basic problem in each of the books and provides an excellent means for its development. Yet despite the great importance of the technique, it is on the whole rather unobtrusively handled. To be sure the reader is frequently reminded of the vastness of the landscape in which the characters move, but its dominance is subtly presented. Cooper never allows it to overwhelm his characters completely as the more violent aspects of nature in his later novels sometimes do. The device demands, of course, an especially sensitive reader, one who has enough imaginative perception to see what Cooper is doing with his landscapes and who can visualize the effect of his spacious descriptions on the characters and the action. To the modern reader who can tolerate little or no description in his novels, such passages may appear nonfunctional, and Cooper may seem to be prolix and boring. But such a reader is also likely to miss completely the theme that Cooper is presenting.

Theme in Cooper—and in Bryant and Irving, too—is necessarily involved with the pictorial mode. Like their painter-friends, all three sought at times to suggest a sense of spaciousness in their works, a sense that, necessary to the meaning they were trying to express, was designed to serve an essential artistic function. We must not see in their depiction of the sublime landscape, therefore, mere artistic fashion nor derivative qualities borrowed from eighteenth-century English literature. Though the aesthetic theory and critical vocabulary came from Europe, and though they did in-

deed draw upon European precedent for some of their devices, their reaction to the American landscape was genuine and significant, and the themes they presented through the use of the material had an immediate relevance to the realities of American life. Irving, it must be admitted, is the weakest of the three in this area, but even he, in *A Tour of the Prairies*, for example, used the spaciousness of the American continent to good purpose.

Bryant and Cooper, on the other hand, made extensive and excellent use of the device. Deeply affected by the spaciousness of the external landscape, especially in its most American aspects of forest and prairie, they attempted to convey through the imaginative use of the material their vision of both the possibilities and the dangers of American life. They drew their pictures on a vast scale because they perceived that the grandeur of the native landscape had a significance that Americans were likely to miss. Well aware of the materialistic side of the American character and the heedless destruction of native beauty and wealth that Americans were capable of, they turned to the depiction of an expansive natural scene to impress on their readers the need for humility, restraint, and self-control in their relation to the external world. That their theme is an important one for Americans of all generations is amply testified to by the despoliation of the natural scene that has continued throughout the succeeding century. Bryant's Indian might still lament the results of the white man's conquest of the continent.

The artistic means that these writers used were, moreover, quite well adapted to their purpose. Living on a spacious continent that opened up broad vistas to all men in their generation, and writing before the Industrial Revolution had gone so far with transportation in America to dull men's perception of space, they found in the sea and the stars, the forest and the prairie, appropriate materials for the expression of their themes. It was not nature alone, however, that moved them, but nature seen especially in its relation to men. All would have agreed with Thomas Cole that human associations are necessary "to render the effect of landscape complete,"[40] and all three writers drew their spacious landscapes with human beings in view. In Bryant and Cooper, however, the natural scene is viewed most specifically in terms of a perverse and

selfish humanity, a relation that gives the deepest thematic meaning to their poems and novels and creates the fine artistic effect so apparent in the best of their works. The spacious landscape is, therefore, no mere decoration in their poems and novels, but an organic element that contributes significantly both to the meaning of their works and to their artistic success.

2. The Precise Detail

The expansive view of the external world expressed in the works of both writers and painters was not their total vision of nature, nor was the representation of a spacious world their only landscape technique. However important the expansive view might be in expressing their most significant themes, neither writers nor painters could well afford to neglect the details in their verbal and graphic landscapes. The vague or sketchy quality that might result could destroy the sense of verisimilitude, which, to a man, they sought to instill in their art. Nor could they restrict their depiction of nature to only its most sublime characteristics. From the point of view of their philosophy, the grander aspects of nature were indeed the most significant ones. Nevertheless, as romantic artists, they also recognized that nature has her softer moods as well. To be true to nature, therefore, they had to include in their works all aspects of the external world, the minute as well as the grand, a purpose they could fulfill only through the use of carefully selected details.

Among contemporary landscape painters, the need for detail was unquestioned. In his "Notes on Art," Thomas Cole suggests as a general principle that all landscapes must be presented in considerable detail. "In subjects of a quiet character," he writes, "it is proper . . . to introduce much detail. When we view the lovely scenes of nature, the eye runs about from one object of beauty to another; it delights in the minute as well as in the vast." Yet even a spacious landscape, he goes on to say, must contain a certain amount of specific detail. "A picture without detail is a mere sketch. The finest scene in the world, one most fitted to awaken sensations of the sublime, is made up of minutest parts."[1] Cole was not alone in his stress on the need for details. Asher B. Durand

advised the student of art to render his foreground objects through precise imitation of natural forms,[2] and both he and Cole frequently presented the details of their paintings—even to the leaves on the trees—with almost photographic accuracy.

The writers too were deeply concerned with the question of accurate detail. In a letter to William Dunlap in March 1832, Cooper criticized the "damnably rigged ships" in a painting attributed to Claude Lorrain,[3] and he pointed out in his third preface (1849) to *The Pilot*, that Scott's novel *The Pirate* "was not strictly nautical, or true in its details." He wrote his own novel, he goes on to say, to "present truer pictures of the ocean and ships than any that are to be found in *The Pirate*" (pp. v–vi). Cooper was equally determined, in other of his works, to make his descriptions accurate. In composing *The Bravo*, a tale of eighteenth-century Venice, he tried to depict the setting in such a way as "to preserve a verisimilitude to received facts," and he drew upon Venetian history to insure the accuracy of his novel.[4] He performed historical research in preparing to write *Lionel Lincoln*[5] and borrowed details from accounts of western travelers in writing *The Prairie*.[6] Indeed, as critics have recently shown, Cooper is often quite accurate in some of the details he includes in *The Last of the Mohicans*, details that he drew, for example, from accounts of the massacre at Fort William Henry.[7]

Bryant was also careful to include specific details in his verse, and he even supplied botanical footnotes occasionally to attest to their accuracy. He justifies his use of the papaya in "The Hunter's Serenade" with a long quotation from Timothy Flint's *Condensed Geography and History of the Western States* (p. 408) and explains the "mock-grape" of "My Autumn Walk" as a literal translation of *ampelopis*, "the botanical name of the Virginia creeper—an appelation too cumbrous for verse" (p. 418). In "The Fountain" he includes the flower *sanguinaria*, in "The Old Man's Counsel," the shad-bush, and further details in his notes the specific characteristics he attributes to them in the poems (p. 413). Indeed, he even demanded at times that poetry adhere to the precise accuracy of direct observation of natural objects, berating his brother John, in a letter of February 1832, for writing about a skylark, when he had never seen such a bird. "Let me counsel you," he

wrote, "to draw your images, in describing Nature, from what you observe around you, unless you are professedly composing a description of some foreign country, when, of course, you will learn what you can from books."[8] Whatever the method used, accuracy of detail was to be a primary consideration of the poet.

The reason for their care was not purely aesthetic. Because they saw, as romantic artists, an important philosophic relation between the objects of physical nature and the truths of the moral world, both writer and painter had of necessity to insure the accuracy of physical detail in their works. To Bryant and Cole especially, who relied so heavily upon the just representation of nature for the expression of their moral themes, the question of the accuracy of detail was of the utmost importance. Thus, Cole writes of the need for accurate depiction of the essential truths of natural forms[9] and Bryant insists upon almost scientific accuracy in his nature description simply because it was only by such means that the fundamental truths of their moral themes could be suggested to and apprehended by their audience. Specific detail of the social world, perhaps—like Cooper's description of Venice, or the historical facts in his American tales—might not be of such overriding importance in the presentation of his themes, since its use did not depend directly upon the theory of correspondence between the physical and moral spheres. But once the presence of accurate detail became an important criterion in evaluating a work of art, it was only to be expected that other scenes besides descriptions of nature should make use of it as well.

Once granted the need for specific detail, the device itself could serve a number of aesthetic purposes. The most obvious use is that which supports the suggestion of sublime immensity in the depicted landscape. The tiny houses and wispy threads of smoke that appear in a painting like Cole's *Oxbow*, or the small human figures in the middle ground of his *View of the White Mountains*, serve the same general function as their verbal counterparts in the large set pieces of description seen from an eminence in the works of Bryant, Irving, and Cooper. Both writers and painters faced the need for establishing a scale for their expansive landscapes, and the minute detail, sharply delineated in an all but overwhelming reach of space, served their purpose well. In this matter,

however, the writers had an important advantage over the painters. The suggestive value of language enabled them to use the same device in scenes less formally organized and less fully developed than the conventional landscape, but where the suggestion of an expansive nature was important to the development of the work. In addition, they could add to the suggestive value of their views—as the painters could not—by including details of sound as well as those of sight, and by suggesting through their use the sublime peace and calm of the external scene.

Bryant, Irving, and Cooper, for example, all use the device of a single bird in the vast expanse of space. Bryant's waterfowl, flying alone through "the desert and illimitable air" (p. 27) is paralleled in *The Sketch Book* by Irving's bird that "mingles among clouds and storms, and wings its way, a mere speck, across the pathless fields of air" (2: 358). Cooper, too, uses a similar device in Chapter 8 of *The Deerslayer*, where he pauses to describe the glorious stillness of the surrounding landscape. Building his scene upward, he first describes in a general way the lake and forest, then "a few piles of fleecy clouds" lying along the horizon, some aquatic fowl skimming the lake, "and a single raven . . . sailing high above the trees, and keeping a watchful eye on the forest beneath him" (p. 138). To be sure, Bryant's and Irving's birds serve an important thematic function in the works in which they appear, and Cooper's raven helps to intensify the sublime stillness of the scene, but all three also help to suggest the immense expanse of space that the scenes encompass.

Details could also be used to suggest the character of other than spacious landscapes or to establish the tone or mood of particular scenes. Just as Cooper used the circling raven in *The Deerslayer* to intensify the stillness of the landscape, so also do Bryant and Irving introduce precise details—some visual and some aural—into their descriptions of quiet scenes. Thus, in *The Alhambra*, Irving describes a sunset view from the tower of Comares. "Not a breath of air disturbed the stillness of the hour," and "the faint sound of music and merriment" arising from the gardens below merely "rendered more impressive the monumental silence of the pile" that overshadowed him (15: 77). In *Tales of a Traveller*, he includes a noontide scene wherein the solitude and stillness are

made the more intense by the sights and sounds—"the whistle of a solitary muleteer," "the faint piping of a shepherd's reed," or "the bell of an ass slowly pacing along, followed by a monk with bare feet, and bare, shining head"—that he introduces into his landscape (7: 336). And in *The Sketch Book*, he describes a quiet scene of brook and meadow in which the only sounds are "the occasional tinkling of a bell from the lazy cattle among the clover, or the sound of a woodcutter's axe from the neighboring forest" (2: 412–13).

Bryant uses the same device in a number of his descriptive poems. In "Summer Wind," he includes a single detail of sound and movement to emphasize the quiet stillness of the landscape.

> It is a sultry day; the sun has drunk
> The dew that lay upon the morning grass;
> There is no rustling in the lofty elm
> That canopies my dwelling, and its shade
> Scarce cools me. All is silent, save the faint
> And interrupted murmur of the bee,
> Settling on the sick flowers, and then again
> Instantly on the wing. [p. 57]

This sudden movement of insect life is repeated for like effect in "Noon," where, after a long description of a hot and silent landscape, Bryant writes:

> The rivulet's pool,
> That darkly quivered all the morning long
> In the cool shade, now glimmers in the sun;
> And o'er its surface shoots, and shoots again,
> The glittering dragon-fly, and deep within
> Run the brown water-beetles to and fro. [p. 205]

The device appears again in "After a Tempest." Here he depicts a broad and peaceful landscape in which "the flight of startled bird," chiding squirrel, and darting insects not only particularize the scene but also intensify its suggestion of peace (p. 67).

Cooper's novels too provide us with similar examples. In *The Wept of Wish-ton-Wish*, he uses the buzzing of bee and hummingbird in much the same way as Bryant (p. 272), while in *The Last*

of the Mohicans, the silence of the summer forest is both broken and defined "by the low voices of the men, the occasional and lazy tap of a woodpecker, the discordant cry of some gaudy jay, or a swelling on the ear, from the dull roar of a distant waterfall" (p. 23). The solemnity of a night on the open sea, "the immensity of the solitude, [and] the deep calm of the slumbering ocean," in *Mercedes of Castile,* are intensified by "the occasional creaking of a spar" on one of Columbus's ships (p. 304); while, conversely, the view of a wrecked ship on the coast of Africa, in *Homeward Bound,* the hull embedded in sand that stretches endlessly away, is described as an impressive scene "in which the desolation of an abandoned vessel was heightened by the desolation of a desert" (p. 213). Like Bryant and Irving, Cooper uses details of both sight and sound to contribute significantly to the overall effect of his silent and desolate scenes.

At other times, however, the writers use their details in more formally drawn landscapes that suggest an aesthetic quality quite different from those we have noted. The spacious views they drew and the silent solitudes they suggested through the use of contrasted detail are both related to the eighteenth-century concept of sublimity and derive from the aesthetic theories of the sublime developed during that period. The writers and painters did not neglect, however, the other kinds of landscape that English theorists had described at the same time. The beauty of one scene, after all, could be quite as aesthetically pleasing as the sublimity of another and could also be as effectively presented through the use of carefully selected detail, the only problem being the kind of detail to be used for that purpose. Indeed, granted the belief that sublimity often resided in the vast, vague, and indefinite qualities of a scene, detailed landscapes were more likely to fall into the category of the beautiful, or, if the details were of a particular kind, into yet a third category that arose toward the end of the eighteenth century—the picturesque.

Among the writers and painters in America, the line between the beautiful and the picturesque was not always clearly drawn. As creative artists rather than aesthetic theorists, they paid little attention to the fine points of distinction between the two categories. All worked too late, moreover, to accept the belief that cer-

tain forms of natural objects were inherently beautiful or pic-
turesque, for Archibald Alison had already established the theory
that beauty and sublimity—he did not admit the picturesque as a
major category—were ultimately derived from mind. Neverthe-
less, many of the ideas of the eighteenth-century theorists were
still current, and it is by no means difficult to find in America ex-
amples of writing which clearly reveal, for example, the influence
of William Hogarth's serpentine line as a mark of beauty,[10] or of
Uvedale Price's theory of "sudden variation" as an important char-
acteristic of the picturesque.[11] The effect of such ideas can thus be
seen in American landscape depiction even after the painters and
writers themselves were no longer much concerned with discuss-
ing the aesthetic categories.

The widespread influence in America of these aesthetic con-
cepts may clearly be seen once again in the works of numerous
travelers in America, who, far from being professional writers, re-
veal the unquestioned preconceptions and predispositions of the
times. Indeed, wherever we look in the travel literature of late
eighteenth- and early nineteenth-century America, we are likely
to find descriptions which demonstrate unequivocally the author's
acquaintance—conscious or unconscious—with these aesthetic
views. Thus, Jonathan Carver, in his *Three Years Travels through
the Interior Parts of North America*, first published in 1778, de-
scribes the country around the Falls of St. Anthony as "extremely
beautiful," the plain relieved by "many gentle ascents, which in the
summer are covered with the finest verdure, and interspersed with
little groves, that give a pleasing variety to the prospect."[12] H. M.
Brackenridge too, a generation later, describes beautiful scenes
along the Missouri River in similar terms, stressing the serenity and
calmness of a beautiful landscape, the "regular rise" of a lovely
upland, and the beauty of Council Bluffs, which "are not abrupt
elevations, but a rising ground, covered with grass as perfectly
smooth as if the work of art."[13] Eighteenth-century theories of the
beautiful as derived from gentle slopes and smooth surfaces are
implicit in these descriptions.

The travelers also reflect at times the belief that a grace of
line and a considerable degree of variety add to the beauty of the
landscape. William Bartram describes "two beautiful rivulets . . .

gliding in serpentine mazes over the green turfy knolls,"[14] and
François Michaux admires the beauty of Point Pleasant on the Ohio
River, for the stream, "four hundred fathoms broad, continues the
same breadth [for four or five miles], and presents on every side
the most perfect line."[15] Bartram, moreover, writes of "a delight-
ful varied landscape" of grassy fields and groves of trees;[16] Fort-
escue Cuming describes a hilly country as "beautifully variegated
with cornfields in tassel—wheat and oat stubble—meadows—orch-
ards—cottages—and stacks of grain and hay innumerable, with a
small coppice of wood between every plantation";[17] and H. M.
Brackenridge details the varied beauty of his camp above the
Chienne River, in which trees, "shrubs, plants, flowers, meadow,
and upland, [are] charmingly dispersed."[18]

Picturesque scenery also abounds in the accounts of these
travelers if we apply Price's criteria of roughness, sudden varia-
tion, and ideas of age and decay as determinants of that type of
landscape.[19] Bartram includes "a picturesque dark grove of Live
Oak, Magnolia, Gordonia and the fragrant Orange, encircling a
rocky shaded grotto, of transparent water, on some border of the
pond or lake," and describes "old weather-beaten trees, hoary and
barbed, with the long moss waving from their snags" as compo-
nents of a picturesque scene.[20] Cuming, on the other hand, stresses
the rugged nature of such scenery, describing a country which he
considers "very picturesque; the tops of the hills terminating in
rocks, some impending and some perpendicular, while the road
leads through a defile winding round their bottoms."[21] George C.
Sibley, too, whose "Journal" (1810) is quoted in Bradbury's
Travels, develops a similar view in his description of the territory
near the Saline River. The country, he writes, is "remarkably
rugged and broken, affording the most romantic and picturesque
views imaginable. . . . It is an assemblage of beautiful meadows,
verdant ridges, and rude, mis-shapen piles of red clay, thrown to-
gether in the utmost apparent confusion, yet affording the most
pleasant harmonies, and presenting us in every direction an endless
variety of curious and interesting objects."[22]

As Sibley's comment indicates, the travelers describe the scen-
ery at times as being a mixture of both the beautiful and the pic-
turesque, rather than purely the one or the other. Thus, Jonathan

Carver describes a view in the mountains as follows: "In many places pyramids of rocks appeared, resembling old ruinous towers; at others amazing precipices; and what is very remarkable, whilst this scene presented itself on one side, the opposite side of the same mountain was covered with the finest herbage, which gradually ascended to its summit. From thence the most beautiful and extensive prospect that imagination can form, opens to your view."[23] In a similar fashion, Thaddeus Mason Harris describes a scene that is also a pleasing mixture of the beautiful and wild. He writes of one mountain that he crossed: "The contrast, between the verdant meads and fertile arable ground of this secluded spot, and the rugged mountains and frowning precipices by which it is environed, gives the prospect we have contemplated a mixture of romantic wildness and cultivated beauty which is really delightful."[24]

It was only to be expected that professional writers like Bryant, Irving, and Cooper should also reflect aesthetic views so firmly implanted in the contemporary mind. All three were concerned with the picturesque aspects of the external world, for all contributed to *The Home Book of the Picturesque*, published in 1852, and Bryant lent his name as editor of *Picturesque America*, published in two volumes in 1872 and 1874. Irving and Cooper, too, sometimes developed in their works the kind of picturesque view we associate with the paintings of Salvator Rosa, for Irving not only describes Italian banditti in the style of that painter (7: 322) but also depicts a group of trappers, hunters, and Indians in *The Adventures of Captain Bonneville* in much the same way (10: 322–23). Cooper presents the camp of Rivenoak, the Huron chief in *The Deerslayer*, in precisely the same style, the Indian "seated in the foreground of a picture that Salvator Rosa would have delighted to draw, his swarthy features illuminated as much by pleasure as by the torch-like flame" (p. 284). Such scenes, however, are not especially common in the works of even these two writers; they, with Bryant, are much more likely to depict either the beauty of external nature or a mixture of the beautiful and the wild in a half-domestic, half-wilderness landscape.

Part of the reason for Bryant's and Cooper's use of the device derives from their belief that the external world was full of mean-

ing, that in addition to the aesthetic function it might serve in their works, it could also be used as an important vehicle for their philosophic views. Since the external world revealed to the perceptive observer the various attributes of its Creator, the depiction of a beautiful nature could not only express his beneficence and peace, but also illustrate the effect on the individual that such a perception should have. Thus, "the lovely landscape" that Bryant describes in "A Summer Ramble" suggests to the poet through its "deep quiet" the eternal peace that shall come to the good hereafter (p. 115), and a beautiful scene that Cooper presents in *The Deerslayer* has, he tells us, a soothing effect on the spirit of his hero because of the "holy calm" that pervades the landscape (p. 33). The beautiful view is not always seen in precisely these terms, and the writers do not consistently draw such explicit conclusions. But so closely related were moral and aesthetic views in the associationist philosophy of the times that the moral meaning may well be implied even where it is not openly expressed.

In describing their beautiful scenes, moreover, all three drew heavily upon the aesthetic theories of the late eighteenth century and included in their depictions such specific detail as would suggest to the reader the aesthetic quality of the scene. As early as 1804, Irving, in his "Journal," was describing Swiss and French scenery in terms of the "beautifully waving lines" of the swelling landscape and stressing the soft and misty quality—reminiscent of Claude Lorrain—to be found in European scenery.[25] In his description of the English countryside in *The Sketch Book*, he includes not only a fine lawn sloping away from a spacious mansion but also the clumps of trees that break the "soft fertile country into a variety of landscapes" (2: 25). In his description of American scenery, too, he stresses the variety to be found in a beautiful view. Thus, in *A Tour of the Prairies*, he writes: "The river scenery at this place was beautifully diversified, presenting long, shining reaches, bordered by willows and cotton-wood trees; rich bottoms, with lofty forests; among which towered enormous plane trees, and the distance was closed in by high embowered promontories" (9: 68).

Cooper, too, reflects the aesthetic views of the times in his depiction of beautiful scenes. Like Irving, he considers "softness" an

important characteristic of a beautiful landscape, for in *The Wing-and-Wing*, he describes "a union of the magnificent, the pictur-esque, and the soft" in the scenery he presents (p. 344), while in *The Two Admirals*, he describes a moonlit landscape in these terms: "the panorama of the headland was clothed in a soft, magi-cal sort of semi-distinctness, that rendered objects sufficiently ob-vious, and exceedingly beautiful. The rounded, shorn swells of the land, hove upward to the eye, verdant and smooth; while the fine oaks of the park formed a shadowy background to the picture, inland" (p. 152). Besides the qualities of softness and gently swell-ing lines, Cooper also demanded variety in a beautiful landscape. Thus, Eve Effingham, in *Home as Found*, is struck by the "beauti-fully variegated foliage" on a mountainside. Tall pines occupy part of the scene, but a second growth has sprung up where the original forest had been cut. "The rich, Rembrandt-like hemlocks, in par-ticular, were perfectly beautiful, contrasting admirably with the livelier tints of the various deciduous trees. Here and there, some flowering shrub rendered the picture gay, while masses of rich chestnut, in blossom, lay in clouds of natural glory among the dark tops of the pines" (p. 201).

Similar details appear in Bryant's poems. "Serene and golden sunlight" falls "like a spell" upon the landscape in "After a Tem-pest" to soften a beauteous scene (p. 67), and "silent valleys, . . . winding and widening, . . . fade" into a "soft ring of summer haze" in "A Summer Ramble" (p. 115). In the opening stanza of "Lines on Revisiting the Country," a nicely varied scene of "broad, round" hills and "waving grass and grain" meets the eye (p. 91), while in "The Old Man's Counsel," a fully drawn land-scape of many diversified but harmonious elements appears.

> The sun of May was bright in middle heaven,
> And steeped the sprouting forests, the green hills,
> And emerald wheat-fields, in his yellow light.
> Upon the apple-tree, where rosy buds
> Stood clustered, ready to burst forth in bloom,
> The robin warbled forth his full clear note
> For hours, and wearied not. Within the woods,
> Whose young and half transparent leaves scarce cast
> A shade, gay circles of anemones

Danced on their stalks; the shad-bush, white with flowers,
Brightened the glens; the new-leaved butternut
And quivering poplar to the roving breeze
Gave a balsamic fragrance. In the fields
I saw the pulses of the gentle wind
On the young grass. My heart was touched with joy
At so much beauty, flushing every hour
Into a fuller beauty. [pp. 191–92]

Not all their depictions of the external landscape are so simply beautiful as passages like these would seem to suggest, for the writers would sometimes include in their descriptions such a profusion of details—many of them contradictory in meaning and mood—that the scenes can best be described as mixed ones. Elements of the domestic and the wild exist side by side in their landscapes, with the shift from one to the other occurring so rapidly as to suggest the principle of sudden variation that Uvedale Price believed was a fundamental characteristic of the picturesque. A parallel practice among the painters is easily seen in many canvases of the Hudson River school which exhibit a similar quality. The presence of both dense forest and cultivated fields, heavy storm clouds and a brilliant expanse of sky in a painting like Cole's *Oxbow* suggests an aspect of the external scene quite different from either the grandeur of the sublime or the serenity of the beautiful. Though elements of both sublimity and beauty are present, the contrasting details suggest a third quality—the picturesque—which is neither.

In such scenes the detail is never dominant, for no matter how diverse the contrasting parts might be, the painters always sought to express a fundamental unity in the scene. Though Cole insisted on the need for details in even the grandest landscapes, he was also careful to observe that they should be "*so* given as to render them subordinate, and ministrative to the one effect."[26] In a similar fashion, when discussing the paintings of George L. Brown, an American landscape painter whose work he had seen in Europe, Bryant praised the artist for his "great knowledge of detail, which he knows how to keep in its place, subduing it, and rendering it subservient to the general effect."[27] Indeed, both Cole and Washington Allston, in discussing the nature of composition, made clear

their belief that the details of a picture must be combined into a unified whole.[28] The principle of order, derived from the just subordination of, at times, quite diverse parts was thus a fundamental tenet of their aesthetic theory. The practice of the painters, moreover, as seen in such works as *The Oxbow* or Durand's *Evening of Life*,[29] illustrates their success in suggesting a unified effect through the harmonious composition of contrasting parts.

Similar landscapes may be found in the works of each of the writers, who compose their scenes with many varied details for a similar aesthetic effect. In *The Adventures of Captain Bonneville*, Irving depicts a landscape along the Snake River that includes both the beautiful and the grand.

> At times, the river was overhung by dark and stupendous rocks, rising like gigantic walls and battlements; these would be rent by wide and yawning chasms, that seemed to speak of past convulsions of nature. Sometimes the river was of a glassy smoothness and placidity; at other times it roared along in impetuous rapids and foaming cascades. Here, the rocks were piled in the most fantastic crags and precipices; and in another place, they were succeeded by delightful valleys carpeted with green-sward. The whole of this wild and varied scenery was dominated by immense mountains rearing their distant peaks into the clouds. [10: 290]

The strong contrast between the "wildness and sublimity" of parts of the scene and the "green and smiling meadows, and wide landscapes of Italian grace and beauty" that are also present (10: 291) provide the sudden variation that Irving seems to have sought in his description. In addition, the soaring mountains that he includes delimit the scene and thus provide a kind of frame within which the view is presented. Through these means, Irving was able to suggest the sense of unified diversity that he, like the painters, wished to instill in his landscape.

A similar view may be found in the vast panoramic description of the Bay of Naples that Cooper presents in *The Wing-and-Wing*. The natural curve of the bay and the frame of mountains ranging inland give a sense of unity to the scene.[30] Within these limits, the wild and the cultivated, the grand and the soft are appropriately

harmonized. Many of the details he includes are widely varied ones. He writes of "a high, rocky island of dark tufa, rendered gay, amid all its magnificent formations, by smiling vineyards and teeming villages, and interesting by ruins that commemorate events as remote as the Caesars." Across a narrow strait, "a bold cape on the main" runs off into "a succession of picturesque, village-clad heights and valleys, relieved by scenery equally bold and soft." Further on, a plain, full of "dwellings and scenes of life" meets the eye, "while the heights behind it teem with cottages and the signs of human labor." Nor are these inhabited portions all there is to the landscape. "Quitting the smiling part of the coast, we reach a point, always following the circuit of the bay, where the hills or heights tower into ragged mountains, which stretch their pointed peaks upwards to some six or seven thousand feet towards the clouds, having sides now wide with precipices and ra-vines, now picturesque with shooting-towers, hamlets, monaster-ies, and bridle-paths; and bases dotted, or rather lined, with towns and villages" (pp. 198–99).

In Bryant, too, "the lovely and the wild" appear together "mingled in harmony" in the fully developed landscape with which he opens "Monument Mountain." "The beauty and the majesty of earth" are both revealed to the observer as he looks down on the landscape below. The eye takes in "at once" both the domestic landscape suggested by "white villages, and tilth, and herds, / And swarming roads" (p. 63), and the untouched wilderness, the

> solitudes
> That only hear the torrent, and the wind,
> And eagle's shriek. [p. 63]

At this point he introduces the enormous precipice that will figure most significantly in the narrative of the poem, stressing through images of both vast size and great age the rugged grandeur of the scene.

> To the north, a path
> Conducts you up the narrow battlement.
> Steep is the western side, shaggy and wild
> With mossy trees, and pinnacles of flint,
> And many a hanging crag. But, to the east,

Sheer to the vale go down the bare old cliffs—
Huge pillars, that in middle heaven upbear
Their weather-beaten capitals, here dark
With moss, the growth of centuries, and there
Of chalky whiteness where the thunderbolt
Has splintered them. [p. 63]

In the panoramic view that follows, Bryant presents a mixed but harmoniously unified landscape. At first he stresses again the sublimity of the view.

It is a fearful thing
To stand upon the beetling verge, and see
Where storm and lightning, from that huge gray wall,
Have tumbled down vast blocks, and at the base
Dashed them in fragments, and to lay thine ear
Over the dizzy depth, and hear the sound
Of winds, that struggle with the woods below,
Come up like ocean murmurs. [pp. 63–64]

Then, with a sharp contrast that suggests Price's principle of sudden variation, Bryant presents a markedly different view.

But the scene
Is lovely round; a beautiful river there
Wanders amid the fresh and fertile meads,
The paradise he made unto himself,
Mining the soil for ages. On each side
The fields swell upward to the hills; beyond,
Above the hills, in the blue distance, rise
The mountain-columns with which earth props
 heaven. [p. 64]

Like Irving and Cooper, Bryant limits the scene with a distant range of towering mountains to suggest the essential unity of the landscape. Within the frame, he marshals his details to express the great variety apparent in the external world.

Significant use of detail in the works of Bryant, Irving, and Cooper is not restricted, however, to the suggestion of the sublime, the beautiful, or the picturesque in nature. They also include detail in their works to serve a thematic purpose related to, but, at

times, somewhat distinct from its use in establishing the aesthetic quality of the natural scene. Since the basic function of detail was largely suggestive, it did not really matter from the technical point of view whether it was used to suggest the aesthetic effect of a landscape or the thematic meaning of a description, incident, or episode. In many instances it might do both, but certain uses of detail in the works of all three men clearly have as their primary function the suggestion of thematic meaning. At the simplest level, this use of detail may reveal the fundamental attitude toward man and nature, which, functioning as a kind of given in a story or poem, establishes the conditions in terms of which it is to be understood. At another level, however, the details may assume symbolic proportions and even become in themselves the very embodiment of the developing theme.

The poems of Bryant provide perhaps the best example of the use of detail to reveal the poet's fundamental attitude toward nature and man. Basic to Bryant's poetry is the view of the world as the harmonious creation of God, innocent in itself and instructive of only good to men. As he wrote in his "Lectures on Poetry": "There are a purity and innocence in the appearances of Nature that make them refuse to be allied to the suggestions of guilty emotion. We discern no sin in her grander operations and vicissitudes, and no lessons of immorality are to be learned from them, as there are from the examples of the world. They cannot be studied without inducing the love, if they fail of giving the habit, of virtue."[31] Bryant was well aware of the obvious presence of evil in life and had of necessity to come to grips with the basic question of its nature and origin. Consistently in his verse, he attributes evil to the passionate nature of fallen man, who is the disruptive element in an otherwise ordered creation.

To suggest the idea, therefore, that men are responsible for the disharmony so apparent in the world, Bryant sometimes turned to the use of sharp and unexpected detail. By including only one appropriate detail in a typical, harmoniously presented landscape, he was able to suggest his basic philosophic position to his readers. Thus, in "The Ages," he uses Edenic imagery in his landscape description, depicting the "youthful paradise" of untouched

America at the time of the discovery. At the end of the passage, however, he includes one striking image to carry the weight of his meaning.

There stood the Indian hamlet, there the lake
Spread its blue sheet that flashed with many an oar,
Where the brown otter plunged him from the brake,
And the deer drank: as the light gale flew o'er,
The twinkling maize-field rustled on the shore;
And while that spot, so wild, and lone, and fair,
A look of glad and guiltless beauty wore,
And peace was on the earth and in the air,
The warrior lit the pile, and bound his captive there. [p. 19]

The single detail enables the poet to convey his point with strict economy and telling effect.

The device need not always be so starkly melodramatic. A group of contrasting details, suitably juxtaposed, could embody a similar meaning. Thus, in "The Fountain," Bryant plays one detail against another to suggest essentially the same theme. In one part of the poem, he includes both the deeply wooded, untouched landscape and a dying Indian, struck by an unseen hand in the forest depths, who crawls from the woods to "slake his death-thirst" at the fountain. In the lines that immediately follow, a "quick fierce cry"—the Indian war whoop—"rends the utter silence," and a violent conflict ensues. Its ultimate significance, however, is suggested by the varied details that Bryant includes.

Fierce the fight and short,
As is the whirlwind. Soon the conquerors
And conquered vanish, and the dead remain
Mangled by tomahawks. The mighty woods
Are still again, the frighted bird comes back
And plumes her wings; but thy sweet waters run
Crimson with blood. Then, as the sun goes down,
Amid the deepening twilight I descry
Figures of men that crouch and creep unheard,
And bear away the dead. The next day's shower
Shall wash the tokens of the fight away. [p. 186]

The violence of passionate men and the transience of their willful acts are both implied by the series of briefly detailed images through which the episode is presented.

Sharp detail of this kind was especially useful to the poet, for it helped to provide the economy of expression that poetry demands. Yet Bryant was not alone in his use of the technique. In his Leatherstocking tales, for example, Cooper also contrasts the passionate acts of men with the sublime vastness that surrounds them. In the more discursive and fully developed fiction, much may be conveyed by means of episode and incident rather than through specific detail. The murder of Asa Bush and the hanging of Abiram White in *The Prairie*, as well as the cold-blooded, businesslike attempt at the scalping of Indians for profit by Hurry Harry and Tom Hutter in *The Deerslayer* are closely related in technique and meaning to what we have noted in Bryant's poems. Even in some of these incidents, however, the sharp detail helps to underscore the meaning. Thus, when Hurry Harry and Tom Hutter invade the Huron camp seeking scalps, the single shriek of Hist, a captive Delaware maiden, shatters the silence of the night to emphasize the horror of the deed that the white men are intent on performing (p. 99).

Much the same point can be made from *The Last of the Mohicans*. That men have invaded the immense forests to kill and destroy is obvious from Cooper's handling of the spatial element in his novel. Some of the details in the book, however, clearly reinforce the theme, especially those which suggest the violence and cruelty of frontier warfare. To be sure, much of the bloodshed is caused by the savage Mingoes, who are described as fiendlike in their actions, but even the sympathetic characters share in it too. When Hawkeye and his Mohican friends overtake and destroy most of the band of Mingoes who have taken Duncan Heyward and the Munro sisters prisoner, the Mohican warriors scalp their fallen foes, and Hawkeye himself coolly goes among the dead Indians and thrusts his knife into their senseless bodies to make certain they are dead (p. 131). In a similar fashion, when the party of whites deceives the French sentry who challenges them at night, Chingachgook lingers behind to kill and scalp him. A single groan in the night reveals the deed; a second groan, a splash of water and

the incident is over (p. 160). Once again, the small detail, intro-
duced for dramatic effect, serves a thematic purpose in suggesting
the sharp contrast between the violent nature of man and the awe-
some natural world that surrounds him.

Details of this sort appear in other contexts besides the broadly
philosophic one, for the writers did not have to include the vast
expanse of nature each time they suggested the cruelty of men or
the harshness of their social world. The details alone, in other
words, carry the full weight of the meaning. Thus, in *Jack Tier*,
Cooper reveals much of the character of Stephen Spike in one
briefly described incident in the book. Running an overloaded yawl
through shoal waters in an attempt to escape capture by the naval
vessel that pursues him, he drops his victims one by one from the
boat and even orders his men to slash the wrist of a woman who
clings for dear life to the hand of one of the crew (p. 445). Wash-
ington Irving, moreover, had used a similar detail in *The Life and
Voyages of Christopher Columbus*, where the Spaniards cruelly
deal with their Indian captives in precisely the same way—even to
cutting their hands—when an overloaded boat is in danger of cap-
sizing (4: 394). In each case, the detail is simply included in the de-
scription without comment by either writer. No philosophic con-
text is provided, nor is one needed. The individual cruelty of both
Spike and the Spaniards is so well revealed through the detail that
authorial comment would be superfluous.

This kind of detail is more common in Cooper's fiction than in
the works of Bryant or Irving, partly because he deals with a sub-
ject matter that makes its inclusion inevitable. In his tales of forest
and sea, the device is especially appropriate in that it enables him
to suggest succinctly the violence and danger of his fictive world
without dwelling unduly on sensational episodes. Cooper is re-
strained in his use of the technique. He does not bombard the
reader with a series of horrors. For this reason, however, the de-
vice is all the more effective when it does appear. One does not
easily forget, for example, the death of Captain Munson in *The
Pilot*, who, struck by a ball from a British cannon, is suddenly
swept from the deck of his ship and falls into water dyed with his
own blood (p. 407); nor that of a British commander in the same
book, who is pierced by a harpoon thrown by Long Tom Coffin

and dies "pinned . . . to the mast of his own vessel" (p. 205).
Equally effective, too, is the death of a Sioux warrior in *The
Prairie*. Rather than let his scalp fall into the hands of the pursuing
Pawnees, he allows a fellow warrior to strike off his head and ride
away brandishing the bloody trophy to keep the scalp away from
his hated enemies (pp. 404–5). Details of this kind are seldom men-
tioned in discussions of Cooper's art,[32] but they play a significant
role in defining the kind of human world in which his characters
act out their roles.

In Cooper's books, moreover, even the natural world ex-
hibits some similar—and rather unexpected—qualities, for the ex-
ternal scene, sublime and beautiful though it may sometimes be
and suggestive of the beneficence of God, is not so simply good as
the natural world revealed in Bryant's verse. For Cooper also pre-
sents another vision of reality, depicting an almost Melvillean
world in which hidden and unexpected danger lurks in the path of
the unwary. To be sure, Bryant recognized the violence and dan-
ger implicit in much of nature, but his hurricane or tornado is
likely to be viewed explicitly as the judgment of God on guilty
men, whereas in Cooper, the cause of natural calamity is not al-
ways so openly assigned, nor does disaster happen only to his
villains. The reason for this difference is not far to seek. Bryant
based his philosophy squarely upon nature itself, which man must
closely observe if he is to penetrate to truth in both the natural and
moral spheres. Because of this theory of correspondence, Bryant
was necessarily committed to the concept of an innocent nature.
Otherwise his philosophy would have been based on an unreliable
source. Cooper, on the other hand, who, though he shared many
of Bryant's attitudes, was more strictly Christian in his views,
could posit a more ambiguous—and realistic—natural world.

The effect on their works is immediately apparent. Whereas
Bryant includes no details in his landscapes that might controvert
his view of the fundamental innocence of nature, Cooper presents
at times such stark and startling ones that he raises a serious ques-
tion concerning its ultimate meaning. Thus, in the closing pages of
The Water-Witch, a romantic novel in which we hardly expect
such details, he includes a vision of an eat-or-be-eaten world. A
group of characters is adrift on a raft when the fins of three or

four sharks are seen cutting the water. The situation is so perilous to some of the sailors perched on the low spars that the Skimmer of the Seas, a smuggler, orders one of his men to try with some tackle to catch one of them. When the line is thrown, however, the sharks dart so voraciously at it that the sailor is jerked into the sea. "The whole passed with a frightful and alarming rapidity. A common cry of horror was heard, and the last despairing glance of the fallen man was witnessed. The mutilated body floated for an instant in its blood, with the look of agony and terror still imprinted on the conscious countenance. At the next moment, it had become food for the monsters of the sea" (p. 427). The sharks disappear, and only the deep dye of the sailor's blood remains on the surface "as if placed there to warn the survivors of their fate" (p. 427).[33]

Similar events occur in other of Cooper's novels. In *The Pioneers*, Judge Temple and some of his household are riding through the "dead stillness" of the forest, when suddenly, without warning, a tree begins to fall and almost crushes the members of the party, who have to ride for their lives. All escape, but the Judge observes that "the sudden fallings of the trees . . . are the most dangerous accidents in the forest, for they are not to be foreseen, being impelled by no winds, nor any extraneous or visible cause against which we can guard" (pp. 243–44). In a similar fashion, the storm that strikes the vessel crossing Lake Leman in *The Headsman* carries a lone Westphalian student to his end in a silent and awful way. A lurch of the boat when he is trying to roll a bale over the side throws both him and the bale into the water. Maso, an Italian smuggler who is near him, grabs for the body, but it never rises again. Though he has seen many men die, Maso is struck by the student's "brief and silent . . . end" (p. 90). This swift "bundling of a man into Eternity," as Melville would later put it,[34] suggests a natural world markedly different from the "seats of innocence and rest" of Bryant's verse (p. 88).

Both Cooper and Irving, moreover, suggest this darker view through the details they include in their treatment of the sea. In *The Sketch Book*, for example, Geoffrey Crayon describes the small detail of the mast of a ship in a "surrounding expanse" of ocean and sees in it suggestions of the lonely death of those who

tried to save themselves by lashing their bodies to the mast with handkerchiefs, the remains of which are still to be seen attached to it (2: 15–16). He follows the detail with an account of a schooner suddenly run down by another ship on a foggy night off the Newfoundland banks. "We struck her just amid-ships," says the captain, who narrates the incident. "The force, the size, and weight of our vessel bore her down below the waves; we passed over her and were hurried on our course. As the crashing wreck was sinking beneath us, I had a glimpse of two or three half-naked wretches rushing from her cabin; they just started from their beds to be swallowed shrieking by the waves. I heard their drowning cry mingling with the wind. The blast that bore it to our ears swept us out of all further hearing" (2: 17). By the time he gets his ship around, all sign of the schooner is gone. They cruised through the fog for several hours, firing signal guns, and listening for the call of survivors, "but all was silent—we never saw or heard any thing of them more" (2: 17).

Similar incidents occur in a number of Cooper's novels, where ships are sometimes destroyed as quickly and as terribly as that in Irving's *Sketch Book*. The ship *Hyperion* clears the Kattegat in *Afloat and Ashore* and is never heard from again (p. 451), and a launch in *Miles Wallingford* is almost destroyed by a warship that takes it by surprise and sweeps down upon it, "overshadowing the sea like some huge cloud." In an instant, the ship is there threatening to crush the launch "beneath the bright copper of her bottom." In another, she is gone, and the launch has escaped destruction (p. 338). An English brig in the same book, moreover, disappears in a most frightening way. Miles Wallingford, the narrator, describes the incident. "She was lying-to, directly on our course, and I was looking at her from the windlass, trying to form some opinion as to the expediency of our luffing-to, in order to hold our own. Of a sudden, this brig gave a plunge, and she went down like a porpoise diving. What caused this disaster I never knew; but, in five minutes we passed as near as possible over the spot, and not a trace of her was to be seen" (pp. 305–6). The physical world of Cooper's books is fraught with hidden and unexpected danger against which the human being is all but helpless. There are threats that cannot be foreseen and calamities that cannot be prevented.

Through the specific, stark detail that he includes, he makes this vision of reality apparent to his readers.

Thematic use of detail, however, did not end here. The device could also serve a broader artistic purpose than simply to suggest the nature of man and the physical reality through which he moves. Indeed, the basic meaning of a work—be it poem or novel—could sometimes be embodied in the details through which the author chose to present it. Such use of detail appears in the works of all three writers. To be sure, there are differences. Both the types of details and the themes to be expressed vary with each author. The use to which Bryant put the technique was much more deeply philosophic than anything we can find in Irving. Its use in Cooper is more subtle and more complex than that which appears in the works of Irving and Bryant. Part of the difference results from their varying angles of vision, part from the different forms in which they wrote. The use of detail in lyric or philosophic verse—where the poet must rely on it heavily to suggest his theme—necessarily differs from that in extended fiction, where the author has both character and narrative action to help convey his meaning. Despite the differences, however, all three writers used the device for the same fundamental purpose.

Bryant's use of the technique derives from the theory of correspondence that lies behind most of his verse. Since, in his view, the physical world itself was full of meaning, a single significant detail of the natural landscape could not only suggest a philosophic theme, but could also serve as a means for embodying that theme in a poem. Some of Bryant's best known verse well illustrates the technique. The waterfowl, winging his way across the evening sky in his annual migration, becomes a sign of that trust which the creature, be he man or bird, must place in the guidance of a beneficent God (pp. 26–27). The yellow violet, blooming early in the year to make "the woods of April bright," represents too the early friends we sometimes forget when we climb past them to wealth or power (pp. 23–24). The fringed gentian, coming late in the year when all the other flowers have faded in the frost, is a sign of the hope that should be in the heart of him whose life has come to the winter years (p. 128). In each case, the suggestive detail drawn from the physical world expresses a moral concept. In-

deed, the fact that it functions perfectly well on the literal level makes it, in Bryant's aesthetic, all the more suitable as an embodiment of his moral theme.

In other of Bryant's poems, the technique approaches the more truly symbolic, for the analogy is not precisely drawn. Rather, the image itself carries the full weight of the meaning. In a little known poem, "Earth's Children Cleave to Earth," Bryant uses the image of mountain mist dissipating in the rising sun as a symbol of man's futile desire to cling tenaciously to physical life. After a single direct statement in the first two lines, "Earth's children cleave to Earth—her frail / Decaying children dread decay" (p. 176), he develops the entire poem through a single image: "the wreath of mist that leaves the vale / And lessens in the morning ray" (p. 176). Slowly it moves upward, yet lingers as long as it can. It

> clings to fern and copsewood set
> Along the green and dewy steeps:
> Clings to the flowery kalmia, clings
> To precipices fringed with grass,
> Dark maples where the wood-thrush sings,
> And bowers of fragrant sassafras. [p. 176]

Ultimately the struggle proves vain, for the mist dissolves in the "beams that fill / The world with glory" and it becomes, reluctantly, "a portion of the glorious sky" (p. 176). That men are as mist is never directly stated in the poem, nor the fact that they resist the very influence they should seek to embrace. Instead, the image itself fully embodies the theme.

Though it never occupies so central a place in Irving's art, the same technique appears in some of his tales and sketches. The image of the quiet nook of still water bordering a rapid stream in "The Legend of Sleepy Hollow," a nook in which straw or bubble slowly revolves undisturbed by the passing current (2: 426), is the figurative embodiment of the whole theme of the story, which involves just such a quiet corner of society, threatened, but not engulfed, by the torrent of change and progress that Ichabod Crane represents in the tale.[35] The sprig of yew that Geoffrey Crayon plucks as he walks through the churchyard, in

"Stratford-on-Avon," "the only relic," he tells us, that he brought from the place (2: 333), suggests both the emptiness of the purported relics of Shakespeare that are shown to the visitors and the true immortality that the bard enjoys in the minds of those who have found pleasure in his works. Similarly, the people who throng through the writer's library, in "Roscoe," when it is auctioned off, and who calculate the monetary value of rare books that had served as sources for his histories (2: 26), represent the evil days on which the author has fallen and typify the ruin that has overtaken him.

Yet, effective though the device may be in some of Irving's works, it occupies a relatively small place in even those in which it does appear, for Irving never assigned it so important a role as it was to play in a number of Cooper's books. In the novelist's hands, the device became at times a primary means—as it never was in Irving—for expressing the theme of an extended literary work. *The Bravo* is a good example, for in that book, Cooper used two unusually striking details which in themselves reveal much of the theme of his novel. A great deal of the action of this Venetian tale involves the duplicity of the aristocratic state in dealing with its recalcitrant citizens. Old Antonio Vecchio, a fisherman, is murdered by the state for pleading too long and too vehemently for the release of his only grandson, who has been impressed in the galleys, and Jacopo Frontoni, the hero, has been forced to assume the mask of a bravo and serve as a spy for the state because he has proved his father innocent of the charge of smuggling that has been made against him. As long as his father lives in prison—where he remains because the state will not retract its errors—Jacopo must serve the purposes of the ruling Senate.

To drive home to his readers the terrible evils of an aristocratic system, Cooper uses the device of the striking detail. Once Antonio is dead, the fishermen rise in protest over his murder, and though he has been killed by the state, the Senate arranges a lavish funeral for him to placate the fishermen. So cynical is the official attitude, however, that in the funeral procession we catch a glimpse of the very boy that Antonio had sought to save. Next to the bier walks Antonio's grandson, released from the galleys,

and the whisper goes through the crowd that he has been freed in pity for "the untimely fate" of his grandfather (p. 383). Cooper's irony is biting in this brief episode, just as it is in another startling incident at the end of the book. To account for the murder of Antonio, the state accuses Jacopo. Since his father has now died, the state's hold on him has weakened. His reputation as a hired assassin, moreover, makes the charge seem reasonable to the people. At the end of the book, therefore, although Cooper builds up suspense by holding out the hope that his hero might be saved, a single swing of the ax beheads Jacopo (p. 412)—a detail that throws into high relief the hideous, self-serving cynicism of the Venetian state.

In other of Cooper's novels, the device is more subtly used— not simply to provide dramatic illumination as in the closing chapters of *The Bravo*, but to aid in the symbolic development of the entire narrative. A good example is *Wyandotté*. In this late novel of the Revolution, Cooper tells the story of Captain Hugh Willoughby, a retired British officer, who, though leaning generally toward the American cause, tries to maintain a neutral position during the conflict. The head of a divided household, some of whom favor the British, some the American side, Willoughby is placed in an intolerable position when he is attacked by a group of irregular partisans disguised as Indians who are bent on seizing his isolated estate in the wilderness, the Hutted Knoll. To resist is to place himself on the British side; to surrender is not only to lose his possessions but to risk being murdered and scalped by some real Indians who have accompanied the irregulars. Though Willoughby holds out for a while, the Hutted Knoll is almost destroyed through the treachery of Joel Strides, Willoughby's overseer, who breeches the captain's defense and lets the attackers enter in the hope that Willoughby's destruction will allow him to acquire for himself, at least temporarily, the lands that he rents from the captain.

Through the use of a single detail, the unhung gates of the Hutted Knoll, Cooper objectifies the relation of Joel and Captain Willoughby. When the Hutted Knoll was built, the captain, a military man, had made good plans for its defense. The lower walls are masonry and therefore impregnable to Indian attack, and the

main gate to the courtyard, massive and heavy, is made up of two leaves that need only be hung to make his defenses complete. The gates are "framed in oak, filled in with four-inch plank, and might have resisted a very formidable assault. Their strong iron hinges were all in their places, but the heavy job of hanging had been deferred to a leisure moment, when all the strength of the manor might be collected for that purpose" (p. 42). Mrs. Willoughby pleads with her husband to hang the gates, for twice before in their lives they had been the victims of Indian surprise, from which only "accident, or God's providence" had saved them, and not their vigilance (pp. 43–44).

So great is the labor of hanging the gates and so strong the sense of security in the wilderness during the years before the Revolution, that ten years pass, and even after the war has actually begun, the gates remain unhung. Part of the reason for the delay at this time is the reluctance of Joel Strides to get the job done, and he talks against taking the men away from their work "when there's no visible danger in sight to recommend the measure to prudence, as it might be" (p. 109). But although Joel's arguments seem perfectly reasonable, one is inclined to suspect that even at this time he has an ulterior motive. He doubts that gates are always a means for security and in general resists the suggestion that they be hung. Yet another year passes, and although the captain always intends to hang the gates, September 1776 finds them still leaning against the wall of the house. "The preceding year," Cooper writes, "when the stockade was erected, Joel had managed to throw so many obstacles in the way of hanging the gates that the duty was not performed throughout the whole of the present summer" (p. 176).

Since the gates represent a breech in the wall of the captain's security and since Joel Strides is partly responsible for their remaining open, the unhung gates themselves become the physical representation of the false security the captain feels with his overseer, whom he trusts. For Joel is a weak spot in the captain's defenses no less than the unhung gates. The reader is not surprised to learn, therefore, that Joel has also breeched the palisades which the captain has erected, has seduced the laborers to follow him rather than the captain, and has even prepared the gates—once

they are half-hung, half-propped in place—to be thrown down in the final assault on the Hutted Knoll. The detail, constantly held before the reader's eyes, is so consistently associated with Joel Strides, and the two are so intimately connected with the downfall of the Hutted Knoll that the detail itself may be seen as functioning thematically throughout the book. It is the means through which the captain's trust and Joel Strides's treachery are most skillfully and artistically presented.

This interpretation is reinforced, moreover, by a contrasting detail that Cooper includes in the book. If Joel Strides and the unhung gates represent a false security, Jamie Allen, the Scottish mason, and the well-constructed wall that he builds represent a true one. "The wall," we are told, "was not only solid and secure, but . . . really handsome. This was in some measure owing to the quality of the stones, but quite as much to Jamie's dexterity in using them" (p. 41). Jamie's stonework is "unexceptionable" (p. 42), and so is his loyalty. When the palisades are built, Jamie goes to work digging the ditch with a will, whereas Joel Strides is excused from the work because he has plowing to do. When other men desert, the mason is among the very few who stand by the captain. Indeed, he even gives his life in defense of the Knoll, for he dies in the assault launched by the treacherous Joel Strides. Jamie Allen is everything Strides is not, a relation clearly symbolized by the impenetrable wall constructed by the former, and the breech in its strength for which the latter is responsible.

An even more subtle use of detail in the thematic development of an entire novel may be found in *The Pioneers*. Here the precise details, developed in rather complex patterns, contribute greatly to the meaning of the book and its artistic expression. Unlike *The Last of the Mohicans* and *The Prairie*, this first of the Leatherstocking tales is not primarily concerned with the sublime aspects of nature. Only once in the book, indeed, does Cooper pause to describe a truly expansive landscape, and it is presented only obliquely through Leatherstocking's account of a particularly spacious view from a peak in the Catskills, one so high that the Susquehanna River is "in sight for seventy miles, looking like a curled shaving under [his] feet, though it was eight long miles to its banks" (p. 300). It is appropriate that Leatherstocking present

this view of the external scene, for he is the spokesman for the values of untouched nature in the book. It is significant, too, that no other character takes the same view of the external world and that Cooper's descriptions in the book reflect less of the sublime than of the picturesque. It is not the broad expanse of nature that is presented here, but nature seen in relation to the men who have settled the land and are building their towns upon it.

Even the views of nature that Cooper draws in the opening pages of the book differ sharply from those presented in the other Leatherstocking tales. Rather than suggest unlimited space, the scenes are all circumscribed by mountains that cut off the view, and the reader's attention is directed not to the mountain peaks or sky, but to the human details in the center of the scene. In the opening chapter when Cooper first describes the physical setting, he presents the elements in an order quite the opposite of his technique in the sublime view. He begins with the mountains, which, he tells us, "are generally arable to the tops," and quickly passes to a consideration of the "narrow" valleys. The elements that he includes are mostly man-made ones: "beautiful and thriving villages, . . . neat and comfortable farms," diverging roads, "academies, and minor edifices of learning, . . . and places for the worship of God" (pp. 1–2). In general, Cooper begins with a fairly broad view and narrows his angle of vision as he proceeds. The effect is to focus the attention not on the expansive setting—which, to be sure, is still there in the background—but on the multitude of small details with which the scene is filled.

Cooper makes use of the device a second time in Chapter 3 of the novel, when Judge Temple and his daughter overlook the village of Templeton as their sleigh moves down the mountain toward the town. This view from an eminence includes an expanse of mountain, forest, and plain, but instead of leading the reader's imagination away from the earth and the objects of men, Cooper seems deliberately to focus upon them. The mountains, as the view recedes, open out into "valleys and glens, or were formed into terraces and hollows that admitted of cultivation," and the distant forests are spotted with clearings from which smoke curls over the tops of trees to reveal "the habitations of man, and the commencement of agriculture" (p. 28). Even the land that

stretches, "far as the eye could reach," on the banks of the lake, is "a narrow but graceful valley, along which the settlers had scattered their humble habitations, with a profusion that bespoke the quality of the soil, and the comparative facilities of intercourse" (p. 29). Cooper then narrows the view to include at first only the village of Templeton and finally brings into focus the house and the grounds of the judge.

Although Cooper enlarges the scene again at the end of the chapter as the characters take a final look at the beautiful valley, the concentration on detail clearly reveals to the reader the focal point of the novel. The problems of settlement of a new country, the opening of the land and the establishment of law and order are the primary concerns of the book. Hence, the focus is kept rather firmly on the appearance of the settlement and the manners of its people, all of which are described with a profusion of detail not always present in Cooper's novels. The style of the buildings, their paint, the plan of the town are all specifically depicted, and Cooper takes pains to describe in detail the clothes of the inhabitants, their talk and attitudes, and methods of dealing. Each of the social classes is sharply revealed in the language and appearance of the characters, and the foreign members of the little community—French, German, Irish, and English—are given appropriate accents and nicely detailed speeches to reveal their characters. The social quality of the novel is admirably presented through the use that Cooper makes of his precise details.

But although *The Pioneers* is most sharply focused upon the social aspects of the community, Cooper does not forget the broader dimensions. The village exists in a wilderness setting, and although man is rapidly acquiring a mastery over nature, his conquest is not complete. A number of details in the novel point up this concept. The wild and dangerous aspects of the natural landscape are clearly suggested by the wolves that Elizabeth Temple and Louisa Grant hear howling in the night and which have at times invaded the town (pp. 214–15), by the falling tree that endangers the lives of the Temples as they ride through the forest (pp. 243–44), and by the panther that almost attacks Elizabeth during a walk on the mountain (pp. 315–18). Yet if forest impinges on town, so also does the settlement impinge on the wilder-

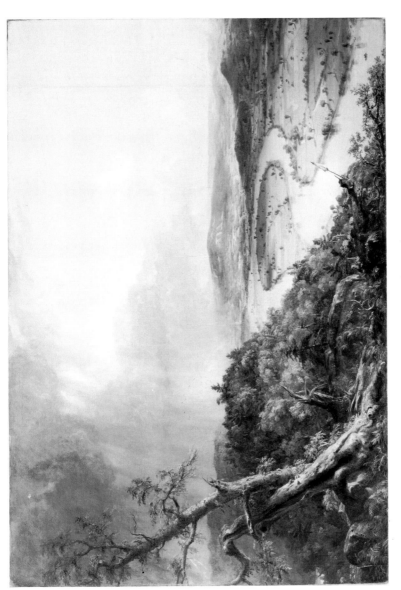

THOMAS COLE, *The Oxbow*

(*The Metropolitan Museum of Art, Gift of Mrs. Russell Sage, 1908*)

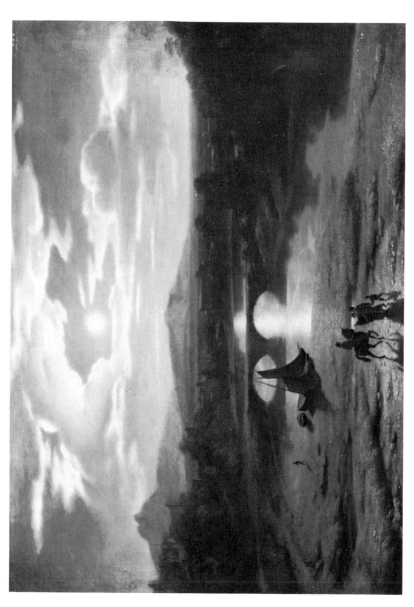

Washington Allston, *Moonlit Landscape*

(*Courtesy, Museum of Fine Arts, Boston*)

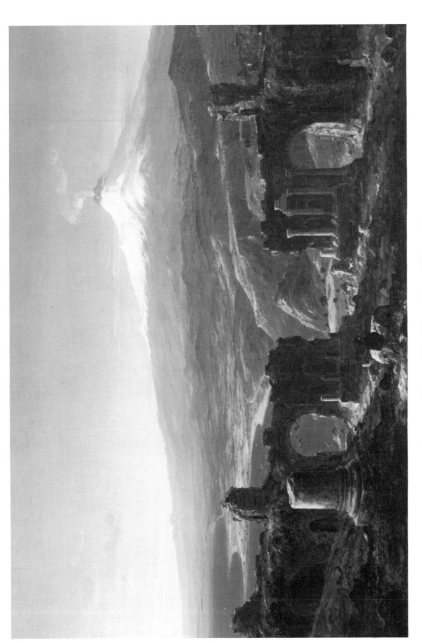

Thomas Cole, *Mt. Etna from Taormina*

(Courtesy Wadsworth Atheneum, Hartford)

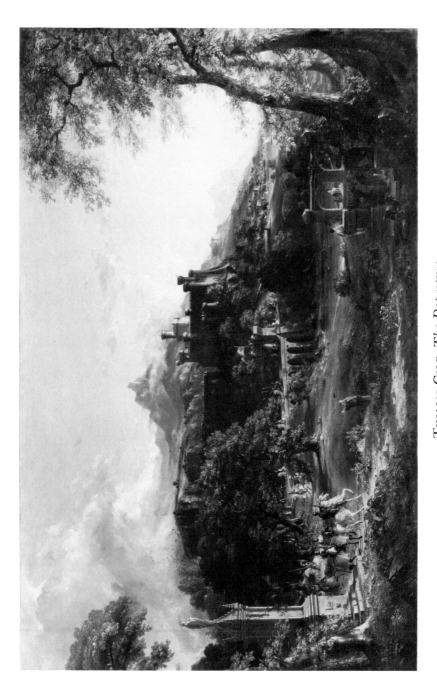

Thomas Cole, *The Departure*

(*In the collection of The Corcoran Gallery of Art*)

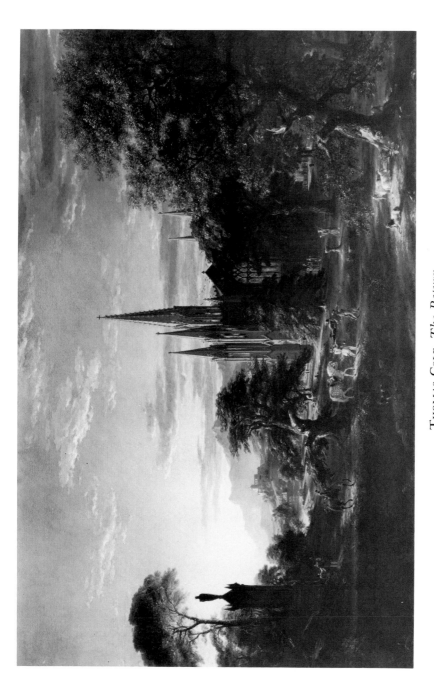

THOMAS COLE, *The Return*

(In the collection of The Corcoran Gallery of Art)

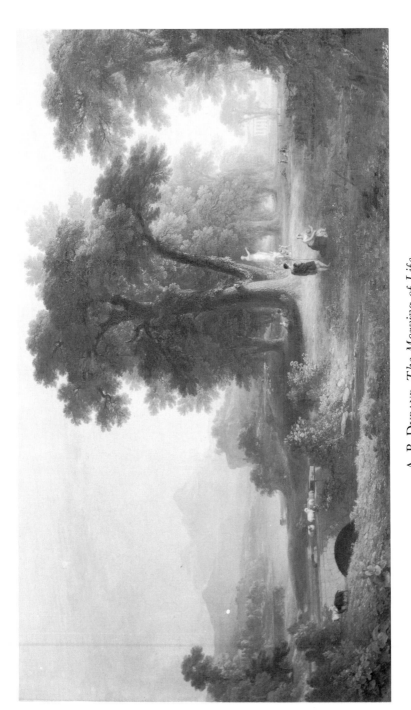

A. B. Durand, *The Morning of Life*

(*Permanent Collection, National Academy of Design*
Photograph courtesy of Frick Art Reference Library)

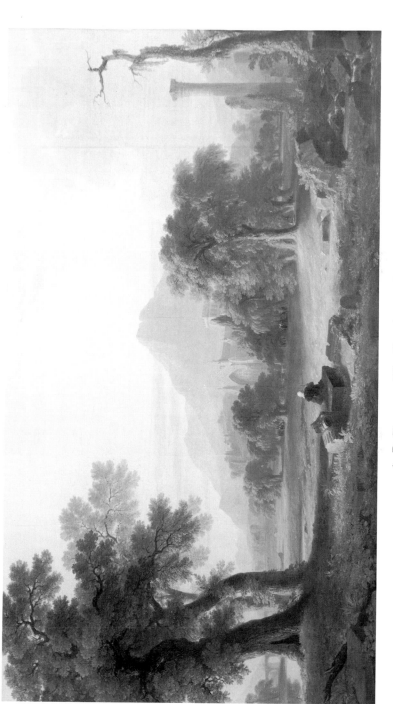

A. B. DURAND, *The Evening of Life*

(Permanent Collection, National Academy of Design
Photograph courtesy of Frick Art Reference Library)

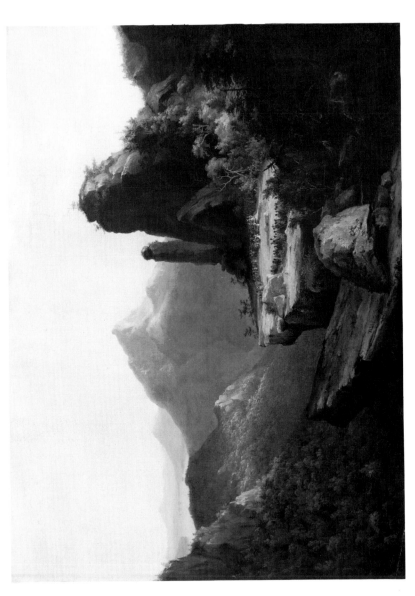

THOMAS COLE, *Last of the Mohicans*

(Courtesy Wadsworth Atheneum, Hartford)

ness, a fact that is clearly suggested by the repeated detail of the
incessant hammers of the settlers heard far across the waters of
the lake or from the side of the mountain (pp. 296, 314). The
invading forces of men can be heard in the forest, the struggle
goes on, and although the wilderness is not yet tamed, the fate of
the panther—or, indeed, of the bear that pauses at one point to look
into a clearing (p. 189)—is sealed.

The attitude that Cooper maintains to this invasion of the
wilderness is also revealed by repeated details in the novel. His
strong objection to the rape of the wilderness and the waste of its
vast resources is firmly stated in such developed incidents as the
pigeon shoot in the spring and the bass fishing on the lake in sum-
mer in which thousands of creatures are needlessly slaughtered by
unthinking settlers. But other details in the book also point to
the same conclusion and serve to keep the concept firmly before
the reader. The "cracking and threatening" sounds of a tree,
which, "threshing and tearing with its branches the tops of its sur-
rounding brethren," falls to the ax of Billy Kirby (p. 191) suggest
the violence that men do to the forest. Yet it is only one of many
that the woodsman fells as he hacks a series of clearings out of the
wilderness. In a similar fashion, the mountains of wood that stand
before the dwellings of Templeton in winter obliquely reveal the
destruction that has been wrought in the forest.

Most significant of all, however, are the numerous stumps that
appear in Cooper's description of the landscape. Always unob-
trusively mentioned, they function as a leitmotiv in the novel.
First introduced in the broad panoramic scene in Chapter 3, where,
covered by snow, they still remain in the yard of Judge Temple's
house, they appear again surrounding the home of the Reverend
Mr. Grant, peering above the level of the snow with white caps
two feet deep upon them. In the thaw that occurs on Christmas
Day, the falling torrents of rain disclose "the dark edges of the
stumps" as the snow rapidly settles around them, and "the black
stubs" of trees become each moment "more distinct, as large
masses of snow and ice [fall] from their sides" (p. 210). When
the snow disappears in the spring thaws, "the green wheatfields
[are] spotted with the dark and charred stumps that had, the
preceding season, supported some of the proudest trees of the

forest" (p. 246), and as the summer advances, "the stumps in the cleared fields [become] hidden beneath the wheat that was waving with every breath of the summer air, shining and changing its hues like velvet" (p. 291).

These details alone embody a great deal of the meaning of the book, for the fields of wheat gradually obscuring the remnants of a despoiled forest is an appropriate symbol for the encroachment of civilization. That the fields are of ripening wheat is especially apt in that the figure clearly expresses Cooper's fundamental attitude toward the settlement of the land. The values of civilization are superior to those of the wilderness and must supplant them. At the same time, however, the complex symbol suggests the price that has to be paid for society. The ugly stumps and stubs are a grim reminder of the vanished forest and suggest the depletion of game that accompanies the destruction of the woods. This, in turn, suggests the fate of the Indians, who, when the forest and game are gone, can no longer survive, or, if they do, are reduced to the degraded state of Indian John. Indeed, it is not too much to say that Indian John himself is a kind of stump or stub left behind from his tribe. Though Cooper does not directly connect the two, the similarity between them is obvious.

The means of destruction, moreover, are always before the reader. In the opening chapters of the novel that describe the Christmas festivities, Cooper frequently mentions the roaring fires of wood that keep the various households comfortable, and although Marmaduke Temple often laments the fact that the woods are being consumed at such a fearful rate, everyone realizes that such fires are necessary if Templeton is to survive. Other fires, however, are less justifiable, a fact that is barely hinted when Cooper first mentions the stumps and stubs near Marmaduke Temple's house, for stubs, we are told, are "unsightly remnants of trees that had been partly destroyed by fire" and which rear "their black, glistening columns twenty or thirty feet above the pure white of the snow" (p. 34). A more fully developed example, moreover, occurs when Billy Kirby is described performing his job as woodcutter, for after he had leveled the trees for a clearing, he would "light the heaps of timber, and march away under the blaze of the prostrate forest, like the conqueror of some city, who,

having first prevailed over his adversary, applies the torch as the finishing blow to his conquest" (p. 191).

The reader is thus in a sense prepared for the climactic scene in the novel, the fire that rages across the mountain near the close of the book and almost destroys the chief characters of the tale. Though a timely thunderstorm extinguishes the blaze before the forest is totally burned, "the woods, for many miles, were black and smoking, and were stripped of every vestige of brush and dead wood." Though the pines and hemlocks escape, the smaller trees retain only "a feeble appearance of life and vegetation" (p. 443). The fire is caused, appropriately, by the carelessness of the settlers, who, pursuing Leatherstocking through the wilderness, "had thrown . . . lighted pine knots in the brush" that kindled like tow and swept across the mountain (pp. 432, 444). The burning woods are the consummation of the kind of heedless destruction that has been constantly held before the reader through the use of precise detail—a destruction that Judge Temple regrets, but which, for the while at least, he is powerless to stop. The settlers scorn the idea that trees could be exhausted and even burn the sugar maples of the forest for firewood. The blackened stubs and burned-over woods, however, foreshadow the despoiled landscape that Cooper was later to depict in *The Prairie*.[36]

Other details, moreover, contribute to the thematic development of the book. In the very first chapter, for example, we find the whole drama of the novel symbolically enacted in one brief incident. When Marmaduke Temple and his daughter come over the mountain on Christmas Eve, a deer crosses their path and Judge Temple stops the sleigh and tries to shoot it. He misses with both barrels of his gun, when two rifle shots bring down the deer. The argument that Leatherstocking and Judge Temple engage in over the possession of the deer represents in small their conflict over the game laws which eventually leads to Leatherstocking's arrest and imprisonment, and Leatherstocking's appeal to his "lawful due in a free country" is the ironic first statement of a whole series of variations on the theme of law that runs through the book. Even the depletion of the game around Templeton is given thematic emphasis this early in the book, and Leatherstocking's shooting of a partridge with a single shot looks forward

to two other incidents in which he performs the same feat: his win-
ning of the turkey shoot the following day and his killing of a
single pigeon during the spring flight when others are slaughter-
ing thousands.

Much more important, however, is the single detail of the
judge accidentally wounding Oliver Edwards, Leatherstocking's
young companion. To be sure, the incident has plot significance,
since it provides the means for the judge to introduce the young
man into his household, and this enables young Edwards and Eliza-
beth Temple to become acquainted and so provide the love
interest in the book. The symbolic meaning of the incident, how-
ever, is equally important. Judge Temple has innocently and inad-
vertently hurt the young man with his gun, a fact which may be
taken to represent their whole relationship. By keeping the papers
of Edwards's father, who remained loyal to England during the
Revolution, and by buying in the confiscated estate of his old
friend, Temple seems to have betrayed his trust and to have hurt
the heir of the loyalist, though Temple himself believes the heir
to be dead. And just as Marmaduke Temple corrects the inad-
vertent wrong of the shooting by having Edwards's wound at-
tended to, so also does he correct the apparent wrong of holding
the lands by giving Edwards half of the estate, once he learns
who he is at the end of the book.

Cooper's use of detail in *The Pioneers* is thus both broad and
significant. The first chapter of the book presents symbolically
the whole conflict of the novel and foreshadows a great deal of the
action. The descriptive passages, drawn with a narrowing focus,
clearly show the primarily social concern of the tale, while Leath-
erstocking's description of a broad panorama and the general sug-
gestion of the surrounding untamed wilderness place the action of
the novel in the appropriate context. The meaning of the settlers'
experience, their wanton waste of the bounties of nature, is not
only revealed directly in fully developed incidents, but is also pre-
sented symbolically through the numerous details of cut and burn-
ing wood, decaying stumps and blackened stubs that recur the-
matically throughout the book. It is too much to say, of course,
that the details alone carry the full burden of the novel's meaning.
Nonetheless, it is important to observe how much of that mean-

ing is either stated or reinforced by the precise details that Cooper saw fit to place in his book. At the very least, they function as leitmotivs to keep before the reader the fundamental meaning of the novel.

Although the technique of precise detail is more complex and more fully developed in Cooper's novels than that which we find in the works of Bryant and Irving, it is only because the novel form provides more opportunity for its exploitation. The patterns of detail that Cooper employs in *Wyandotté* and *The Pioneers* cannot be used to such an extent in works of a more limited scope. The difference, however, is really one of degree. Each writer in his own way makes use of detail for aesthetic and thematic purposes, and for each the technique is basically much the same. At times its function is aesthetic: to enhance the depiction of a spacious world or to suggest the beauty or picturesque quality of a particular scene. But if the details they include are used to suggest the aesthetic categories of the eighteenth-century rhetoricians, we must not assume that this aspect of their work is merely conventional. For just as they found in the concept of the sublime a perfectly natural way to view and depict the spaciousness they perceived in the external landscape, so also did they see in the beautiful and the picturesque appropriate contexts for describing the views that they knew from close observation of nature.

Still, it is neither the accurate depiction of the details of nature nor the aesthetic convention that is of most importance, but the thematic use to which they put their materials. Details of the physical world and of the affairs of men are included in their works for the expression of their major themes, and this is the function that merits our most serious attention. The details must often be seen in the context of an expansive nature, where their primary function is not merely to enhance the spaciousness of the landscape, but to suggest a theme that may best be expressed through the juxtaposition of the vast and the minute. On many occasions, however, much of the attention is focused on the details themselves. When this occurs, the details may suggest almost any theme the author wishes to present, from his fundamental vision of the nature of reality to the specific meaning of a localized action. Whatever the meaning to be expressed, however, they

function as an important element in the descriptive style, one that exploits to the full the suggestive value of language and adds considerable depth of meaning to the basic mode of expression.

3. Light & Shadow

Although much of the basic meaning of landscape could be expressed through the careful arrangement of details in an expansive view, yet another element was indispensable to both writers and painters if the theme of a work was to be communicated with the fullest aesthetic effect. Landscape presents to the eye a varying tone as light and shadow play across it, and a scene at sunrise is not the same as that at noon or sunset, even though its physical components remain unchanged. Much of the aesthetic value resides in the peculiar qualities imparted to it by the light, and the meaning itself can change as the relative values of light and shadow shift with the passage of sun and clouds. For this reason, landscape painters from the time of Claude Lorrain have been especially careful of the lighting of their landscapes, the effect of which may clearly be seen in the landscape art of the seventeenth and eighteenth centuries. It was only to be expected, therefore, that the Hudson River painters, whose work derives from this landscape tradition, should be equally concerned with the principle of chiaroscuro, the arrangement of light and shadow, in their art, and that their friends among the writers should share their aesthetic views.

That the proper arrangement of light and shadow was considered to be an important element in contemporary landscape painting is easily established from the theory and practice of the painters themselves. Both Cole and Durand, for example, discuss the importance of chiaroscuro in both nature and art. In his "Letters on Landscape Painting," Durand writes at some length on the effect of sunlight on the natural landscape not only in developing "the full power of color" but also in evolving "the interminable variety of light and shade which constitutes the magic of chiaroscuro—that controlling element of effect which theorists have in vain endeavored to portion and systemize." When he

treats its use in painting, moreover, he considers the arrangement of light and shadow so important that he advises the beginning painter to direct his attention to the chiaroscuro rather than to color, pointing out that "a fine engraving gives us all the essentials of a fine picture, and often a higher suggestiveness than the original it represents."[1]

For Thomas Cole, too, chiaroscuro was a matter of great concern. He writes of the effect that the changes of light and shadow have upon the "lone man in the wilderness," and he sometimes describes a verbal landscape with due emphasis upon the effect of light. Thus, he writes in a story called "The Bewilderment": "The sun was sinking beneath a dark fringe of pines and rocks, leaving the vales in solemn shadow: here and there beams of reflected light shot up from the depths, and discovered the quick brook or the quiet pool." He was also concerned with the proper use of chiaroscuro in painting and planned his own compositions with care. As he wrote to Samuel Ward in 1839 concerning *The Voyage of Life*, he was "making studies of the subject, introducing and arranging in them all the necessary objects, determining the chiaroscuro, &c." before he put brush to canvas so that, when he turned to the actual work, he could "proceed with certainty and facility." Indeed, he was sometimes critical of how others handled the device. Though he greatly admired the *Transfiguration* of Raphael and thought it a unified composition, he felt that "its chiaroscuro, though not disagreeable, [was] not as a whole complete." "The picture," he thought, "might possibly have been better connected in its light and shadow."[2]

It is hardly surprising, then, that the paintings of Cole and Durand show a marked similarity in technique. Both use the Claudian device—common to all the painters of the Hudson River school—of placing the source of light in the background of the composition, a technique that insures a dark foreground and a highlight in the distant sky. Thus, the pattern of light and shadow we find in Cole's *Dream of Arcadia*[3] has its parallel in Durand's *Evening of Life*, for in both paintings, the shadowy foregrounds stand in strong contrast to the brightly lighted sky. In a similar fashion, the series of highlights that brighten the fore and middle grounds in Durand's *Mohawk Valley*[4] and help to hold the com-

position together have their counterpart in Cole's *View of the White Mountains*. Of all the painters, however, Cole makes by far the most striking and dramatic use of the technique. The brilliant light that penetrates the dense shade of the abyss in *John the Baptist in the Wilderness*[5] and shines brightly upon the massive rock from which he preaches, and the strong chiaroscuro he used in *The Expulsion from the Garden of Eden*,[6] where masses of light and shadow stand in dramatic contrast, illustrate very well the extreme use of a device found everywhere in the landscapes of the Hudson River school.

The writers, too, were well acquainted with the principle of chiaroscuro. Bryant, for example, whose knowledge of art was broad,[7] occasionally writes of the use of light and shadow in pictures he had seen in Europe. He comments upon the "depth of shadow and strength of light" in watercolor drawings that he saw in London in 1845, and he criticizes a picture by an Irish artist named Maclise for "the fault of hardness and too equal a distribution of light."[8] He preferred the softer tone of the Claudian manner. His discussion of Cole's paintings in the address he delivered after the painter's death in 1848 reveals his appreciation for Cole's use of the technique. He particularly mentions the "broad masses of shadow dividing the sunshine that bathes the solitary plain" in Cole's *Ruins of Aqueducts in the Campagna di Roma*, and he describes *The Sunset on the Arno* in terms of its chiaroscuro. It is "a fine painting, with the river gleaming in the middle ground, the dark woods of the Cascine on the right, and above, in the distance, the mountain summits half dissolved in the vapory splendor that belongs to an Italian sunset."[9]

Irving and Cooper were also aware of the importance of chiaroscuro as a painterly device, for they both include in their prose some verbal landscapes which, firmly depicted in terms of their light and shadow, are clearly associated with the fine arts. Indeed, they sometimes include the names of particular artists. Thus, in "The Painter's Adventure," a story told from the point of view of a French artist in his *Tales of a Traveller*, Irving includes the following description:

> The setting sun, declining beyond the vast Campagna, shed its rich yellow beams on the woody summit of the Abruzzi.

Several mountains crowned with snow shone brilliantly in the distance, contrasting their brightness with others, which, thrown into shade, assumed deep tints of purple and violet. As the evening advanced, the landscape darkened into a sterner character. The immense solitude around; the wild mountains broken into rocks and precipices, intermingled with vast oaks, corks, and chestnuts; and the groups of banditti in the foreground, reminded me of the savage scenes of Salvator Rosa. [7: 337–38]

Although chiaroscuro is not the only element of style that Irving includes in the landscape, the prominence that he gives it in his description indicates the importance he attached to it as a painterly device.

Similar descriptions appear in a number of Cooper's novels. In *Wyandotté*, the rays of the sun gild the "leaves of the surrounding forest with such touches of light as are best known to the painters of Italy" (p. 128), while in *The Deerslayer*, Cooper includes two sharp details that he associates with the styles of particular artists. He writes of the "dark Rembrandt-looking hemlocks" that contrast sharply with the mirrorlike brightness of the Glimmerglass (p. 21), and he describes the camp of the Hurons, in which Rivenoak's features are illumined by the firelight, as "a picture that Salvator Rosa would have delighted to draw" (p. 284). Indeed, in *The Headsman*, he describes a scene in the technical language of painting:

A vast hill-side lay basking in the sun, which illuminated on its rounded swells a hundred long stripes of grain in every stage of verdure, resembling so much delicate velvet that was thrown in a variety of accidental faces to the light, while the shadows ran away, to speak technically, from this *foyer de lumière* of the picture, in gradations of dusky russet and brown, until the *colonne de vigueur* was obtained in the deep black cast from the overhanging branches of a wood of larch in the depths of some ravine, into which the sight with difficulty penetrated. [p. 298]

The writers' knowledge of the device, however, did not come to them through painting alone. For a hundred years and more chiaroscuro had been widely used in the verbal as well as the

graphic landscape. As early as John Dyer's *Grongar Hill*, the play of light across the external scene had been used for effect in landscape description, a practice that was continued in Dyer's later poems and in Thomson's *Seasons* ("Summer," ll. 48–55, 81–94). Indeed, examples of the technique may be found throughout the eighteenth century. It appears in Cowper's *Task* (1: 345–49; 5: 1–10) and is especially noteworthy in Wordsworth's first published poem, "An Evening Walk," where scenes of mingled light and shadow appear on page after page. Important, too, in the development of the technique is the prose of the late eighteenth century, especially the romances of Ann Radcliffe, whose tales are full of strikingly lighted scenes. She pauses frequently in such works as *The Romance of the Forest* and *The Mysteries of Udolpho* to describe a sunrise or sunset, or the play of moonlight across the shadowy landscape. Such use of chiaroscuro, as Elizabeth W. Manwaring has shown, derives ultimately from the landscape styles of Claude Lorrain and Salvator Rosa,[10] but for the first generation of American romantics, these works in poetry and prose provided a literary precedent for their own use of the technique.

A similar use of the device appeared in the landscape description of some of the travelers in America in the late eighteenth and early nineteenth centuries. William Bartram, for example, writes of the striking contrast he saw as he approached a lovely savanna, where "the glittering water pond, plays on the sight, through the dark grove, like a brilliant diamond," and he describes the flight of some Spanish curlews "turning and tacking about, high up in the air" during a time "of high winds and heavy thunder storms." Their "plumage gleams and sparkles like the brightest crystal, reflecting the sun-beams that dart upon them between the dark clouds."[11] Thaddeus Mason Harris also had an eye for the effects of light in nature. He describes the fading of a brilliant sunset, the grandeur of a mountain sunrise, and the striking changes that appear to the eye as he crosses a series of mountains, the tops of which alone are in the full rays of the sun. On another occasion, when he mounts the third of a series of ridges he is crossing, he describes the surrounding scene as brilliantly lighted. "The whole horizon was fringed with piles of distant mountains. The inter-

mediate vallies were filled with clouds, or obscured with thick mists and shade: but the lofty summits, gilded with the blaze of day, lighted up under an azure heaven, gave a surprising grandeur and brilliancy to the whole scene."[12]

James Flint, too, pauses at times to describe the striking effects of light. He was much impressed by the grandeur of the glare of light from a forest fire extending for over a mile along a ridge in the evening, and he comments twice on the sublime effects of the flashes of lightning that illuminate for the moment the "dense black clouds" among which they play. He entered the woods at dusk, on one occasion, to view a camp meeting, where "large fires of timber were kindled, which cast a new lustre on every object. The white tents gleamed in the glare. Over them the dusky woods formed a most romantic gloom, only the tall trunks of the front rank were distinctly visible, and these seemed so many members of a lofty colonnade. The illuminated camp lay on a declivity, and exposed a scene that suggested to my mind the moonlight gambols of beings known to us only through the fictions of credulous ages."[13] Though Flint—like Bartram and Harris—is describing scenes that he had actually witnessed, his method of presenting his experience, like theirs, reveals a taste instructed by the verbal and graphic landscapes that had become the common property of both English and American artists by the time the nineteenth century opened.

It is hardly surprising, therefore, that Bryant, Irving, and Cooper should introduce some dramatic lighting effects into their landscape descriptions. A long aesthetic tradition had developed a taste for them in their readers and led to the expectation that chiaroscuro should be an important element in the verbal as well as the graphic landscape. Like Mrs. Radcliffe before them, they sometimes include in their works descriptions of dawn and sunset, the brilliant light flooding the highest point in the landscape. In his earliest book, *Precaution*, Cooper writes of a beautiful sunrise in which "the lofty turrets of [a mansion's] towers were tipt with the golden light of the sun" (p. 236), and Irving includes a similar scene in *Bracebridge Hall*, wherein the sun, rising "in all its splendor," lights up "the mountain summits" and then steals down, "height by height," to gild "the domes and towers of Granada"

(6: 235). Bryant, on his part, describes a view, in "A Walk at Sunset," in which the mountain tops are bright in the rays of the setting sun, that sinks "in glory" behind them (p. 37). Such use of chiaroscuro has its counterpart in paintings like Cole's *Mountain Sunrise*,[14] where a dramatic effect is achieved through the strong contrast of light and shadow.

Like Mrs. Radcliffe, too, all three writers include some dramatic lighting effects in their nighttime scenes. In "The Waning Moon," for example, Bryant writes of the play of moonlight across the crests of waves that restlessly move on the ocean (pp. 52–53), and Irving, in *Tales of a Traveller*, describes through his persona the moonbeams that stream "on the tall tower of St. Mark, and [light] up the magnificent front and swelling domes of the cathedral" (7: 75)—views which resemble the use that Cooper makes of moonlight in *The Bravo*. At other times, the source of the striking effect is not the moon, but fire. The bonfires that glow from the silvery mountaintops on a bright moonlit night in Irving's *Alhambra* lend an eerie effect to the moon-drenched landscape (15: 355), while in Cooper's *Water-Witch*, a burning ship is starkly outlined against the deep shadow of ocean and sky, a sight that Cooper describes as both fearful and beautiful (p. 405). Landscapes depicting a nighttime scene are not very common among the painters, but Washington Allston's *Moonlit Landscape*[15] provides at least one good analogy to the sort of thing the writers were doing in their prose and verse.

The striking and dramatic effects apparent in so many of these examples do not represent, however, the major ends the device could be made to serve. Unlike Mrs. Radcliffe, who consistently uses the technique to titillate her readers with a naive Gothicism, Bryant, Irving, and Cooper were seldom interested in suggesting the kind of awe or terror that was her stock-in-trade. Rather, they turned the device to other, more sophisticated purposes. Because the lights and shadows in many of their descriptions are really no more than details in their broadly drawn landscapes, they sometimes serve the same aesthetic and thematic purposes as other details of sight and sound. Thus, they are often used to suggest the sublime, beautiful, or picturesque qualities of the depicted scene or to contribute to our understanding of the theme. At other times,

however, the lights and shadows assume symbolic value and so function in the work as to become an essential part of the meaning. Not every work, of course, illustrates this broad use of chiaroscuro, yet so important is the technique, especially in Cooper's novels, that a close examination of the device in the works of all three men is necessary if we are to understand the literary purposes to which this painterly device could be put.

To suggest the aesthetic quality they wished to instill in the landscape, the writers would often select appropriate details of light and shade. The burning ship in Cooper's *Water-Witch* combines two of the three qualities, the beautiful and the sublime. More often, however, he, like Bryant and Irving, preferred to suggest only one. All three writers, for example, associate softness of light with the beautiful. Thus, Bryant writes in "To the Apennines":

> Your peaks are beautiful, ye Appenines!
> In the soft light of these serenest skies;
> From the broad highland region, black with pines,
> Fair as the hills of Paradise they rise,
> Bathed in the tint Peruvian slaves behold
> In rosy flushes on the virgin gold. [p. 159]

Irving describes "a smoky haze in the atmosphere," in *A Tour of the Prairies*, that tempers "the brightness of the sunshine into a golden tint, softening the features of the landscape" (9: 100), and Cooper includes a description, in the opening lines of *The Heidenmauer*, in which the evening light resembles the "soft and melancholy glory" that one might perceive through a Claude glass (p. 1).

Cooper, however, did not restrict his description of beauty to the soft lights of the picturesque tradition. Rather, he seems to include the sharp variation of light and shadow in the same aesthetic category. In his introduction to *The Heidenmauer*, he praises American scenery over that of the Rhine Valley because "ten degrees of a lower latitude supply richer tints, brighter transitions of light and shadow, and more glorious changes of the atmosphere, to embellish the beauties of our western clime" (p. vii). If bright transitions of light and shade can contribute to the

beautiful, we can well understand his assignment of beauty to the burning ship in *The Water-Witch*, or to the following description of the Fourth of July fireworks in *Home as Found:*

> The effect was singularly beautiful. Groups of dark objects became suddenly illuminated, and here a portion of the throng might be seen beneath a brightness like that produced by a bonfire, while all the background of persons and faces were gliding about in a darkness that almost swallowed up a human figure. Suddenly all this would be changed; the brightness would pass away, and a ball alighting in a spot that had seemed abandoned to gloom, it would be found peopled with merry countenances and active forms. The constant changes from brightness to deep darkness, with all the varying gleams of light and shadow, made the beauty of the scene, which soon extorted admiration from all in the balcony. [p. 315]

At other times the use of light and shadow in the works of all three men helps to suggest the sublimity of the natural scene. Thus, Bryant, in "The Hurricane," describes "the mighty shadow" of the storm as it approaches. The clouds

> darken fast; and the golden blaze
> Of the sun is quenched in the lurid haze,
> And he sends through the shade a funeral ray—
> A glare that is neither night nor day,
> A beam that touches, with hues of death,
> The clouds above and the earth beneath. [pp. 116–17]

Darker and darker the sky becomes as the storm overshadows all, and "a lurid glow" from the lightning flashes across the landscape (p. 117). Cooper, on the other hand, draws a stronger contrast between the light and the dark and associates his sublime scene with the rugged vastness of the Alps. As a group of travelers in *The Headsman* work their way through a gorge of bare rock in the evening, they look up at the col through which they must finally pass. "The light which still tranquilly reigned in this part of the heavens," Cooper writes, "was in sublime contrast to the gathering gloom of the passes below" (p. 308). Although the sublimity of neither scene is determined entirely by the lighting,

the chiaroscuro adds significantly to the sublime effect in each.

In night scenes, too, the chiaroscuro contributes markedly to the sublimity of the view. In Irving's *Tales of a Traveller*, the narrator of "The Story of a Young Robber" pauses to describe the effect of a nighttime landscape. "The night was magnificent," he writes—a word sometimes used to suggest the sublime. "The moon, rising above the horizon in a cloudless sky, faintly lit up the grand features of the mountains, while lights twinkling here and there, like terrestrial stars in the wide dusky expanse of the landscape, betrayed the lonely cabins of the shepherds" (7: 350). In Cooper's *Red Rover*, a moonlit seascape suggests even more intensely the sublimity of the view.

> The night was misty rather than dark. A full and bright moon had arisen: but it pursued its path through the heavens, behind a body of dusky clouds, that was much too dense for the borrowed rays to penetrate. Here and there a straggling gleam appeared to find its way through a covering of vapor less dense than the rest, falling upon the water like the dim illumination of a distant taper. As the wind was fresh and easterly, the sea seemed to throw upward from behind its agitated surface more light than it received; long lines of glittering foam following each other, and lending a distinctness to the waters, that the heavens themselves wanted. The ship was bowed low on its side; and, as it entered each rolling swell, a wide crescent of foam was driven ahead, the element appearing to gambol along its path. But, though the time was propitious, the wind not absolutely adverse, and the heavens rather gloomy than threatening, an uncertain (and, to a landsman, it might seem an unnatural) light gave a character of the wildest loneliness to the view. [p. 197]

Chiaroscuro has always been an important element in picturesque art. At times the effect is achieved through natural light playing upon the picturesque elements in the landscape. Thus, at one point in *The Deerslayer*, Cooper describes the breaking of dawn over the Glimmerglass and includes in the view the castle of Tom Hutter, a house built on piles far out on the lake, as a quaint and picturesque object starting out of the gloom (p. 332). Elsewhere in the novel, moreover, he describes both the ark and the castle

as faintly visible in the soft glow of light that, even on the darkest nights, still shines in the middle of the lake (pp. 156, 263). On other occasions, the dancing light of a fire illumines a picturesque view. Thus, in *The Wing-and-Wing*, as Ghita Caraccioli watches beside her dying lover, Raoul Yvard, "the light of the fire . . . [casts] a picturesque glow upon the group around the dying man" once the night sets in (p. 457). After Raoul has died, the brightly burning fire, casting its light on his body and upon the seamen sleeping among the ruins, continues to make a "wildly picturesque" view (p. 463).

Similar scenes may be found in Irving's works. In *The Sketch Book*, for example, Crayon describes the kitchen of an inn almost as if it were a Flemish painting, the brightly polished vessels shining in the glow of "a large lamp" that throws "a strong mass of light" upon a group of people sitting around the stove. "Its yellow rays partially illumined the spacious kitchen, dying duskily away into remote corners; except where they settled in mellow radiance on the broad side of a flitch of bacon, or were reflected back from well-scoured utensils, that gleamed from the midst of obscurity" (2: 190). In describing the natural scene, Irving sometimes used a similar technique. Thus, in *A Tour of the Prairies*, he depicts the camp of his party on a stormy night in these terms.

> As the night thickened, the huge fires became more and more luminous; lighting up masses of overhanging foliage, and leaving other parts of the grove in deep gloom. Every fire had its goblin group around it, while the tethered horses were dimly seen, like spectres, among the thickets; excepting that here and there a gray one stood out in bright relief.
> The grove, thus fitfully lighted up by the ruddy glare of the fires, resembled a vast leafy dome, walled in by opaque darkness; but every now and then two or three quivering flashes of lightning in quick succession, would suddenly reveal a vast champaign country, where fields and forests, and running streams, would start, as it were, into existence for a few brief seconds, and, before the eye could ascertain them, vanish again into gloom. [9: 96–97]

Descriptions of this kind seem somewhat mannered to the modern taste, adhering so closely as they do to the painterly tech-

nique. Better, perhaps, are those in which the chiaroscuro is included not only to suggest a particular aesthetic effect but also to contribute to the basic mood or meaning of the piece. Such use of chiaroscuro is also found among the painters, and Thomas Cole has left us a description of his intentions for using the device in this way in his five-part series *The Course of Empire*. As he wrote to Lumen Reed, his patron, on September 18, 1833, he planned the chiaroscuro in each of the canvases to achieve a specific effect. In the first, depicting the savage state, he planned a view of the wilderness, "the sun rising from the sea, and the clouds of night retiring over the mountains. . . . There must be a flashing chiaroscuro, and the spirit of motion pervading the scene, as though nature were just springing from chaos." By contrast, in the second picture, representing the pastoral state, the chiaroscuro was to "be of a milder character," while in the third, a noonday scene depicting the height of empire, the chiaroscuro was to be "broad." In the fourth, however, showing the destruction of the city at the hands of an invading army, there was to "be a fierce chiaroscuro, masses and groups swaying about like stormy waves." Though Cole does not specify the quality of the light and shadow to be used in the final scene depicting the desolation of empire, it is quite obvious from the painting itself that he planned it to be of a milder character.[16]

A similar use of chiaroscuro to suggest the mood or meaning of a scene can be found among the writers, for just as the lighting effects of Cole's canvases help to create the basic tone and support the fundamental meaning of his paintings, so too does the use of chiaroscuro function in the writers' descriptions. Most impressive, perhaps, are those in which the authors depict the effect of changing light. In this matter, the writers enjoyed an advantage not possessed by the painters, who were forced by their medium to freeze time at a given moment and who could overcome this limitation of their art only through the somewhat awkward device of a series of paintings. Time can pass, however, in the writers' descriptions, and the lighting effects can change in the course of the depiction. Thus, in his poem "The Prairies," Bryant includes as part of the scene the play of light and shadow as clouds move over the landscape. At first the view seems stationary, but in an instant all is movement.

The clouds
Sweep over with their shadows, and, beneath,
The surface rolls and fluctuates to the eye;
Dark hollows seem to glide along and chase
The sunny ridges. [pp. 130–31]

The play of light across the rolling hills suggests the ocean swell, an image that helps to connote the sense of vastness that Bryant sought in his poem. The use of light and shadow serves, therefore, a double purpose. It not only creates a sense of reality in the description itself but also contributes to the fundamental meaning of the landscape.

A different kind of movement appears in Irving's "Westminster Abbey," where light and shadow play an important role in establishing both the tone and the meaning of the sketch. Crayon begins his meditation with the evocation of the pale light of autumn, a light that shines in the square of the cloisters and gilds the "pinnacles of the abbey towering into the azure heaven" (2: 214), but which almost fades from sight when he enters the gloom within. Inside, in the aisle where Mary, Queen of Scots, is buried, "the light struggles dimly through windows darkened by dust," and "the greater part of the place is in deep shadow" (2: 221). The light fades entirely toward the end of the piece, for even that which manages to pierce the dark aisles within soon withdraws with the setting sun. As Crayon approaches the end, he writes:

> The last beams of day were now faintly streaming through the painted windows in the high vaults above me; the lower parts of the abbey were already wrapped in the obscurity of twilight. The chapels and aisles grew darker and darker. The effigies of the kings faded into shadows; the marble figures of the monuments assumed strange shapes in the uncertain light; the evening breeze crept through the aisles like the cold breath of the grave; and even the distant footfall of a verger, traversing the Poet's Corner, had something strange and dreary in its sound. [2: 224]

The fading light and deepening shadow help maintain the mood of gentle melancholy so important to the effect of the sketch. More significantly, however, the deepening shadows at the end suggest as

well the passing of all things into the darkness of total oblivion, a process that is reflected in the changing light itself.[17]

For Cooper, too, the device was at times a useful one. Consider, for example, the sunset he describes in Chapter 5 of *The Pioneers*, a scene that includes a double movement. Not only is the sun setting as the description develops, but the point of view of the observer changes as the view is described. It begins with Elizabeth Temple on the top of the mountain overlooking Templeton, while the sun, expanding "in the refraction of the horizon," begins to sink behind the dark pines of the western hills. Cooper then stops the movement briefly to describe the effects of light on the scene: the birches shining in the sunlight, the dark pines sharply "delineated far in the depths of the forest; and the rocks . . . brightened, as if smiling at the leave-taking of the luminary." At this point, however, the observer descends the mountain with Elizabeth and leaves the day behind. The effect is to accelerate the onslaught of darkness. The light recedes "step by step from the earth into the clouds," and in the valley below, the houses become "gloomy and indistinct." The darkness and cold descend over everything (p. 49). As in Bryant's description in "The Prairies," the movement of light and dark adds a sense of reality to the scene. As in Irving's sketch, the increasing darkness helps to create the basic mood of the episode. And the scene suggests as well the theme of unending change that lies at the heart of the book.

Yet another example appears in *The Wept of Wish-ton-Wish*, a sunset in which the thematic implications are even more pronounced. A colony of Puritans in seventeenth-century Connecticut have been attacked and all but destroyed by a band of Indians. In the gradually darkening scene which Cooper describes, they have gathered to bury their dead. The sun is already in the treetops, and though most of the fields are still bathed in light, the forest is gradually darkening into night. Then, in highly evocative language, Cooper describes the changing scene.

A broad and gloomy margin was spreading from the boundary of the woods, and here and there a solitary tree cast its shadow on the meadows without its limits, throwing a dark, ragged line in bold relief on the glow of the sun's rays. One—it was

the dusky image of a high and waving pine, that reared its dark green pyramid of never-fading foliage nearly a hundred feet above the humbler growth of beeches—cast its shade to the side of the eminence of the block. Here the pointed extremity of the shadow was seen, stealing slowly towards the open grave,—an emblem of that oblivion in which its humble tenants were so shortly to be wrapped. [pp. 197-98]

A description of this kind far transcends the mannered set pieces that Cooper, like Bryant and Irving, sometimes created. It clearly demonstrates, too—like similar scenes of changing light in the other writers—that chiaroscuro could serve a thematic as well as aesthetic purpose in the works in which it appears.

In most of these descriptions, the use of chiaroscuro is basically suggestive, the meaning largely derived from the tone of the passages. Both writers and painters, however, also used the device for more specifically symbolic purposes. Darkness and light, after all, have long been used in literature and art to convey particular symbolic meanings: to represent ideas of good and evil, life and death, heaven and earth, readily grasped by even the most un-sophisticated reader or viewer. A convenient example of this use of the device is found in a passage from Cole's "Journal" for January 24, 1835. Commenting upon the heavy burdens of life, Cole draws an extended analogy: "Although pain and trouble may accumulate, as we pass along, hope sheds a light upon our path, and brightens like a star, as the darkness deepens. In the depth of night we see not the earth around us, while there are visible splendours in the fields of heaven: so divine joys shine from eternity when trouble flings a gloomy obscurity around the things of time."[18] The religious significance he assigns to light and shade in a passage like this is also apparent in a number of his paintings, as, for example, the striking *John the Baptist in the Wilderness*, where the flood of light falling on John bespeaks the importance of his message, or *The Vision*,[19] the fourth canvas of his un-finished series *The Cross and the World*, wherein the shades of life roll dramatically back before the brilliant light of eternity.

A similar use of chiaroscuro to express symbolic meaning may also be seen in the painters' handling of sunrise and sunset in their extended allegorical series, where the rising and setting sun are

frequently associated with the beginning and end of life. The titles alone of Durand's pair of paintings, *The Morning of Life* and *The Evening of Life*, describe the time of day presented in each, while the first panel, depicting childhood, in Cole's *Voyage of Life*, contains the expected sunrise view. Cole, moreover, sometimes used the technique in paintings that represent the beginning and end of a story or narrative. Thus, his *Departure*, a painting which shows a knight and his retinue about to leave for the wars, parallels *The Savage State*, the first panel of *The Course of Empire*, in that both depict an early morning view, whereas *Return*, which shows the knight's defeated men bearing his body home, is similar to *Desolation*, the final scene in *The Course of Empire*, in that both present an evening landscape.[20] Though the images may be trite—and perhaps too frequently used—the quality of light in each of the canvases, derived from the chiaroscuro, reveals quite well the meaning that each attempted to impart through his paintings.

In the works of the writers, too, light and shade are sometimes assigned quite specific—and, indeed, even predictable—meanings. In Bryant, as in Cole, the pains, errors, and evils of life are usually associated with darkness, while joy and truth are always represented by light, and the earth is viewed as a vale of shadow in contrast to the brilliance of heaven. Thus, he writes, in "The Ages," of "that ray of brightness from above," which, with the coming of Christ, "struggled, the darkness of that day to break" (p. 16). In "Life," he presents another, and somewhat different, image of the world as the abode of darkness:

> Well, I have had my turn, have been
> Raised from the darkness of the clod,
> And for a glorious moment seen
> The brightness of the skirts of God;
>
> And knew the light within my breast,
> Though wavering oftentimes and dim,
> The power, the will, that never rest,
> And cannot die, were all from him. [p. 175]

Like Cole, too, he uses the stars as signs of guidance and hope. In his "Hymn to the North Star," he stresses the function of Polaris

as a beacon for the lost and wandering, and he extends the meaning to include a moral function as well. Thus, it becomes in the last stanza "a beauteous type of that unchanging good" by which "the voyager of time" should guide his way (p. 75).

Like the painters, too, he sometimes includes in his verse a sunrise or sunset view, images which he associates most often with the approach of death. The sunrise that concludes "The Journey of Life"—after he has described a nighttime walk through shadows where only "broken gleams of brightness" light the path—explicitly represents the afterlife that opens to him "from the empyreal height, / With warmth, and certainty, and boundless light" (p. 137). In a similar fashion, his allegorical poem, "Waiting by the Gate," uses an evening landscape to suggest the end of physical life. The sunshine streams across the "quiet wood and lea," while atop the gateway, which obviously signifies death, the clouds lie "in eternal shadow" (p. 260). Neither of these poems is among Bryant's best, for the imagery in both is obvious and trite. Better, perhaps, is the more complex symbolism he uses in "A Walk at Sunset," where the setting sun suggests the Indian legend that departed warriors "went to bright isles beneath the setting sun." This thought, in turn, naturally leads him to see in the sunset an emblem not only of that departed race, but, since the sun must return again, of all the change that ceaselessly goes on in the world (pp. 37–38).

Irving, at times, also invests his chiaroscuro with allegorical meaning, his persona describing human life in terms of its lights and shadows, or depicting the end of life in terms of the setting sun. The latter images are, of course, rather conventional. Thus, in *A History of New York*, the old burghers, sitting under the trees on the Battery, contemplate the setting sun, "an emblem of the tranquil end toward which they were declining" (1: 294); in "The Pride of the Village," in *The Sketch Book*, the setting sun lights up "all nature into a melancholy smile. It [seems] like the parting hour of a good Christian, smiling on the sins and sorrows of the world, and giving, in the serenity of his decline, an assurance that he will rise again in glory" (2: 400). More interesting, however, is an image Irving includes in *Bracebridge Hall*, where, in "Family Relics," Crayon describes the passage of a lovely girl along a gallery.

The sun shone through the row of windows on her as she passed along, and she seemed to beam out each time into brightness, and relapse into shade, until the door at the bottom of the gallery closed after her. I felt a sadness of heart at the idea, that this was an emblem of her lot: a few more years of sunshine and shade, and all this life, and loveliness, and enjoyment, will have ceased, and nothing be left to commemorate this beautiful being but one more perishable portrait. [6: 50]

Whatever one may think of the touch of sentiment in the description, the image is certainly more fresh and more effective than either of the two sunsets.

With Cooper, we face a somewhat different problem, for although, like Bryant, Irving, and Cole, he sometimes used the device for rather conventional purposes, he frequently made his light and shadow serve a more subtle artistic function. To be sure, he sometimes assigns a specific meaning to a particular object or scene. In *The Sea Lions*, for example, the bright stars shining through the clear, cold night of the polar latitudes are "sublime emblems of the power of God . . . twinkling like bright torches glowing in space" (p. 378), and the brilliant light of an antarctic day is filled with similar religious significance. The day is "marked by the caprice and changeful light of high latitudes," the ocean "glittering under the brightness of an unclouded sun," and the icebergs "glowing in prismatic light" (p. 248). This view turns the thoughts of Roswell Gardiner and Stephen Stimson toward their Creator, much as the last rays of the sun shining upon a dazzling white Alpine peak in *The Headsman* suggest to the onlookers "a bright stepping-stone between heaven and earth" (p. 68). In all these scenes, the light and dark, associated as they are with the evocation of vast space, assume a rather conventional meaning.

On other occasions, however, the meaning is more subtly suggested, and the images themselves function less obtrusively in the book. Thus, in *Mercedes of Castile*, Cooper does not underline the explicit meaning of the sunrise he depicts on the morning of Columbus's great discovery in 1492. The emerging sun, "gilding [the] prominent points [of the island], and throwing others into shadow" (p. 354), need not be taken symbolically, but it surely suggests the dawn of a new era with the discovery of America. It is not in such small examples, however, that Cooper's handling of

the technique may best be seen. Because he is writing long fiction, Cooper could make more complex and more extensive use of chiaroscuro than could Bryant in his short descriptive poems or Irving in his brief stories and sketches. Cooper could develop his symbolic descriptions more fully and, throughout the course of the novel, could relate one to another in such a way as to create a symbolic pattern of light and shadow for the entire book. To understand, therefore, how chiaroscuro functions as a symbolic element in Cooper's novels, we must go beyond his brief use of the device and examine its broader function in expressing the theme or establishing the tone of an entire novel.

A good example appears in *The Prairie,* a book that begins and ends with a striking sunset landscape. Every reader of the novel will recall the symbolic encounter of Ishmael Bush with the trapper (Leatherstocking) in the opening chapter. As Bush and his tribe push westward through the limitless expanse of the Great Plains, they are confronted by a startling sight:

> The sun had fallen below the crest of the nearest wave of the prairie, leaving the usual rich and glowing train on its track. In the centre of this flood of fiery light a human form appeared, drawn against the gilded background as distinctly, and seemingly as palpable, as though it would come within the grasp of any extended hand. The figure was colossal; the attitude musing and melancholy; and the situation directly in the route of the travellers. But imbedded, as it was, in its setting of garish light, it was impossible to distinguish its just proportions or true character. [p. 8]

The conflict that is to develop between the squatter and the trapper receives a strong symbolic statement in this encounter. Two titanic figures confront each other, the trapper barring the way to Bush and his clan, and the struggle between the men assumes epic proportions. The fate of a nation depends upon which of the two, the conserver or the despoiler of the landscape, shall prevail, and the end is clearly foreshadowed as the scene develops.

The image fades as the sun sinks further below the horizon. "In place of the brightness which had dazzled the eye, a grey and more sober light had succeeded, and as the setting lost its brilliancy,

the proportions of the fanciful form became less exaggerated, and finally distinct" (p. 9). The trapper is making his last stand in the wilderness, and his final passing—as well as the fading of all he represents—is clearly implied in the setting sun. The light is handled in such a way, however, that a great deal more than this conventional meaning is suggested by the highly evocative scene. As in many a landscape painting of the Hudson River school, the light shines *toward* the observer from out of the depths of the background, surrounds the trapper with a halo of light, and, in effect, almost sanctifies him. We are justified in reading this supernatural meaning into the scene, for elsewhere in the novel "the bright and glorious sight of the heavens," shining in transient gleams through turbulent masses of clouds, is made to suggest an unchanging value that transcends the violence of "the lower world" (p. 94). Hence, the picture of the trapper when we first meet him, transformed by a kind of divine light, not only suggests his physical defeat at the hands of lawless men but also implies the fundamental soundness, in Cooper's view, of the moral attitude toward nature that the trapper affirms in opposing the selfish materialism of Ishmael Bush.

This interpretation is supported by the symbolic use of night and of dark, turbulent clouds throughout the novel. It is night when the band of Sioux, riding demonlike across the moonlit landscape, drive off the livestock of Ishmael Bush and leave him stranded on the prairie (pp. 35, 58, 66). "Dark, driving clouds" sweep across the lowering sky when the body of the murdered Asa Bush, Ishmael's son, is found (p. 155). Above all, it is night when Abiram White dies at the hands of his brother-in-law, Ishmael, for that murder. White is led to his execution at sunset, but he pleads so strongly for a few more hours of life that he is left on a narrow shelf of rock, his arms are bound behind him, and a rope, fastened to a tree, is tied around his neck. There he remains until, his strength failing, he falls from the ledge and strangles. That event takes place under ominous skies which Henry Nash Smith rightly associates with the style of Salvator Rosa.[21] "Light fleecy clouds" streak across a "cold and watery" moon that only at moments can soften the fields below by its mild light. Once again Cooper injects a supernatural quality into the scene, for the wind, rushing across the prairie, sounds "like the whisperings of the

dead," and a shriek like that from another world sweeps "frightfully through the upper air" (p. 432). The horror of both the crime and the execution is suggested by the tormented landscape.

This scene contrasts sharply with the carefully drawn tableau of the trapper's death, two chapters later, which, in a powerful restatement of the first striking image in the book,[22] takes place in the calm glory of an autumnal sunset. The "sheet of golden light" that spreads across the plain instills a kind of religious glow into the landscape (p. 451). The trapper's body is carefully placed to receive "the light of the setting sun . . . upon the solemn features," and the old man slowly declines to a "tranquil and placid death" (pp. 453–54). Surrounded by friends, both white and Indian, who pay him the deepest respect, he fixes his gaze on the clouds which hang "around the western horizon, reflecting the bright colors, and giving form and loveliness to the glorious tints of an American sunset. The hour—the calm beauty of the season—the occasion, all [conspire] to fill the spectators with solemn awe" (p. 460). Every element in the scene, even the trapper's humble acceptance of death in his willing answer to his Maker's call, stands in vivid contrast to the dark and violent horror of Abiram White's ghastly end.[23]

Not every use of chiaroscuro in Cooper's novels is so dramatically striking as these, for Cooper at times could make more subtle and less obtrusive use of the technique. In *The Deerslayer*, for example, the element seldom intrudes so strongly as it does in the earlier book, yet the patterns of light and shadow, though perhaps not so obvious as in *The Prairie*, are all-pervasive and perform an important thematic function in the tale. From the very beginning, when we first meet Hurry Harry (Henry March) and Deerslayer moving through the dark woods toward the Glimmerglass, light and dark become identified with particular elements in the landscape. Deep shadow invests the shore, for the sun can hardly penetrate the virgin forest, but the lake itself and the whole expanse of the landscape lie bathed in brilliant light when Harry and Deerslayer first leave the forest and step upon the shore. Even at noon, the forest is somber in contrast to the jewel-like brightness of the water; even in the darkest night when the woods are intensely black, a ribbon of light gleams down the

middle of the lake. Cooper maintains these relative values of light and shade throughout the book to suggest in the breathtaking beauty of the scene the holy calm of the landscape.

The Glimmerglass represents the permanent values of nature, serene and beautiful despite the human violence that takes place around and upon it, and Cooper returns at intervals to describe the view as it changes beneath the play of light and shadow.[24] We see it at dawn, at noon, at sunset, in the depths of night, but the fundamental meaning is always the same. Indeed, the recurring pattern of night and day that transforms the landscape suggests in itself the order of God's universe, the permanence of the values that Deerslayer alone reads in the external scene. Hurry Harry and Thomas Hutter, bent on taking Indian scalps for the bounty placed on them by the colonial government, are largely unaffected by the moral value of the landscape (pp. 332, 340), and Hurry in particular frequently treats the hunter with a degree of contempt. The calm of the landscape is forever in contrast with the passions of Hurry and Hutter, but it is in singular accord with the serene and simple mind of the hunter, whose values are implicit in the natural scene. The setting of the book, therefore, drawn in complex patterns of varied light and shadow, serves an essential function. It is an integral part of the action that contributes significantly to its fundamental meaning.

It is not only in the general meaning of the tale that the light and dark play an important role. Even in specific incidents the lighting of a scene sometimes reinforces the meaning that Cooper wishes to express. Consider the first main encounter that each of the men has with the Hurons. Hurry and Hutter go ashore on a pitch-black night to seek the Indian camp, where they believe that they can make quick work of tearing scalps from even the women and children to get the bounty. To them, the Indians are hardly above the level of animals, and they feel little compunction about murdering them for gain. Deerslayer, on the other hand, remains aloof from this occupation, and, after Hurry and Hutter fall into the hands of the Hurons, he spends the night in a canoe on the lake. Then, in a scene that contrasts in every way with that of the night before, Deerslayer meets his first Huron warrior on the banks of the lake just as dawn is breaking. They face each other on equal

terms, both men armed and alert, and, after offering his adversary a chance for his life, Deerslayer kills his first Indian in honorable battle. To point up the contrast even more, the Indian's scalp *could* be taken by Deerslayer, since his enemy lies dead before him, but he rightly refuses to desecrate the body of a fellow human.

As Deerslayer returns from this encounter, the sun appears over the eastern mountains and sheds "a flood of glorious light" on the shining water, and Cooper comments on the beauty of the scene that contrasts so sharply with the "ruthless and barbarous" incidents that had happened there (p. 122). Deerslayer is innocent of any barbarous act. He has killed a man, it is true, but that was in self-defense, the Indian first seeking his life. Hurry and Hutter are ruthless and barbarous, however, as are their Huron enemies, and one cannot escape the impression that the dawn not only symbolizes the beginning of Deerslayer's life as a warrior (the dying Huron has named him Hawkeye), but is also intended to suggest that his actions are essentially right. Cooper does not insist upon the point, and the events of the night and morning can be taken completely realistically. Nevertheless, the attitudes of the various men toward the Indians, the motives with which they face their adversaries, and the moral meaning of their acts—all suggest that Cooper intended a sharp contrast in the juxtaposed scenes and that he reinforced that meaning by the contrast of dark and light which he uses in describing the action.

A similar use of light and shadow to represent a specific meaning occurs after Hutter's death when the fortunes of the characters have reached their lowest ebb. Deerslayer has been captured by the Hurons, but has been permitted by them to spend one night on parole with his white friends on the lake. Harry March, however, has decided to leave and strike out for the fort, in effect deserting Hutter's daughters in the face of almost overwhelming danger. Deerslayer puts the woodsman ashore far down the lake at the very spot where, three days before, they had first entered upon it. Cooper deliberately contrasts the two scenes. "If it was then glorious in the bright light of summer's noon-tide, it was now sad and melancholy under the shadows of night. The mountains rose around it, like black barriers to exclude the outer world; and

the gleams of pale light that rested on the broader parts of the basin, were no bad symbols of the faintness of the hopes that were so dimly visible in his own future" (p. 419). Only occasionally does Cooper draw so specific a meaning from his carefully lighted scenes, but the passage clearly indicates the symbolic force he expected the description to have for his readers.

Because of the presence of such an episode, moreover, we are justified in reading similar meaning into subsequent scenes in which light and shadow appear. Thus, Deerslayer spends the rest of the night at the castle and rises again just as a brilliant dawn streams "down into the valley, bathing 'in deep joy' the lake, the forests, and the mountain sides" (p. 445). He returns to the Huron camp, as he had promised, just as the sun reaches the zenith at noon. Though both of these incidents may be taken as natural details in the story, they also clearly indicate that the moral position that Deerslayer assumes is to be associated with light. The declining sun, on the other hand, suggests quite a different meaning. Hetty Hutter, the morally pure but simple-minded daughter of Tom Hutter, is buried at sunset two days later after having been mortally wounded during the fight, and all the characters leave the lake shortly thereafter. It is just at sunset, too, when Deerslayer (now called Hawkeye) and his Delaware companions return to the scene some fifteen years later on their way to another war. The effect of both these scenes is to suggest the loss of the moral view that Hetty and Deerslayer have consistently maintained in the book, and the eventual passing from American life of the values implicit in the untouched landscape, values that will ultimately be ignored as men invade and destroy the wilderness.

Not every appearance of chiaroscuro in the novel can be interpreted in so precise a fashion. Indeed, it would probably be a mistake to attempt to do so. The patterns of light and dark in *The Deerslayer* are obviously intended to provide a broad frame of reference for the tale and to suggest the values in terms of which the motives and actions of the various characters are to be judged. It is the great beauty and serenity of the ever-changing cycle of nature that is most important in the book, not such specific symbols as do occasionally appear. Yet in other novels, Cooper

did at times use the fundamental patterns of light and dark to suggest specific symbolic meanings. A good example is *The Bravo*, a social and political novel of Venice which makes an even greater use of light and shadow than does *The Deerslayer*. The chiaroscuro is as broad as that which reinforces the structure of the later book, but the various elements function much more intimately in the action of the tale. Indeed, so closely related is the use of chiaroscuro to the thematic development that only a detailed analysis can indicate its true significance.

The general pattern of light and dark is easily discerned, for Cooper arranges his bright and shadowy scenes for maximum pictorial effect. The first seven chapters of *The Bravo*, for example, take place at night, and Cooper carefully paints his scenes in subdued tones, the shadowy courts and squares of Venice lit by torches and bathed in the soft glow of the moon. Chapter 8, however, begins with a passage that is obviously intended to dazzle: "A brighter day than that which succeeded the night last mentioned never dawned upon the massive domes, the gorgeous palaces, and the glittering canals of Venice" (p. 96). Cooper goes on in this vein for the next three chapters. He describes the bright and colorful public ceremonies—the marriage with the Adriatic, and the various regattas—only to return in Chapter 11 to the dark and subdued tones with which he began the novel. Cooper repeats this contrast several times to establish the major pattern of light and dark that dominates the book.

The primary tone, however, is one of darkness. Twenty-five of the thirty-one chapters take place at night; the remaining six provide the highlights that intensify the prevailing gloom. Within the darkened chapters, moreover, Cooper introduces only dim or fitful light, best typified by the description of Venice in the first paragraphs of the book. As the story opens, just after sunset, the moon has already risen and bathes the tops of the public buildings—the Ducal Palace and the Cathedral of St. Mark—with a "solemn and appropriate light" (p. 3). Tall columns are silhouetted against the evening sky, while their bases lie in shadow. Beneath the arches of the buildings that face the piazza, lamps and torches cast a brilliant glare that contrasts sharply with the mellow glow of the moon. Hundreds of masked people hurry to

and fro in the light of the torches—a strange and motley multitude bent on gaiety and pleasure. This description, recalled at intervals throughout the book and repeated at the conclusion, establishes the tone for the chapters that follow and suggests the symbolic values of each of the elements presented.

The darkness and silence of night, for example, are most frequently associated with the buildings of the state, the homes of the senators, and the workings of Venetian policy. Early in the book, during the first night of the action, Cooper describes the doge's palace in unequivocal terms. Dark and silent but for the rays of the moon and the footfalls of sentinels, it becomes "a fit emblem of that mysterious power which was known to preside over the fortunes of Venice and her citizens" (p. 35). The palace court, moreover, in contrast to the gaily lighted piazza, is consistently described as dark and forbidding. Indeed, even the homes of important senators partake of the general darkness. The palace of Signor Gradenigo, a member of the secret Council of Three, shows "more than common gloom" and, like the doge's palace, typifies the Venetian state. Within its walls, Cooper writes, "the noiseless steps and the air of silent distrust among the domestics, added to the gloomy grandeur of the apartments, rendered the abode no bad type of the Republic itself" (p. 53). Clearly, official Venice lives and acts in symbolic darkness.

This suggestion is strongly reinforced by Cooper's description of the secret tribunal which wields the real power in the state. Twice in the novel characters are summoned before the Council of Three. Each time the dimness of the scene suggests the "gloomy and secret duties" (p. 367) that the council performs. One passage, however, the questioning of old Antonio, is particularly significant in the way that Cooper handles the lighting, for the scene perceptibly darkens as Antonio is brought to the council. First met on the quays by Jacopo, who is sent to summon him, Antonio is led through the "dimmer and broken light of the court," "along the gloomy gallery," and "through many dimly lighted and obscure passages," until he arrives at an apartment "of a dusky color, which the feeble light rendered still more gloomy" (pp. 140–41). Admitted to the council chamber, Antonio finds himself in a room draped in black and lighted by a single lamp. All the

doors are concealed by the somber hangings which give "one general and chilling aspect of gloom to the whole scene" (pp. 149–50). The masked council members sit across the room, two dressed in robes of black, and one in a robe of crimson.

These men, who act anonymously in the name of the state, hold the power of life and death over all who are brought before them. Selected by lot from a larger body of senators, they are in effect the supreme power in Venice, whom the doge himself would not dare to disobey. Since they act in secret, they are responsible to no man for their deeds, and though they pretend in public to believe in justice, they are really concerned only with the protection of their own senatorial class. They decide all questions purely in terms of self-interest and do not scruple to kill to maintain their power. It is appropriate, therefore, that black be associated with these men, their institutions and their deeds, that their homes as well as the public buildings of Venice should suggest the ugly truth that lies concealed behind the imposing facades which these men and their state present to the world. It is appropriate, too, that their decrees be enacted under cover of darkness, that old Antonio, innocent of any serious wrong but considered dangerous to the state, should be secretly drowned in the Lagunes late at night by the council's agents. For the truth of Venice, Cooper clearly implies, is unremitted gloom.

Such a conclusion is only intensified by the brilliantly lighted chapters that contrast so sharply with the dim and shadowy ones. Cooper first uses the full light of day to depict the impressive public ceremonies of Venice. He describes the glittering canals, the brilliant spectacles, and the magnificent pageantry with obvious relish, but the careful reader immediately perceives the symbolic values of the sunlight. If the truth of Venice is shadow and silence, what shall we make of the brightness and clamor that dominate these chapters? A clue is immediately offered in the ceremony of the marriage with the Adriatic, a symbolic act of the doge to express the Venetian rule of the seas. At the time of the tale, however, Venetian power has already begun to decline, and the ambassadors from the northern maritime states are amused at Venetian pretension (p. 101). The doge himself, moreover, is only a figurehead, though he assumes the pomp and position of

a powerful ruler. The reader soon comes to realize, therefore, that the Venice that greets his eye in the full light of day is an utterly false one, an empty show which hides the truth that the state cannot afford to reveal.

Venice by daylight must therefore be equated with falsehood and hypocrisy, an interpretation well borne out by all the sunlit passages. It is daylight when Don Camillo is courteously received among the senators in the Broglio, although the night before the council had stolen his bride, Donna Violetta, and had thwarted their plans for escape. It is broad daylight when the state gives old Antonio a lavish funeral to appease the rebellious fishermen who rise in protest over his murder. It is daylight too when the council calls for the arrest of Jacopo for a murder he did not commit. He is tried by day in the public courts, after secretly being condemned the night before by the Council of Three. Above all, it is a brilliant morning when, with a great display of justice, the state beheads him. Indeed, just after the execution, Cooper points up the brightness of the scene as Father Anselmo, who knows the truth of Antonio's death and Jacopo's innocence, looks up "at the windows of the palace, and at the sun which shone so gloriously in the heavens" (p. 413). Cooper is using bright light to reveal the flagrant falsehood of all that Venice professes to be and to intensify by contrast the black truth that is its reality.

The light of day, however, is not the only type that Cooper uses. Two other sources of light recur throughout his darkened chapters: the brilliant lamplight of the piazza and the mellow glow of the moon. The first may be quickly dismissed, for it obviously represents the false gaiety of the Venetian festa, the means that the bulk of the people use to escape, if only for a little while, the prying eyes and ruthless power of the soulless state. Cooper describes the piazza at night repeatedly in the book and crowds the details of the scene upon one another so rapidly that the reader is left with the impression of hundreds of people moving frenetically here and there across the square without serious purpose or direction. Thus, in the final paragraph of the book, "the gay laughed, the reckless trifled, the masker pursued his hidden purpose, the cantatrice and the grotesque acted their parts, and the million existed in that vacant enjoyment which distinguishes the pleasures

of the thoughtless and the idle" (p. 413). So corrupt and corrupting is the vicious rule of the Venetian state that the mass of the people live only for themselves in the artificial pleasures of the piazza at night.

The moonlight, on the other hand, suggests the only positive values to be found in the book. Soft though it may be and generally unobtrusive in much of the description, it is repeatedly presented as contrasting with the other symbols developed in the novel. Thus, in the opening pages of the book, Cooper deliberately contrasts it with the torchlight of the piazza: "While all beneath the arches was gay and brilliant with the flare of torch and lamp," the great buildings of the city "were slumbering in the more mellow glow of the moon." "The base of the Campanile lay in shadow, but a hundred feet of its grey summit received the full rays of the moon along its eastern face" (pp. 2–3). The mellow glow can penetrate even the gloomy shadows of the palace court (p. 35). It imparts a "quivering brightness" to the waters of the canals and lends an air of "solemn but grand repose" to the buildings it touches. "Occasionally the front of a palace received the rays on its heavy cornices and labored columns, the gloomy stillness of the interior of the edifice furnishing, in every such instance, a striking contrast to the richness and architectural beauty without" (p. 43).

The light of the moon is intended, therefore, to contrast with both the darkness of official Venice and the false gaiety of the piazza. Indeed, it is most frequently associated with the uncorrupted characters in the novel. Thus, when Jacopo first meets Antonio on the square at night after the fisherman has vainly sought help from Signor Gradenigo for his grandson impressed in the galleys, the light of the moon bathes the poor fisherman with its gentle glow. Antonio's position brings "the whole of his muscular form and bronzed features beneath the rays of the moon," and his "dark, anxious, and stern eyes" gaze "upon the mild orb, as if their owner sought to penetrate into another world, in quest of that peace which he had never known in this" (p. 83). The full light of the moon repeatedly falls on the face of Jacopo; on Gelsomina, his fiancée; on Father Anselmo when he pronounces the absolution after Antonio's last confession; indeed, even on the

dead features of old Antonio when his body is brought by the protesting fishermen to the very palace of the doge. Thus, the moonlight seems intended to suggest the existence of a moral order that transcends the corrupt social order of Venice.

Such a conclusion is supported by Cooper's description of Venice on the night that Antonio is murdered. The moon is at its height as the chapter opens, and falls in a flood on domes and towers, "while the margin of the town [is] brilliantly defined by the glittering bay." Cooper chooses his words carefully here, for he wishes to suggest a kind of supernatural glory in the scene. "The natural and gorgeous setting was more than worthy of that picture of human magnificence; for at that moment, rich as was the Queen of the Adriatic in her works of art, the grandeur of her public monuments, the number and splendor of her palaces, and most else that the ingenuity and ambition of man could attempt, she was but secondary in the glories of the hour." To reinforce the impression that he wishes to create, Cooper deliberately enlarges the scene to include the infinite reaches of space which always in his novels suggest the power and glory of God. "Above was the firmament, gemmed with worlds, and sublime in immensity. Beneath lay the broad expanse of the Adriatic, endless to the eye, tranquil as the vault it reflected, and luminous with its borrowed light" (p. 192).

It is against this magnificent background that Antonio meets his end. The reader who comes upon the scene with a thorough awareness of what Cooper is doing with his light and shade is acutely conscious of the symbolic value of the moonlight that plays across the water.[25] Antonio's boat lies "quivering in the rays of the moon" as Jacopo comes to seek him, and the old man tells his companion that he sees the image of his Savior in the natural world around him. He has "prayed much since the moon has risen" (pp. 193–94), and he needs only his confession to the Carmelite, who is later brought to the Lagunes by Antonio's assassins, to be completely at peace with his God. Antonio does not flee when the gondola of the state approaches, for he is not conscious of having committed any crime, but assumes that the agents of the senate are seeking Jacopo. The Bravo, however, withdraws along one of the "bright streaks that the moon drew

on the water, and which, by dazzling the eye, effectually concealed the objects within its width" (p. 199). Jacopo is thus permitted to observe what occurs protected by the saving glow of the moon.

He sees the Carmelite pronounce the absolution, observes the gondola of the state approach a second time to remove the monk, and hears the fall of Antonio's body into the water. He tries to come to the rescue, his gondola flying "down the streak of light, like the swallow touching the water with its wing" (p. 205). But, although he arrives too late to save the old man's life, he, like the good Carmelite, has seen in the light of the moon what Venice would like to conceal in darkness or behind the brilliant display of its daylight pageantry. The moonlight is thus the truth-revealing element in the book. Both Jacopo and Father Anselmo fully perceive for the first time the utter cynicism of the aristocratic state, and both resolve to serve it no more. Father Anselmo returns to the palace of Donna Violetta so shocked by his experience that he marries Camillo and Violetta at once and resolves to help them escape. Jacopo, on the other hand, goes alone to the Lido, where he even contemplates suicide rather than return to the service of the senate.

In the ensuing action, Donna Violetta is kidnapped by a gondola of the state, and Don Camillo, who searches the harbor in an attempt to rescue her, eventually lands on the Lido, where he unexpectedly meets Jacopo. In a highly effective scene in symbolic moonlight, Don Camillo learns the truth of the Bravo's past and hears him swear that he will no longer do the senate's will. Since he has already served the state so long and so well, Jacopo knows much of its devious policy and the means it uses for accomplishing its ends. He enlists in Camillo's cause, therefore, and finally succeeds in retrieving the stolen bride and uniting the lovers on board a felucca, which, on the following moonlit night, carries them off to the States of the Church. Thus, each of the unwilling witnesses to Antonio's death contributes to the success of Don Camillo in subverting the plans of the senate, the only major incident in the book which shows a person able to evade the evil machinations of the state.

The patterns of light and dark that Cooper creates in *The*

Bravo are clearly of the utmost importance in understanding the theme of the book and in perceiving its artistry. The dark and forbidding tone that dominates so much of the novel reinforces the impression that one receives from the action of the devious ways of the state and the secrecy of its true operation. The contrasting public acts, performed in the full light of the sun, represent, in essence, the mask behind which the state conceals its true nature. The fitful glare of the torchlit piazza at night becomes a symbol of the falsity of life under such a tyrannical system, and the full glow of the moon plainly suggests the presence of a transcendent moral order, adhered to by some of the characters, but largely ignored by the state and the bulk of its corrupt inhabitants. Taken together, all these elements reacting with one another create a rich and complex pattern that contributes much to the meaning of the novel and to the aesthetic pleasure that one derives from its perception.

Bryant and Irving never created so rich and complex a pattern of light and shadow, nor did Cooper himself always employ chiaroscuro to so great an extent as he did in these three novels. Not every subject for poetry or fiction was suited to its use, nor was it at all desirable that it should appear in every work. As a literary technique, the device could hardly be used so extensively as the expansive depiction of nature or the precise detail, and it served of necessity a somewhat more limited function. Yet in its proper place, chiaroscuro was almost as useful to the writers as it was to the painters. The verbal landscape could no more ignore the presence of light and shadow than could the graphic one, and the writers, like their friends among the painters, used it for a number of purposes. At one level, it might simply provide the appropriate mood or tone for a landscape description. At another, and more important one, however, it could help reinforce the thematic meaning they sought to express in their works.

Not that they always succeeded in what they attempted to do. All three writers erred at times in the uses to which they put their light and shade, and few would prize today those examples of the technique in which it is made to serve too conventional a purpose. These lapses aside, however, the writers often succeeded in making their chiaroscuro fulfill a significant function. It fre-

quently serves a legitimate purpose in suggesting the literal appearance of the external world: the play of sunlight and clouds across the prairies, the effect of light and darkness on an American lake, or the glow of moonlight or fire in a nighttime scene. In addition, however, it often suggests a range of meaning far beyond the literal and reaches, at times, even to the symbolic. Indeed, in some of Cooper's novels, the patterns of light and shadow function so intimately in the book as to become essential parts of both structure and meaning. Though Bryant, Irving, and Cooper were not uniformly successful in their handling of the device, it did provide for all three men an important means for the artistic expression of their basic themes.

III. Time

Although much of the meaning expressed in the works of Bryant, Irving, and Cooper derives from the spatial arrangements they made in their depictions of the external scene, space is but one dimension of experience. No matter how strongly the writers might stress the relation of man to a spacious universe, they could not afford to ignore his equally important position in time. Indeed, their experience in the nineteenth-century world made this concern imperative, for wherever they turned, the problem of time and change was constantly before their eyes. Born in the closing decades of the eighteenth century when the United States was hardly more than the thirteen original colonies, all survived until at least the middle years of the nineteenth century when California was admitted to the Union and the country was rapidly approaching the Civil War. Granted these seventy or eighty years of intense change, it is small wonder that all three men should handle the problem of time in terms of the philosophical question of mutability, for if time taught any lesson to men, it was that nothing terrestrial is permanent. Bryant and Cooper made important use of this theme in a number of their most significant works, and Irving made the whole concept of mutability his single most important subject.

Though the painters too were undoubtedly attracted to the theme of mutability, the limitations of the spatial medium restricted its expression in their art. Not that time is ever absent from even the most static landscape, for the artist can hardly avoid its suggestion in his depiction of external nature. The type of light he selects for his view, the details of the physical world—the trees and streams—he includes, the suspended activity of the animal and human figures he depicts—all betray the fact that time has stopped for only a moment, that movement and change, though held in suspension, are nonetheless potentially present in the landscape. To include the theme of mutability, however, the

painter would have to use a number of more obvious devices to make his theme explicitly clear to his viewers, and the means at his disposal were necessarily limited. Thus, although striking parallels may be found in the way that the verbal and graphic artists handle the theme, they are much less numerous and more limited in scope than those we have observed in their treatment of space.

In the works of the writers, the concept of mutability could most easily be expressed through the principle of contrast. The changes that had taken place in the natural or social scene could be sharply illustrated through the depiction of the same setting at different points in time, or if the writer chose not to present the same scene twice, he could include in his landscape description suggestive details—like ruined buildings or blasted trees—to reveal the changes that had already occurred in the scene. Both devices, of course, were also open to the painters, who, through their use, could suggest the passage of time in their works and so introduce a narrative element into their fundamentally spatial art. The writers, however, were not content to let the matter end here. Deeply committed to a principle of order in terms of which the changes so apparent in the physical and social world could at last be reconciled, they included in their works a second principle of time—continuity—wherein change is circumscribed and ordered in terms of either a cyclical development in man and nature or a providential ordering of things to some important end. This temporal principle was even less easily handled in painting than that of contrast and appears but infrequently in the works of the artists.

1. Contrast

To American writers and painters in the early nineteenth century, many aspects of life must have seemed transient and unstable. The rapid westward movement of settlers during the first half of the century and the consequent despoliation of the wilderness as they cut the forests and planted the fields with crops was only one aspect of a whole series of changes that were destined to transform American life beyond recognition. The rapid progress made by

science and industry added a new dimension to American society. In addition, the many discoveries made in natural science during the century further emphasized the sharp contrast between the relative intellectual stability of the early years of the century and the great uncertainties that were soon to follow. Foremost among these discoveries was that announced by Sir Charles Lyell in his *Principles of Geology* (1830–1833), for he proposed a theory which denied permanence even to the eternal hills, and men were faced with the unsettling reality that the physical world itself on which they stood was constantly undergoing an endless process of change.

Bryant, Irving, and Cooper were all keenly aware of the forces of change that were afoot in both the physical and social spheres. "The world is always in a state of change," Bryant wrote from Spain in 1857, "but at the present time causes are at work . . . which thrust change upon the heels of change more suddenly than ever before."[1] Indeed, in the address he delivered on Robert Burns in 1871, he notes the relief he feels in giving his attention to something so relatively permanent as literature "in these times of great and rapid changes in the political and social world."[2] Cooper, on his part, frequently sees the phenomenon in terms of the social change that had occurred in American life, illustrating, in the words of one of his characters in *Home as Found*, the "disposition to change [that was] getting to be universal in the country" (p. 326) so that a period of a few years, as he writes satirically in the preface to *Homeward Bound*, throws persons and institutions out of favor and brings new ones into popularity (pp. iv–v). Irving, too, in "The Legend of Sleepy Hollow," makes the American propensity for migration, change, and progress a major point in the thematic development of his story. Though the writers see the problem in individual ways, all are agreed on the fact of change as a significant element in the nineteenth-century world.

Each of the major aspects of change, moreover, found expression in one or another of their works. All three, for example, treat the theme of the displacement of the red man as the settlers invaded the land and turned it into farms and villages. This is Cooper's great theme in the Leatherstocking tales, which treat the process from its early stage on the eastern seaboard to its

culmination on the Great Plains two generations later. Bryant, too, developed a similar theme in several of his major poems. Both "The Prairies" and "The Fountain" include the displacement of the Indian as part of the process of change that has transformed the country since the discovery, and "An Indian at the Burial-Place of His Fathers" shows the completion of the cycle, the Indian returning to lament the radical change that the white men have wrought in the landscape. Although Irving, unlike Bryant and Cooper, is seldom noted for his use of Indian material, he includes in his *Sketch Book* two pieces, "Traits of Indian Character" and "Philip of Pokanoket," which develop aspects of the theme, and he touches upon a later stage of the process in *A Tour of the Prairies* (9: 46–47, 157).

All three writers, too, were much concerned with the rapid advance in technology that was also helping to transform the native scene, though each reacts to it in a different way. In "Fifty Years," the poem he wrote for the fiftieth anniversary of his class at Williams College, Bryant is content merely to list some of the scientific developments of the age in transportation, communication, and photography, and then lament the fact that man's moral being had not kept pace with his technical progress (pp. 387–88). Cooper, on the other hand, is more equivocal in his treatment of the material. In his preface to *Afloat and Ashore*, he agrees with Bryant that "the moral changes in American society have not kept pace with those that are purely physical" (p. iv), and later in the book he allows his narrator to comment on the deterioration of manners that modern steamboats, with their hurry and bustle, have caused in American society (pp. 520–21). Yet in the final chapter of *The Oak Openings* and speaking in his own voice, he seems to praise the speed and convenience of rail and steamboat travel on the trip he took from New York to Michigan in 1848. Indeed, he has only words of admiration for the harvesting machine he saw in operation on Prairie Round.

Irving, too, was greatly impressed with the speed of steamboat travel when he returned to America in 1832 after seventeen years abroad,[3] yet he also comments on the cost that such progress entails. "The march of mechanical invention," he writes in *Astoria*, "is driving everything poetical before it. The steamboats,

which are fast dispelling the wildness and romance of our lakes and rivers, and aiding to subdue the world into commonplace, are proving as fatal to the race of the Canadian voyageurs as they have been to that of the boatmen of the Mississippi." In the course of time, they will only be remembered "among the poetical images of past times, and as themes for local and romantic associations" (8: 48–49). Other of Irving's works develop similar themes. In *Bracebridge Hall*, for example, Geoffrey Crayon reports a related development in England, where, as the Squire comments in "English Gravity," "our fine streams [are] dammed up and bestrode by cotton-mills; our valleys smoking with steam-engines, and the din of the hammer and the loom scaring away all our rural delights" (6: 263). Though Crayon does not completely assent to the Squire's opinions, the vision of change presented here is closely related to that which Irving depicts in his treatment of America.

Bryant and Cooper, moreover, even made use of the great geologic discoveries that shook the intellectual world of the nineteenth century. The poet, for example, refers in passing to the concept of a changing earth in "Monument Mountain," where we find the river wandering

> amid the fresh and fertile meads,
> The paradise he made unto himself,
> Mining the soil for ages. [p. 64]

In both "The Fountain" and "A Hymn of the Sea," however, he makes the scientific knowledge an integral part of his verse. Musing upon the changes that have taken place near the fountain, Bryant brings the former poem to a climax with the greatest change of all. He wonders if in future years the hills shall sink into the sea, or perhaps rise instead "upheaved in broken cliffs and airy peaks" (p. 188). And in the latter poem, he envisions an equally drastic physical change as

> restless surges eat away the shores
> Of earth's old continents; the fertile plain
> Welters in shallows, headlands crumble down,
> And the tide drifts the sea-sand in the streets
> Of the drowned city [p. 204]

while coral reefs are built up from the ocean floor and volcanic islands rise from the sea.[4]

Cooper, too, makes much the same use of the science of geology. Like Bryant, he occasionally mentions the material only in passing, the references taking a number of different forms. At times he merely comments on the geologic formation of actual sites, such as the Venetian Lagunes and Lido in *The Bravo* (pp. 22–23), or the origin of the striking mountain scenery around Vevey, Switzerland, in *The Headsman* (p. 130). At other times, he discusses the formation of imaginary settings, such as the unusual isolated rock used as a kind of landmark in *Wyandotté* (p. 376), or the coral islands that his characters find in the Pacific in *Afloat and Ashore* (pp. 244–45, 262). He even includes in *The Monikins* a reference to fossil remains of such extinct animals as "the mastodon—the megatherium, guanadon [*sic*]; and the plesiosaurus" (p. 134). Like Bryant, too, he once used his knowledge of geology as an essential element in the development of an entire work, for in *The Crater*, the emergence of a group of islands after an earthquake in the Pacific provides him with the means for depicting the rise of a whole society from its very beginnings. In a similar fashion, the subsequent destruction of this realm in a second cataclysm illustrates clearly his sense of the transience of all material things—including the earth itself.

But if all three writers were deeply concerned with the problem of a changing world, they were not content merely to illustrate the concept of mutability in their works. The facts were clear enough. All their experience both here and abroad had confirmed the impermanence of all earthly things. The meaning of change, however, was quite a different matter, and one they had of necessity to reckon with in their prose and verse. With their painter friends, therefore, they sought a mode of expression that would not only emphasize the fact of mutability but also suggest its basic meaning for men. The facts were easily conveyed. They could simply include in their landscapes some objects by which the passage of time and the consequent change in the scene might be easily perceived. Some relic of the past that was out of place in the present setting, some element in the natural scene like a dead or blasted tree would serve to remind the reader or viewer of the

inevitable process of change that is constantly going on in the world, and suggest through the association of ideas the philosophical theme that the artist wished to express.

Devices like these were by no means original with Bryant, Irving, and Cooper, or their artist friends. Long used by both writers and painters, they had become by the early nineteenth century rather conventional elements in Romantic iconography. The device of ancient ruins used to express a philosophic concept had appeared in American literature at least as early as Anne Bradstreet's "Contemplations," first published in 1678, and had frequently appeared in English poetry from the works of Dyer and Thomson in the early eighteenth century to those of Byron and Shelley in the nineteenth. One book, however, stood out as perhaps the most influential in encouraging American artists of the early nineteenth century to use the ruins theme: the Comte de Volney's *Les Ruines, ou méditations sur les révolutions des empires* (1791). The American edition of this work, rendered into English by Thomas Jefferson and Joel Barlow, appeared in 1802, and although it was generally opposed by conservative Americans because of its strong antireligious bias, its influence was considerable. Bryant probably became acquainted with it while attending Williams College,[5] and other contemporary writers and painters were undoubtedly familiar with it as well.[6] Though none of them subscribed to the extreme rationalistic conclusions of the work, they used the same basic device to convey their own interpretations of the meaning of change.

The most obvious meaning to be derived from the ruined remains of the past was the folly of human pride that delights in ephemeral things. Bryant was well aware of this interpretation of the ruins theme. In his review of Henry Pickering's poem *The Ruins of Paestum*, Bryant observes that the poem "opens with a reflection upon the oblivion into which, to the confusion of human pride, the builders of those mighty edifices have fallen, the works of whose hands have for so many ages survived even the memory of their names."[7] And in a letter he wrote from France in 1834, he mentions the churches, monuments, and chateaux he has seen, drawing the appropriate conclusion on the transience of those values in which some men place their faith: "They were re-

collections of power, and magnificence, and extended empire; of valor and skill in war which had held the world in fear; of dynasties that had risen and passed away; of battles and victories which had left no other fruits than their monuments."[8] Such objects remind proud men of the vanity of human wishes, of the transitory nature of power, wealth, position, and military glory. In this view, the meaning of change is moral: men should not place their faith in things that will not last.

An extended treatment of this theme may also be found in Bryant's verse. In "The Ruins of Italica," a poem he adapted from the Spanish poet Rioja, he develops it at length. Assuming the mask of one who views the remains of a Roman city in Spain—an act which arouses in his mind a series of associations connected with the spot—he describes it in its former glory. Here Scipio planted "his conquering colony," one whose might was widely feared and whose men seemed almost invincible. It was the birthplace of Trajan, Saint Theodosius, and the poet Silius, a glorious city, full of magnificent buildings, gay crowds, and great men. But time has not spared it, for its dreaded walls are overthrown, and the magnificent circus

> Is now a tragic theatre, where Time
> Acts his great fable, spreads a stage that shows
> Past grandeur's story and its dreary close. [p. 258]

And stressing the contrast between the glory that was and the desolation that alone remains, he writes:

> Where rose the palace, reared for Cæsar, yawn
> Foul rifts to which the scudding lizards haste.
> Palaces, gardens, Cæsars, all are gone,
> And even the stones their names were graven on. [p. 259]

The conclusion is inevitable. Time and decay will not respect any of the vaunted works in which men take pride. Troy, Athens, and Rome, each great in its turn, have fallen prey to the ravages of time, and the same fate awaits all the material achievements of men.

Similar views appear in the works of Bryant's contemporaries,

though sometimes expressed with individual variations. Thomas Cole, for example, saw "a lesson to human pride" in the ruins of Kenilworth Castle,[9] a view that Irving includes in his sketch of Westminster Abbey in *The Sketch Book*. Passing along the cloisters and "contemplating this mingled picture of glory and decay," Crayon describes the carved effigies of three abbots in the pavement beneath his feet. Only their names remain, the figures being "nearly worn away by the footsteps of many generations." Then he observes: "I remained some little while, musing over these casual relics of antiquity, thus left like wrecks upon this distant shore of time, telling no tale but that such beings had been and had perished; teaching no moral but the futility of that pride which hopes still to exact homage in its ashes, and to live in an inscription. A little longer, and even these faint records will be obliterated, and the monument will cease to be a memorial" (2: 214–15). Cooper, on the other hand, gives a somewhat different emphasis to the concept, when, in the early chapters of *The Red Rover*, he has Mrs. Wyllys observe that "ruins in a land are, like most of the signs of decay in the human form, sad evidences of abuses and passions which have hastened the inroads of time" (p. 52). But despite the different emphases, all these men agreed on the basic meaning of the device. The ruins of the past are signs of moral failure in men.

This concept is well exemplified in Cooper's *Prairie*, where the idea is developed at length, but with an important variation. To Cooper's mind, the Great Plains, with their "wide and empty wastes" and "rich and extensive bottoms," exhibited a "wild and singular combination of swelling fields and of nakedness, which gives that region the appearance of an ancient country, incomprehensively stripped of its people and their dwellings" (p. 424). This idea he exploits in the great debate that takes place between the trapper (Leatherstocking) and Dr. Bat, the scientific rationalist, in Chapter 22 of the book, where he not only introduces the ruins-of-empire theme but also transplants it into the American setting. Thus, when Dr. Bat corroborates the facts—of which the trapper has only heard rumors—that the Holy Land has been transformed from a fertile to a barren place and that pyramids remain standing to this day in the deserts of Egypt, Leatherstocking draws several

conclusions. He wonders at the power of a Deity whose creatures can perform such wonders as the construction of the pyramids, and he comments upon the moral failure of men whose wickedness, pride, and waste have destroyed such wonderful civilizations and converted the fertile earth into a barren desert.

The trapper then turns to the surrounding plains and applies the same moral to the American landscape. He assumes that the empty land is evidence of the passing of a mighty empire. Thus, he asks Dr. Bat, "Look about you, man; where are the multitudes that once peopled these prairies; the kings and the palaces; the riches and the mightinesses of this desert?" The doctor, as one might expect, will not accept this suggestion and asks quite logically, "Where are the monuments that would prove the truth of so vague a theory?" "They are gone," the trapper replies. "Time has lasted too long for them. For why? Time was made by the Lord, and they were made by man. This very spot of reeds and grass, on which you now sit, may once have been the garden of some mighty king" (pp. 283–84). The trapper, of course, is drawing an unwarranted conclusion, and Cooper is wise in putting this theory into the mouth of the ignorant old man. Yet the meaning he suggests by his use of the ruins theme is perfectly valid—and is directed toward his contemporaries. Pride and waste can transform a fertile land into a desert, a lesson that must be learned by greedy Americans who exploit the land with little thought of the consequences.

Cooper was not alone in placing the ruins theme in an American context, nor in drawing a moral conclusion from the despoliation of nature. Bryant had already made much the same point in "An Indian at the Burial-Place of His Fathers," a poem that was published some three years before *The Prairie*. After describing the change that the white man has wrought in the landscape, the Indian, who speaks the poem, admits the complete defeat of his people and the eventual loss of all their lands. But the white man's victory may be a hollow one, for his treatment of the earth can bring consequences that he does not foresee. The Indian, however, can see them, for he continues:

> But I behold a fearful sign,
> To which the white men's eyes are blind;

> Their race may vanish hence, like mine,
> And leave no trace behind,
> Save ruins o'er the region spread,
> And the white stones above the dead. [p. 60]

Although the ruins theme is subordinate here, it is clearly pertinent to the development of the poem, for the white man's action in cutting the trees has reduced the water table, the springs have dried up, and the land is in danger of becoming "a barren desert" (p. 60).

In seeking to develop an American ruins of time, however, the writers faced a serious difficulty. On the one hand, they perceived that the process of change afoot in the United States might have moral consequences as serious as those that were symbolized by the ruins of ancient empires, yet they were handicapped in their treatment of the theme by the absence of such relics of past grandeur in the American landscape. Subscribing as they did, moreover, to an associationist psychology, they recognized that Americans would not be suitably impressed by the theme unless it could be embodied in materials that would deeply affect them with its truth. Old World ruins alone would not do. The American myth of the Garden would have it that the causes of such destruction had been left behind in Europe, that Crèvecoeur's "new man" in America would create a society free from the evils of the past. That Cooper and Bryant did not fully subscribe to that myth is clear enough from the Leatherstocking tales and "An Indian at the Burial-Place of His Fathers." But they needed some means to express their more sober theme in such a way as to duly impress their optimistic American audience.

To be sure, a few American ruins did indeed exist, scattered here and there across the landscape, and each of the writers occasionally mentions one or another of them in his works. In *The Heidenmauer*, for example, Cooper alludes to "the walls of some fortress or the mounds of an intrenchment of the war of independence" as examples of American ruins (p. 53), and he pauses in *The Last of the Mohicans* to describe the remains of a blockhouse thrown up in one of the earlier Indian wars. Like many another such wilderness fort, it survives as "a species of ruins . . . intimately associated with the recollections of colonial history" (p.

144). Bryant describes, in his *Letters of a Traveller*, such relics as Fort Holmes at Mackinaw and the Fort of St. Mark at St. Augustine,[10] and Irving pauses at the end of the first chapter of *Astoria* to note in these words the passing into oblivion of Fort William, a village on the shores of Lake Superior: "its council chamber is silent and deserted; its banquet hall no longer echoes to the burst of loyalty, or the 'auld world' ditty; the lords of the lakes and forests have passed away; and the hospitable magnates of Montreal" have also vanished (8: 25). The mere presence of such ruins in the American landscape was not enough, however, to support the concept of an American ruins of empire, and none of the writers used them for this purpose.

One relic of the American past did catch the imagination of William Cullen Bryant and provided the means for expressing the theme in one of his major poems. These were the Indian mounds that the received opinion of the time took to be evidence of, in Bryant's words, "the existence of a semi-civilized race dwelling within our borders, who preceded the savage tribes found here by the discoverers from the Old World, and who disappeared at some unknown era, leaving behind them no tradition, nor any record save these remarkable monuments."[11] Though modern research has demonstrated that the Mound Builders were definitely an Indian people, Bryant and his contemporaries considered the mounds as evidence that a civilized race had been destroyed by the Indians, an interpretation made all the more plausible by the reports of early travelers that the Indians were ignorant of their origin. David Taitt had observed in 1772 that the present tribes of Indians could give no "Account of the Reasons of their being made,"[12] and William Bartram had written, a few years later, that the Indians "are as ignorant as we are, by what people or for what purpose these artificial hills were raised."[13] Their forefathers had found them in precisely their present condition when they occupied the country.

The presence of the mounds, therefore, seemed to indicate that America had had a true pre-Columbian history parallel to that of the Old World. Bartram suggests in his treatment of them that the ruins of empire theme is implied by their presence. Thus, he writes: "Not far distant from the terrace, or eminence, over-looking the low grounds of the river, many very magnificent

monuments of the power and industry of the ancient inhabitants of these lands are visible. I observed a stupendous conical pyramid, or artificial mount [sic] of earth, vast tetragon terraces, and a large sunken area, of a cubical form, encompassed with banks of earth; and certain traces of a large Indian town, the work of a powerful nation, whose period of grandeur perhaps long preceded the discovery of this continent."[14] Even more explicit is the moral that Thaddeus Mason Harris draws from the mounds he observed in his travels. "The labour of collecting such a prodigious quantity [of earth] must have been inconceivably great. And when we consider the multitude of workmen, the length of time, and the expense, requisite to form such a stupendous mound; when we reflect upon the spirit of ambition which suggested the idea of this monument, of great but simple magnificence, to the memory of some renowned prince or warrior, we cannot but regret that the name and the glory it was designed to perpetuate are gone—LOST IN THE DARKNESS OF THE GRAVE!"[15] Thus, by the time the nineteenth century opened—Harris was writing in 1803—the theme of the ruins of time had already been engrafted on the Indian materials.

Its best expression in literature is in Bryant's poem "The Prairies," written during his visit to Illinois in 1832, where he was deeply impressed by the "boundless wastes and awful solitudes."[16] But although Bryant begins his poem with the deliberate evocation of a spacious landscape, it is the progression of time that most occupies his attention. As he rides across the prairies, it seems to him that his horse's hoofbeats make "a sacrilegious sound," trampling perhaps upon the dust of vanished multitudes. "Are they here?" he asks,

> The dead of other days? And did the dust
> Of these fair solitudes once stir with life
> And burn with passion? [p. 131]

The answer is provided by "the mighty mounds / That overlook the rivers," for they tell of "a disciplined and populous race" who had

> Heaped, with long toil, the earth, while yet the Greek
> Was hewing the Pentelicus to forms

> Of symmetry, and rearing on its rock
> The glittering Parthenon. [p. 131]

By the allusion to classical antiquity, Bryant deliberately attempts to arouse suitable associations in the minds of his readers: the destruction of the Mound Builders' civilization is not different in kind nor in meaning from the decay of ancient empires, with which it may well have been contemporary.

The poet goes on to describe the peaceful industry by which he imagines this early race lived, farming the prairies and tending their herds, and he pictures the simple domestic pleasures, which, like other men, they must have enjoyed. But their culture was not to last, for they were conquered by tribes of Indians who completely destroyed them.

> The red man came—
> The roaming hunter tribes, warlike and fierce,
> And the mound-builders vanished from the earth.
> The solitude of centuries untold
> Has settled where they dwelt. The prairie-wolf
> Hunts in their meadows, and his fresh-dug den
> Yawns by my path. The gopher mines the ground
> Where stood their swarming cities. All is gone;
> All—save the piles of earth that hold their bones,
> The platforms where they worshipped unknown gods,
> The barriers which they builded from the soil
> To keep the foe at bay—till o'er the walls
> The wild beleaguerers broke, and, one by one,
> The strongholds of the plain were forced, and heaped
> With corpses. [p. 132]

All that remain are the mounds, age-old symbols of the mutability of men and nations.

Bryant, however, does not end on this note. He goes on to observe that other changes are now at work in the scene, inasmuch as the Indian, too, has left his hunting grounds, driven out by the white man, just as he had supplanted those who had been there before him. An "advancing multitude" of settlers soon shall come to occupy the lands that others had once held (p. 133). "Thus change the forms of being," Bryant writes,

> Thus arise
> Races of living things, glorious in strength,
> And perish, as the quickening breath of God
> Fills them, or is withdrawn. [p. 132]

The logic of the poem, therefore, clearly indicates that the relics of the American past contain a warning for modern men. If other American cultures have successively vanished, leaving only scattered relics by which they may be remembered, the nineteenth-century settlers who are moving into the land should take heed lest their society be similarly destroyed. If they do not learn the lesson of the past, they will simply court the destruction that has been visited upon those who have preceded them.

Yet valid though this theme may be, one must seriously question the means through which it is expressed. To be sure, in Bryant's poem the device of ancient mounds works reasonably well—certainly better than that which Cooper employed in *The Prairie* —but even at best the theme of an American ruins of time is weak. The point is not the historical accuracy of the material. Even if the mounds *had* been what Bryant believed them to be, they would not have been a suitable vehicle for an American version of the ruins theme. To compare the Indian mounds with the relics of Egypt, Greece, or Rome is more than a little absurd. The two are not comparable by any stretch of the imagination and cannot be made to serve similar functions. The attempt by American authors to find and use native antiquities is interesting and understandable, but one suspects they were not themselves wholly convinced of their value. The device appears but rarely in their works—albeit in important ones like Bryant's poem and Cooper's novel. More often, the writers turned to other, more appropriate means for expressing their view of a mutable world.

The ruins of man-made things were not, after all, the only objects in the landscape by which the concept of change could be expressed in art. Though crumbling walls and falling columns were ideally suited to the presentation of the theme of mutability, the natural world also provided ample means for its expression. The physical world is constantly undergoing a process of inexorable change as hills are worn away and trees grow old and die. Hence, the writers and painters had only to go to the natural scene to

find appropriate symbols for their theme. Change in the physical world was easily shown, for example, through the image of a natural ruin, a dead or blasted tree placed prominently in an otherwise verdant landscape. Such a symbol carefully placed in an appropriate context could suggest a number of related concepts. It could serve as a stark reminder of the transience of all things in nature, or perhaps more specifically of the common mortality that all living things share. It might even have a human connotation in reminding the viewer himself of the fate that awaits him in common with all humanity.

The blasted tree was a rather conventional symbol in American landscape art. Indeed, wherever one turns among the landscapes of the Hudson River school, a dead or dying forest giant is likely to be found. Its meaning, moreover, seems always to be the same, a meaning clearly suggested in Durand's *Evening of Life*, where the twisted remnant of an ancient tree is outlined against a darkening sky. The absence of such an element in the painting's companion piece, *The Morning of Life*, and the presence of ruined columns in the canvas in which it does appear clearly reveal the significance of the blasted tree as a sign of age and approaching death. In other paintings, too, similar objects suggest a related theme. The shattered, twisted stems that frame the right half of the canvas in Cole's *Landscape with Tree Trunks*, the stumps and fallen trees in the foreground of Durand's *Catskill Mountains near Shandaken*, the stark, upright trunk that dominates the landscape in Vanderlyn's *Niagara*—indeed, even the leafless branch stretching across the sky in Inman's *Picnic in the Catskills*—all stand in strong contrast to the life and beauty in the rest of the canvases and serve as stark reminders of the mutability of all things on earth.[17]

Although the device is by no means so common in the works of the writers, they too occasionally use a blasted tree for like effect. In Cooper's *Prairie*, for example, the ancient willow from which Ishmael Bush hangs his brother-in-law, Abiram White, both looks and functions like one of the blasted trees in the paintings. Though it had once been a massive tree towering above the peaked rock near which it stands, its beauty has long since faded with the ebbing of its life. "As if in mockery of the meagre show of verdure that the spot exhibited, it remained a noble and solemn monument of former fertility. The larger, ragged, and fantastic branches still

obtruded themselves abroad, while the white and hoary trunk stood naked and tempest-riven. Not a leaf nor a sign of vegetation was to be seen about it. In all things it proclaimed the frailty of existence, and the fulfillment of time" (pp. 424-25). A related use of the device appears, moreover, in the falling tree that almost kills Judge Temple and his party as they ride through the woods in *The Pioneers*. It too is "old and decayed,"—"one of the noblest ruins of the forest" (pp. 243-44)—and it falls across their path almost as if to remind them of their own mortality.

In Bryant's verse the device is occasionally used as a sign of the passage of time. Thus, in "Among the Trees," a "lofty group / Of ancient pear-trees," planted by some forgotten man, still burst into bloom each spring, though one of them "bears a scar / Where the quick lightning scored its trunk" (p. 324); while in "The Rivulet," a group of "tall old maples," though still verdant,

> tell, in the grandeur of decay,
> How swift the years have passed away,
> Since first, a child, and half afraid,
> I wandered in the forest shade. [p. 51]

In these two poems, the decayed and lightning-scarred trees are mentioned only in passing, serving, like their counterparts in the Hudson River paintings, as single details used to suggest the transience of life and the inevitability of death. In "The Dead Patriarch," however, Bryant made the decaying tree the basic image for the entire poem. Here, an ancient tree stands dead, stripped of its leaves by the passage of many years.

> From thy dead stem the boughs have dropped away;
> And on its summit, perched in middle sky,
> The clear-eyed hawk sits watching for its prey.
>
> Henceforth, the softening rain and rending blast,
> Summer's fierce heat, and winter's splintering cold,
> Shall slowly waste thee, till thou lie at last
> On the damp earth, a heap of yellow mould. [p. 397]

Though Bryant ends his poem with the promise of new life that shall rise eventually from the mould of the fallen giant, the tree itself functions in the poem much as do the ruined trunks in the painters' canvases and in Cooper's novels.

Irving, too, uses the device in a number of his sketches, though most usually in an English context. In *Bracebridge Hall*, Crayon describes "the ruin of an enormous oak" so "battered by time" and lightning that "it is now a mere trunk, with one twisted bough stretching up into the air, leaving a green branch at the end of it" (6: 91), and he comments upon the great windfalls he has seen in America, in which the strongest trees have been uprooted and splintered. He feels regret at the sight of "their magnificent remains, so rudely torn and mangled, and hurled down to perish prematurely on their native soil" (6: 93). In *Newstead Abbey*, on the other hand, Irving relates the device more specifically to the ruins theme when he describes the Parliament Oak in Sherwood Forest, a tree that six centuries have reduced "to a mere crumbling fragment." Nevertheless, "like a gigantic torso in ancient statuary, the grandeur of the mutilated trunk gave evidence of what it had been in the days of its glory" (9: 346). To Irving, this and the other aged forest giants of Sherwood "were noble and picturesque in their decay, and gave evidence, even in their ruins, of their ancient grandeur" (9: 348).

But if the obvious mutability of all things in nature provided both painters and writers with appropriate symbols for embodying their concepts of the meaning of change, so also did the apparent permanence of those aspects of the natural world that exist on a time scale far beyond the limited life of man. Indeed, even the forest trees could serve this function, for the long-lived forest giants need not be in decay to impress on the human observer his transience in the natural world. Thus, in "A Forest Hymn," Bryant suggests the great age and endurance of the trees by including in his verse "the century-living crow" who is born, grows old, and dies among their branches (p. 79). In a similar fashion, he writes, in "Among the Trees," of an ancient oak that was spared when the forest was cut perhaps two centuries before:

> An unremembered Past
> Broods, like a presence, mid the long gray boughs
> Of this old tree, which has outlived so long
> The flitting generations of mankind. [p. 324]

The same device appears in Cooper's *Home as Found*, where a single enormous pine provides a useful scale for the measure of

time and change. Though it is called the "Silent Pine," the characters consider the name inappropriate, for as Eve Effingham, the heroine of the book, asserts, the pine speaks eloquently "of the fierce storms that have whistled round its tops—of the seasons that have passed since it extricated that verdant cap from the throng of sisters that grew beneath it, and of all that has passed on the Otsego, when this limpid lake lay like a gem embedded in the forest. When the Conqueror first landed in England this tree stood on the spot where it now stands! Here, then, is at last an American antiquity" (p. 202). So deeply moved are the characters by the great age and size of the tree that they discuss its meaning at some length, emphasizing its significance as a sign of the passage of time. John Effingham, for example, repeats the image that Eve uses, transferring the historical allusion to the American past. He reports the reaction of one man who saw the tree in these terms: "that mass of green waved there in the fierce light when Columbus first ventured into the unknown sea" (p. 203).

The long-lived tree was not the only means by which this aspect of the theme of change could be expressed. Other elements in the natural scene could provide an even more extended time scale against which to measure the transience of man and his accomplishments. Thus, when Thomas Cole visited the catacombs in Italy in 1842, he described the various records of the past that he saw in them—the remains of the early Christians and the pictures and inscriptions they left on the walls. But instead of commenting specifically on the briefness of human life and the stretch of time that separates him from their age, he simply closes the account with a sharply contrasted view. "We came into the open air—into the light of the glorious sun, and again stood and gazed upon the mountains. There they are, as eighteen hundred years ago: they are not changed; as they looked then, they look now."[18] The juxtaposition of enduring mountains and crumbling memorials of the historic past carries the weight of the theme. In this context, it is a variation of the ruins theme, but instead of stressing the fading of human accomplishment, it affirms the stability of those values which men of the early nineteenth century saw in the external scene.

Cole was aware that the physical world did change. On his visit to Volterra some eleven years before, he had examined the deeply

eroded hills and had commented upon the geologic structure of the area that had caused such a desolate landscape. "I had often mused," he writes, "upon the brink of a rocky precipice, without a thought of its destructability; but here the great mass, bearing marks of rapid and continual decay, awakened the instantaneous thought that it was perishable as a cloud." Immediately thereafter he describes "the ruin of an old Etruscan wall" and the sound of a nearby convent bell. This gives him the opportunity to compare the two time scales that have yielded the results he sees before him. "Brief, thought I, are the limits of mortal life: man measures time by hours and minutes, but nature by the changes of the universe. Here, before me, is one of her hour-glasses, in which the sands have seen untold ages, and yet the mind cannot reckon their exhaustion."[19] The double time-scheme, then, provides a yardstick with which to measure change, nature itself providing the scale against which the life of man and his accomplishments are to be seen.

This concept adds a new dimension to the ruins theme, for it affords the writers and painters the opportunity to suggest alternative values by the way they compose their landscapes. Thus, in Cole's *Ruins of Aqueducts in the Campagna di Roma*, the dark and decaying Roman aqueduct that sweeps across the middle ground of the painting is paralleled by a distant range of mountains bathed in sunshine, while a goatherd tends his flock in the broad fields. The mountains and pastoral scene contrast sharply with the crumbling ruins to suggest not only the transience of human glory but also the enduring values symbolized in the beauty and peace of the surrounding landscape. Bryant, too, in some of his poems, suggests a similar theme. The desolation of the Roman walls in "A Day-Dream" is contrasted with the ever-renewing life of the poppy that grows upon them (p. 255), while the frailty of men, represented by the Etrurian tombs in "To the Apennines," is set against the apparent changelessness of the mountains (p. 159). In all these examples, the contrast between two time scales carries the weight of the theme. A lesson to human pride is certainly suggested when the briefness of man's mortal span is compared with the enduring and regenerative qualities symbolized in the natural scene.

Irving makes similar use of the device in *Bracebridge Hall*,

where he sets a description of ruins in much the same context. Commenting upon the effect that European ruins have on the American traveler unaccustomed to "the sight of enormous piles of architecture, gray with antiquity," Crayon observes:

> I cannot describe the mute but deep-felt enthusiasm with which I have contemplated a vast monastic ruin, like Tintern Abbey, buried in the bosom of a quiet valley, and shut up from the world, as though it had existed merely for itself; or a warrior pile, like Conway Castle, standing in stern loneliness on its rocky height, a mere hollow yet threatening phantom of departed power. They spread a grand, and melancholy, and, to me, an unusual charm over the landscape; I for the first time beheld signs of national old age, and empire's decay, and proofs of the transient and perishing glories of art, amidst the ever-springing and reviving fertility of nature. [6: 11]

The same kind of contrast appears, moreover, in *Tales of a Traveller*. Seen by the narrator from the mountain heights at sunrise, the ancient ruins scattered across the Italian landscape are dwarfed by "the immense Campagna, with its lines of tombs, and here and there a broken aqueduct stretching across it" (7: 322)—a view that recalls not only Cole's *Ruins of Aqueducts in the Campagna di Roma*, but also his *Mt. Etna from Taormina*.[20] In the latter painting, as in the tale, the contrast between the ruins and the glories of the surrounding landscape suggests a value in nature that transcends the decay of material things.

The most elaborate use of the device appears, however, in Cole's series of paintings *The Course of Empire*. These five canvases depict the evolution of a great civilization from its original barbaric state through its period of power and glory to its eventual conquest and ruin. Each canvas presents a different stage in the development, and the viewer is left to fill in the gaps and imagine the gradual change that has taken place in the landscape. Such a historical process would have to encompass a span of many centuries, a period of time that seems long in relation to the briefness of human life. In each panel, however, Cole includes a detail that suggests the presence of yet another time scale, one much longer than even that of historic time. At the entrance to the harbor that provides

the basic setting for each canvas, an oddly shaped rock is depicted, clearly defined against the sky. This object, the same in every picture, not only identifies the scene, but also, because of its unchanging form, suggests the permanence of nature in contrast to the transience of even man's mightiest empires. Only it remains, unaffected by the constant change and turmoil that have swirled around its base.

An identical device appears in Cooper's *Crater*, a book that resembles Cole's series of paintings in both theme and development. Like the artist, Cooper depicts the rise and fall of a whole society through the growth and decay of an imaginary country in the South Pacific, but he compresses the process into the space of a man's life. Mark Woolston, an American sailor shipwrecked on a barren crater, acquires an extensive territory when an earthquake raises the ocean floor above the surface of the water. Woolston develops the land, and eventually a civilized society occupies his islands. Cooper's society, however, unlike Cole's, is not sacked by an invader. Rather, after it becomes corrupted by internal elements, a second earthquake occurs and the islands sink once again into the sea. This event is known to the absent Woolston only because he finds a single peak remaining above the water when he returns to his domains. In Cooper's words, this peak resembles "that sublime rock, which is recognized as a part of the 'everlasting hills' in Coles' [*sic*] series of noble landscapes that is called 'The March of Empire.'" The peak now stands alone, "ever the same amid the changes of time, and civilization, and decay," the only object remaining from the many islands on which Woolston's colony had prospered (p. 479).

Use of the device, however, was not restricted to such grand themes as the fate of whole societies. It could also serve to measure the change that takes place in a single human life. Bryant, for example, employs the technique in this way in his poem "The Rivulet," where the unchanging natural scene serves as a personal yardstick for the poet. Thus, he recalls as a man his earlier visits to a pleasant stream, a spot which had attracted him first as a small child and where he had once gone to write his first rude verses. "Years change thee not," he observes, addressing the stream. Though the aging trees clearly reveal to him how swiftly the years have passed, the "ever-joyous rivulet"

> Dost dimple, leap, and prattle yet;
> And sporting with the sands that pave
> The windings of thy silver wave,
> And dancing to thy own wild chime,
> Thou laughest at the lapse of time. [p. 51]

The sounds are still as sweet as they were to the ears of his child-hood, the waters sparkle as clearly as they did before, and the birds and flowers complete the pleasant scene as they always have. Thus, Bryant deliberately suggests the image of an unchanged natural scene against which to measure the transience of his own life.

For he is, after all, no longer the boy he was, dreaming his beautiful dreams on its banks. Instead, he has become a sober and somewhat disillusioned man. Thus, he continues,

> Thou changest not—but I am changed
> Since first thy pleasant banks I ranged;
> And the grave stranger, come to see
> The play-place of his infancy,
> Has scarce a single trace of him
> Who sported once upon thy brim. [p. 52]

Bryant insists, however, that the fault is not nature's. Although the world has lost for him "the coloring of romance it wore," nature has kept her early promise. Her "radiant beauty" still "Shows freshly, to my sobered eye, / Each charm it wore in days gone by" (p. 52). In this context, then, unchanging nature provides a stable value that is to be seen and understood by changing men. Indeed, the poet observes that he may well return to its banks one day as an aged man to see but dimly the sparkle of the water and hear but faintly its merry call. The message, however, will not have changed. Even after he is dead, the rivulet will go on. Other children here will live out their lives and die, but the rivulet will continue in its endless infancy. "Singing down [its] narrow glen," it will "mock the fading race of men" (p. 53).

Precisely the same device appears in *Salmagundi*. In number 15 of that series, Anthony Evergreen, one of the personae that the Irvings and Paulding used in writing the papers, reports some reflections that Launcelot Langstaff makes on the subject of revisiting

scenes from which one has long been separated. Although they may help us recall our former pleasures, he writes, they are also apt to awaken us to the contrast between what we once were and what we have since become. "They act in a manner as milestones of existence." Thus, he goes on to say,

> I look round me, and my eye fondly recognizes the fields I once sported over, the river in which I once swam, and the orchard I intrepidly robbed in the halcyon days of boyhood. The fields are still green, the river still rolls unaltered and undiminished, and the orchard is still flourishing and fruitful —it is I only am changed. The thoughtless flow of mad-cap spirits that nothing could depress—the elasticity of nerve that enabled me to bound over the field, to stem the stream, and climb the tree—the "sunshine of the breast" that beamed an illusive charm over every object, and created a paradise around me—where are they?—The thievish lapse of years has stolen them away, and left in return nothing but grey hairs, and a repining spirit.[21]

There is more of the sentimental here than there is in Bryant, but the use of nature to serve as a yardstick of change is fundamentally no different.

A much more subtle use of the technique, however, appears in those works in which the parallel between man and nature is not so explicitly drawn, but where the mere presence of the appropriate elements in the landscape description carries the burden of the theme. A good example occurs in "Rip Van Winkle," where the Catskill mountains, reflecting the changing hues of weather and light, dominate the little village that lies at their feet. But although the mountains appear somewhat changeful and magical at the opening of the story, they provide an unchanging point of reference for the confused Rip when he awakens from his long sleep and returns home. As he approaches his much altered native village, Rip does not know what to make of the change he sees in it. He is not completely disoriented, however, for he notes the unchanging appearance of the surrounding landscape. "There stood the Kaats-kill mountains—there ran the silver Hudson at a distance—there was every hill and dale precisely as it had always been" (2: 55). By including the unchanged aspects of the natural scene, Irving

provides a yardstick for measuring the change that has taken place in both Rip and his village.

Cooper, too, uses his natural description in a similar way at the close of *The Deerslayer*. In the concluding pages of that novel, Hawkeye and Chingachgook return to the Glimmerglass fifteen years after the events detailed in the main part of the book. Much has changed in their lives. Hist has died, and the son, Uncas, that she bore her husband now accompanies the two warriors. But despite the changes that occur in human lives, the broader aspects of nature remain the same. Thus, Cooper writes, "They reached the lake just as the sun was setting. Here all was unchanged; the river still rushed through its bower of trees; the little rock was wasting away by the slow action of the waves in the course of centuries; the mountains stood in their native dress, dark, rich, and mysterious; while the sheet glistened in its solitude, a beautiful gem of the forest" (p. 571). The castle, however, has decayed, and the ark has run ashore and filled with water. Only a ribbon remains to remind them of the beautiful Judith. The bones of some of those who died in the battle have been disinterred by wild beasts and scattered, and the graves of Hetty and her parents can no longer be located in the lake. Everything human has changed, Cooper seems to say. Only the surrounding forest and hills remain the same as they were.

Yet if Bryant, Irving, and Cooper were often quite skillful in suggesting the meaning of change through the arrangement of various details in a single landscape, they did not limit themselves to the use of this technique. The ruins of ancient empires or the blasted remains of a forest giant placed in an otherwise verdant landscape could serve, after all, only a rather limited purpose in the development of relatively narrow themes, and the writers could not afford to overdo the device. The same may be said of the contrast that is implied when the briefness of man's life or the emptiness of his achievement is simply set against the longer time scale and more permanent values embodied in the natural scene. This contrast could sometimes be developed with greater freedom and increased effectiveness if presented instead through a series of more fully drawn landscapes. The writers, therefore, sometimes expressed their vision of change through the more elaborate device of contrasted

views, sometimes embedded in the natural course of the narrative, but occasionally functioning as the major structural device of the piece.

This device has a close analogue in the practice of the painters, who occasionally went beyond the restrictions of a single canvas to paint landscapes in series. By this means, they too could develop more fully the theme of change that they wished to express in their works. Two paths were open to them. They could present their vision of a mutable world through an allegorical representation of the concept, or they could depict in more realistic fashion the changes that actually take place in the external scene. Both Durand and Cole made use of allegory. Durand's series, *The Morning of Life* and *The Evening of Life*, expresses the theme through paired views which contrast images suggestive of youth and freshness with those suggestive of age and decay; and Cole's *Voyage of Life* depicts through four canvases, each presenting a different stage from childhood to old age, the passing of life down an allegorical stream into the sea of eternity. These series find their counterpart among the writers in the poetry of William Cullen Bryant, whose poem "The Flood of Years" also uses allegorical means to express the mutability of all things in human existence.

More important, however, especially from the literary point of view, was the second option: contrasted views of the same scene. Cole made use of this device in two of his series. In *The Course of Empire*, he depicted the growth and destruction of a whole civilization by painting five views of the same setting in different points of time, each view presenting a different stage in the process. More limited in scope, and thus more closely related to the kind of thing the writers did in their prose and verse, is his series of two paintings *Departure* and *Return*. Seen together, the pictures tell a brief story of high expectations and utter defeat. The first, a morning landscape in early summer, shows a group of knights leaving a castle, led by their lord, who "reins in his charger, and turns a look of pride and exultation at the castle of his fathers and his gallant retinue." The contrasting view is evening in early autumn. The expectations of victory have been destroyed, for now "a mournful procession" approaches the castle.[22] The few retainers that have been spared bear home on their shoulders the body of their dead or dying lord.

In painting such views, Cole faced a rather serious technical problem. If he did not vary the scene, he ran the risk of monotony in his series, each canvas resembling too closely the one that went before. If he changed the view too drastically, the observer might not recognize the scene as the same. Cole solved this problem in his landscape series through his use of both point of view and detail. By shifting the point of view from one canvas to the next, he achieved a varied perspective. In *The Course of Empire*, he alters both the angle of vision and the distance from the harbor entrance. In *Departure* and *Return*, he views the two scenes from opposite points of the compass, thus giving himself almost complete freedom in the composition. To insure the identity of the various parts of the two series, moreover, he used the device of a single dominant detail in each canvas to mark the scenes as the same. The oddly shaped rock at the entrance to the harbor serves this purpose in *The Course of Empire*. In *Departure* and *Return*, the statue of the madonna in the foreground of the former and a short distance from the foreground in the latter provides the appropriate point of reference.[23]

The writers were confronted with no such difficulty. Since they were not required to "fill the canvas" in every landscape description, they could simply present a scene in detail only once and concentrate on changes alone in any subsequent depiction of the view. Yet even they occasionally used the device of identifying marks in the landscape. In *The Crater*, Cooper uses the same device as Cole does in *The Course of Empire*, the easily recognized peak that marks the spot where Woolston's islands have disappeared beneath the waters of the Pacific. In "An Indian at the Burial-Place of His Fathers," Bryant uses a similar technique. When the Indian arrives at the burial place of his tribe, he is able to recognize the spot as the right one by the significant objects that still remain in the landscape. The Indian speaks:

> It is the spot—I know it well—
> Of which our old traditions tell.
>
> For here the upland bank sends out
> A ridge toward the river-side;
> I know the shaggy hills about,
> The meadows smooth and wide,

> The plains, that, toward the southern sky,
> Fenced east and west by mountains lie. [p. 58]

In Bryant's poem, the identifying device is more than a single detail. Nonetheless, the technique is much the same as that used by Cooper and Cole, and it serves a similar purpose.

For once the scene is properly identified, the Indian goes on to present a series of contrasts. To the white man's eyes, the present scene is lovely, with its green lawns stretching between the sheer hills. To the Indian, on the other hand, it would be more beautiful were it still covered with its ancient forests. Domestic animals now graze the hills and meadows, and laborers till the fields. The Indian, however, would prefer to see the landscape as his traditions recall it, with deer bounding through the woods and Indian warriors pursuing the game. He would like to have seen the burial mounds remain sacred as the resting place of the dead. Instead, the green wheat grows tall over the graves of the warriors, and the white man's plow turns up their bones in the furrows. Although neither landscape is drawn in complete detail, the poem presents in effect a pair of contrasted views. To be sure, the contrast takes place only in the mind of the narrator, and the earlier landscape exists solely in his traditions. Still, the technique that Bryant uses here is basically the same as that in Cole's series of landscapes. Two points of time are juxtaposed to show the change that has taken place in the interim.

The meaning of that change varied from artist to artist. Whereas Cole employed the technique in *Departure* and *Return* to comment upon the folly of human expectation and pride, Bryant used the device to warn his greedy countrymen that their despoliation of the natural landscape might turn their fertile country into a barren desert. Irving, on his part, resembles both Cole and Bryant in the themes he develops through his use of the device. In *The Conquest of Granada*, for example, he depicts through his persona, Fray Antonio Agapida, the defeat of a Christian army in paired descriptions that are closely analogous to those in Cole's paintings. The Christian knights depart from Antiquera in grand display, plumes waving, steeds prancing, and banners flying—"their various devices and armorial bearings ostentatiously displayed" (14: 86). Caught in the rocky defiles on their approach to Malaga, however,

the army is badly mauled at night by the defending Moors. When morning dawns, the contrast is striking:

> What a different appearance did the unfortunate cavaliers present, from that of the gallant band that marched so vauntingly out of Antiquera! Covered with dust, and blood, and wounds, and haggard with fatigue and horror, they looked like victims rather than like warriors. Many of their banners were lost, and not a trumpet was heard to rally up their sinking spirits. The men turned with imploring eyes to their commanders; while the hearts of the cavaliers were ready to burst with rage and grief, at the merciless havoc made among their faithful followers. [14: 91]

The close relation to Cole's paintings is obvious at once.

At other times, however, Irving's use of the device is more closely related to Bryant's, for he sometimes depicts the havoc wrought in the American landscape by the incursion of the white men. Thus, in his *Life and Voyages of Christopher Columbus*, he contrasts the southern coast of Cuba as it appeared in Columbus's day, "so populous and animated, rejoicing in the visit of the discoverers," with the desolate appearance it now presents (3: 411), and he draws extended pictures of the changes wrought in the Vega Real on Hispaniola by the depredations of the Spaniards. When the discoverer first views the plain, it is described in these terms:

> It was the same glorious prospect which had delighted Ojeda and his companions. Below lay a vast and delicious plain, painted and enameled, as it were, with all the rich variety of tropical vegetation. The magnificent forests presented that mingled beauty and majesty of vegetable forms known only to these generous climates. Palms of prodigious height, and spreading mahogany trees, towered from amid a wilderness of variegated foliage. Freshness and verdure were maintained by numerous streams, which meandered gleaming through the deep bosom of the woodland; while various villages and hamlets, peeping from among the trees, and the smoke of others rising out of the midst of the forests, gave signs of a numerous population. The luxuriant landscape extended as far as the eye could reach, until it appeared to melt away and mingle with

the horizon. The Spaniards gazed with rapture upon this soft voluptuous country, which seemed to realize their ideas of a terrestrial paradise; and Columbus, struck with its vast extent, gave it the name of the Vega Real, or Royal Plain. [3: 357]

The view is roughly parallel to the scene recalled in the traditions of Bryant's Indian.

Later descriptions of the Vega reveal the effect that the white men have on landscape and Indians. When, a year after his first sight of the plain, Columbus returns to the spot whence he had viewed it, he is moved by much different feelings from those he had experienced before. For "the vile passions of the white men had already converted this smiling, beautiful, and once peaceful and hospitable region, into a land of wrath and hostility," and he finds himself returning as a conqueror to people he had once thought of serving as "patron and benefactor" (4: 45). Some three years later the scene is even more changed. By this time the Vega has been thoroughly desolated.

That beautiful region, which the Spaniards but four years before had found so populous and happy, seeming to inclose in its luxuriant bosom all the sweets of nature, and to exclude all the cares and sorrows of the world, was now a scene of wretchedness and repining. Many of those Indian towns, where the Spaniards had been detained by genial hospitality, and almost worshiped as beneficent deities, were now silent and deserted. Some of their late inhabitants were lurking among rocks and caverns; some were reduced to slavery; many had perished with hunger, and many had fallen by the sword. [4:188]

The most extensive use of the device in Irving appears in "Rip Van Winkle," where much of the meaning of the tale is expressed through the contrasted images of Rip's village before and after his twenty-year sleep. The aura of peace and tranquillity cast over the village in the opening paragraphs of the story establishes the basic security of a stable, unchanging society. The village is "of great antiquity," the yellow brick houses with "latticed windows and gable fronts, surmounted with weather-cocks" revealing their age and Dutch origin. It is set, moreover, at the foot of peaceful moun-

tains, and the light smoke that curves up from its houses bespeaks its tranquillity (2: 41, 44). Within the village, the small Dutch inn, nestled beneath the shade of a large old tree, where the men gather on a long summer's day to tell "endless sleepy stories about nothing" and to discuss the events in whatever old newspapers fall into their hands (2: 47), serves as an appropriate symbol of the peaceful, unchanging society that the Dutch had established in the Hudson valley. It is a society in which the simple, good-natured man like Rip Van Winkle—a man averse to the profit motivation of American society—alone can flourish.

That neither the man nor the society could long endure in the progress-minded nineteenth-century American civilization is clearly revealed by the contrasted view of the village which greets Rip's eyes when he returns from his sleep in the Catskills. It is "larger and more populous" now, with "rows of houses which he had never seen before, and those which had been his familiar haunts had disappeared" (2: 54–55). The inn with its sheltering tree has been replaced by a Yankee hotel, "a large rickety wooden building . . . , with great gaping windows, some of them broken and mended with old hats and petticoats," and by "a tall naked pole, with something on top that looked like a red night-cap." Even the "character of the people seemed changed. There was a busy, bustling, disputatious tone about it, instead of the accustomed phlegm and drowsy tranquillity" (2: 55–56). The stable village of Rip's youth has been drowned in a flood of change, as new settlers, presumably from New England, have invaded and altered the whole society. Thus, the contrasted pictures of Rip Van Winkle's village serve an important purpose in the story not only in expressing the fundamental theme of mutability that appears in so many of Irving's works, but in criticizing as well the idea of progress that was making such sweeping changes in nineteenth-century American life.

In Cooper's novels, too, the device of contrasted views served important thematic functions. Occasionally it appears as a simple illustration of the disastrous effects wrought in the external scene by passionate men. In *The Last of the Mohicans*, Cooper describes the view from the peak overlooking Fort William Henry as it appears both before the surrender and during the subsequent massa-

cre by the Hurons. A similar contrast, also revealing the violence of human passions, appears in *The Heidenmauer*, where the Abbey of Limburg is described in a number of contrasting scenes. When first we see it, drenched by the light of the moon, the description stresses its fortresslike appearance, the group of buildings surrounded by a "strong and massive wall [that] encircled the entire brow of the isolated hill" (p. 10). Later descriptions, however, emphasize the beauty and richness of the abbey: the magnificence of its chapel, the beauty of its frescoes, and the great wealth of its appointments. But the abbey is sacked by the forces of count and burgomaster, representing the aristocracy and the town, the economic rivals of the abbey, and when next we see it, it is in ruins. Though the outside wall remains, the roofs of the buildings within have fallen, and the towers and walls are blackened by fire. In this state, it presents, in Cooper's words, "one of those sad and melancholy proofs of the effects of violence which are still scattered over the face of the Old World like so many admonitory beacons of the scenes through which its people have reached their present state of comparative security; beacons that should be as useful in communicating lessons for the future as they are pregnant with pictures of the past" (p. 272).

In *Satanstoe*, on the other hand, Cooper uses the device to express a concept more closely related to that presented in Cole's *Departure* and *Return* and in Irving's *Conquest of Granada*, for Cooper includes in his book a series of three landscapes which express a similar theme of great expectations brought to complete defeat. On all three occasions, Corny Littlepage, the hero of the novel, is high on a peak above the English position at Fort William Henry, and describes the view that stretches below him, twice just before and once just after Abercrombie's unsuccessful assault on the French at Ticonderoga. In the first description, the time is evening, and the scene is viewed from the eastern side of the lake "just as the sun approached the summits of the western mountains" (p. 351). The scene itself is the usual expansive view, the lake extending both north and south from this point, and the whole scene is encompassed, far as the eye can reach, by receding ranges of mountains. On the southern end of the lake are the ruins of William Henry, and the "thousand white specks" that lie near it are the

tents of the English army (pp. 352–53). Cooper has set the stage for the sharp changes to be delineated in the subsequent views.

The following morning, Corny is again on the peak. The sun has just risen, touching "the mountain-tops with gold, while the lakes and the valleys, and hill-sides even, and the entire world beneath, still reposed in shadow." Corny gazes a moment at the strikingly lighted scene, which suggests to his view "the promises of day and the vestiges of night." Turning his eyes then toward the fort, he sees the beginning of the English advance.

> Abercrombie's army was actually in motion! Sixteen thousand men had embarked in boats, and were moving toward the northern end of the lake, with imposing force, and a most beautiful accuracy. The unruffled surface of the lake was dotted with the flotilla, boats in hundreds stretching across it in long, dark lines, moving on toward their point of destination with the method and concert of an army with its wings displayed. The last brigade of boats had just left the shore when I first saw this striking spectacle, and the whole picture lay spread before me at a single glance. America had never before witnessed such a sight; and it may be long before she will again witness such another. For several minutes I stood entranced; nor did I speak until the rays of the sun had penetrated the dusky light that lay on the inferior world, as low as the bases of the western mountains. [pp. 354–55]

The theme that Cooper is developing is immediately apparent both in the lighting of his landscape and the importance he places on the size, strength, and order of the flotilla, an emphasis which arouses in the mind of the reader every expectation for the success of the expedition.

The hopes of the army are blighted, however, in the ensuing battle, for Abercrombie's attack is repulsed and the English are forced to retreat, their forces sprawled over the lake in defeat. The morning after the battle, Corny Littlepage, who has fought with the English army, is again upon his eminence and describes the scene as it now appears.

> If the night had been so memorable, the picture presented at the dawn of day was not less so! We reached that lofty

look-out about the same time in the morning as the Indian had awakened me on the previous occasion, and had the same natural outlines to the view. In one sense also, the artificial accessories were the same, though exhibited under a very different aspect. I presume the truth will not be much, if any exceeded, when I say that a thousand boats were in sight, on this as on a former occasion. A few, a dozen or so at most, appeared to have reached the head of the lake; but all the rest of that vast flotilla were scattered along the placid surface of the lovely sheet, forming a long, straggling line of dark spots that extended to the beach under Fort William Henry in one direction, and as far as eye could reach in the other. [pp. 378–79]

In contrast to the ordered array of the preceding description—the striking force moving in even lines with method and purpose—the ships are now seen straggling back, the lines broken, the order and purpose gone. Indeed, Cooper appends his own moral in the contrast that Corny draws between the two scenes.

How different did that melancholy, broken procession of boats appear, from the gallant array, the martial bands, the cheerful troops, and the multitude of ardent young men who had pressed forward in brigades less than a week before, filled with hope, and exulting in their strength! As I gazed on the picture, I could not but fancy to myself the vast amount of physical pain, the keen mental suffering, and the deep mortification that might have been found, amid that horde of returning adventurers. We had just come up from the level of this scene of human agony, and our imaginations could portray details that were beyond the reach of the senses, at the elevation on which we stood. [p. 379]

Like Irving and Cole, Cooper employs the device to suggest the mutability of earthly glory and the vanity of human desires.

More important, however, in Cooper's art was his use of the device in developing the theme of an entire novel. It appears, at times, in the form of a final scene or episode that stands in strong contrast to all that has gone before in the book and thus underlines the meaning of the whole. The return of Hawkeye and Chingachgook to the Glimmerglass after the lapse of fifteen years at the end of

The Deerslayer serves something of this purpose, for it shows the empty results of all the struggle and passion detailed throughout the novel. The castle is crumbling, the ark is sunk, and almost all trace of the Hutters has vanished. In a similar fashion, the last two chapters of *The Crater*, in which unexpected immigrants invade and destroy the stable society established by Mark Woolston in his South Pacific islands, contrast sharply with the major part of the book and help to reveal the theme of the decay of value in modern society that Cooper expresses through his novel. On one occasion, however—in *The Wept of Wish-ton-Wish*—Cooper made the device the major structural one in the book, detailing in the two halves of his novel the change that takes place as a frontier society develops.

The Wept of Wish-ton-Wish is divided almost precisely in half by the destruction of Mark Heathcote's settlement in the Connecticut valley during an Indian attack in the spring of 1663. The first sixteen chapters describe the founding of the Connecticut colony by a group of Massachusetts Puritans and its development over many years. They concentrate, however, on the period between the fall of 1662, when Conanchet, a young Narragansett chief found lurking outside the walls, is imprisoned in the stockade, and the following spring, when the settlers, their homes destroyed by the Indian assault, resolve to rebuild them. The last sixteen chapters, on the other hand, depict a second attack by Narragansetts and Wampanoags during King Philip's War of 1675–1676, after the colony has been rebuilt and has flourished for some dozen years, and develop the changes that have taken place in the interim. The two halves of the book stand in strong contrast to each other. The physical appearance of the settlement has been greatly altered as the colony, reborn from its ashes, continues to grow and develop, and the attitudes of the inhabitants have been sharply changed with the appearance of new settlers whose views are somewhat different from those of the Heathcotes.

Within the first half of the book, moreover, other contrasts appear. The early descriptions of the colony stress its loveliness and peace. The physical location itself is a spot "of great natural beauty in the distribution of land, water, and wood," and Heathcote manages to develop it "into an abode that was not more de-

sirable for its retirement from the temptations of the world, than for its rural loveliness" (p. 8). As in all new settlements, a certain ugliness is introduced when the trees are cut and the fields cleared. The view, as we see it, then, when the main events of the first part begin, is marred by the girdled trees, "piles of logs, and black and charred stumps" that are the natural consequences of settling the land. Yet in one of the fields, "bright green grain [is] sprouting forth luxuriantly from the rich and virgin soil" (p. 14). Like the village of Templeton in *The Pioneers*, the valley of the Wish-ton-Wish illustrates in the details of the landscape the contrasting values of wilderness and civilization, with the obvious conclusion that the values of the latter will eventually supplant those of the former.

Most important in the landscape, however, are the buildings that Heathcote has constructed, the long rambling dwelling in which the colonists live and the various barns, stables, and sheds for their cattle and sheep. Dominating them all is a large block-house which stands "on a low, artificial mound, in the centre of the quadrangle" formed by their dwellings and offices. This cita-del of the colony, to which the settlers can retreat as a last resort during an attack, is "high, hexagonal in shape, and crowned with a roof that [comes] to a point, and from whose peak [rises] a towering flagstaff" (pp. 15–16). The stone foundation is built as high as a man is tall, and the sides are of great square logs, in which are cut two different rows of narrow loops. Surrounding the buildings, moreover, is "an unbroken line of high palisadoes, made of the bodies of young trees, firmly knitted together by braces and horizontal pieces of timber" and always kept in a perfect state of repair (p. 16). Neat and comfortable, this frontier fortress stands out in the landscape as a bastion of defense for the valley that lies deep in the untouched wilderness into which only partial inroads have been made.

Yet although the Heathcotes have carefully provided for the defense of their home, including the removal of stumps and brush from the vicinity of the buildings, the major tone suggested in the descriptions of the settlement is not military, but one of prosperity and peace. An orchard is already planted and growing in contrast to the wild native forest (p. 16), and although the fear of an In-dian incursion is never absent, Cooper pauses after one alarm to

note that the dawn returned "to the secluded valley, as it had so often done before, with its loveliness unimpaired by violence or tumult" (p. 81). Such peace is not to last, however, for in the spring of 1663, a band of Indians sets the outbuildings on fire and threatens to take the settlement by storm. Ruth Heathcote, the wife of Mark's son, Content, gazes "in fearful sadness" at the spectacle. "The long-sustained and sylvan security of her abode was violently destroyed, and in the place of a quiet which had approached as near as may be on earth to that holy peace for which her spirit strove, she and all she most loved were suddenly confronted to the most frightful exhibition of human horrors" (p. 165). Though the Heathcotes have always tried to deal fairly with the Indians and have done them no injury, the red men invade the settlement and burn the citadel above their heads.

The Heathcotes survive the attack by taking refuge in a deep well within the fortress, but Conanchet, their prisoner who has now been freed, does not realize that they have survived the burning. He therefore departs with Ruth's young daughter and a half-wit boy, Whittal Ring, who were caught outside the blockhouse. But although the settlers escape with their lives, their island of peace has been devastated.

> Instead of those simple and happy habitations which had crowned the little eminence, there remained only a mass of blackened and charred ruins. A few abused and half-destroyed articles of household furniture lay scattered on the sides of the hill, and here and there a dozen palisadoes, favored by some accidental cause, had partially escaped the flames. Eight or ten massive and dreary-looking stacks of chimneys rose out of the smoking piles. In the centre of the desolation was the stone basement of the block-house, on which still stood a few gloomy masses of the timber, resembling coal. The naked and unsupported shaft of the well reared its circular pillar from the centre, looking like a dark monument of the past. The wide ruin of the out-buildings blackened one side of the clearing, and, in different places, the fences, like radii diverging from the common centre of destruction, had led off the flames into the fields. [p. 191]

Thus, within the first half of the book, Cooper has used his contrasted descriptions to illustrate both the violence of passionate

men and the injustice that has been done the Heathcotes by Indians they have never harmed.

The second half of the novel begins with a description that contrasts in every way with all that has gone before. The buildings of the Heathcotes no longer occupy the focus of attention. Rather, a whole new settlement has been made in the valley, a settlement which already manifests a relatively advanced state of development and cultivation. The encircling forest wall has been pushed back, and ugly new clearings may be seen off in the distance. Some forty houses have been built, a mill has been constructed on a stream near the center of the valley, and a church stands "near one end of the hamlet" (pp. 207–8). An inn has been opened in the settlement, and for the general protection of the inhabitants, "a stockaded dwelling" occupies "a convenient spot near the hamlet," its defenses made stronger than usual by "flanking block-houses" (p. 210). Few signs of the original forest remain in the hamlet, for sufficient time has passed for the stumps and stubs to have been removed. Indeed, only one gigantic sycamore in the center of the wide street remains as it stood when the white men first arrived in the valley. The setting has changed remarkably in the intervening years.

Some half a mile away from the fort, a house of some pretensions marks the site of the earliest settlement. The Heathcotes have prospered: their buildings, "though simple," are "extensive." They reveal the owner to be a farmer in easy circumstances and are "remarkable in that settlement, by the comforts which time alone could accumulate, and some of which denoted an advanced condition for a frontier family" (pp. 210–11). Surrounding the buildings, the smooth surface of the fields and the complete absence of stumps indicate long occupancy of the land. The gardens are planted with fruit trees, and a luxuriant apple orchard is near by. But one detail remains from the past to identify the scene as the same described in the early chapters of the book: the ruined block-house stands on its eminence to the rear of the principal building and, in a sense, still dominates the scene. "A blackened tower of stone, which sustained the charred ruins of a superstructure of wood, though of no great height in itself, rose above the tallest of the trees [in the apple orchard], and stood a sufficient memorial

of some scene of violence in the brief history of the valley. There was also a small block-house near the habitation; but, by the air of neglect that reigned around, it was quite apparent the little work had been of a hurried construction, and of but temporary use" (p. 211). A change has come over the valley of the Wish-ton-Wish, but one which, uncharacteristically, seems to have been for the better.

That it *is* for the better, however, is by no means certain. To be sure, the material improvements are obvious, but the change in the people is quite another matter. The Heathcotes remain much the same as they have always been. Though Mark is now an old man of ninety, his inner nature—"the moral man"—is little changed (p. 227), and he and his son, Content, both maintain the essential honesty and sense of justice that have always character-ized them. They had bought their land twice, once from the white authorities and once from the Indians; they speak the truth, even when it is to their disadvantage; they are willing to show mercy and forgiveness to those who have harmed them—including the Indians who burned their settlement. The Heathcotes, however, are now only one of many families in the valley, and although they are respected by all, other settlers in the Wish-ton-Wish are neither so just nor so charitable. The intervening years have in-troduced into the settlement several new voices whose opinions are much different from those of the Heathcotes, and some of whose actions are such that the Heathcotes could never counte-nance. The results, moreover, stand in ironic contrast to those of the first half of the book.

Among the new voices to be heard in the colony is that of Dr. Ergot, a medical man who takes great pride in his learning. If the Heathcotes have sometimes shown themselves to be superstitious, Dr. Ergot sins in the opposite extreme by being overly prone to accept without question "the science, and wisdom, and philosophy of Europe," even when his own senses contradict those opinions. Thus, he accepts the view "that the stature of man hath degener-ated, and must degenerate in these regions, in obedience to estab-lished laws of nature," even when a tall and muscular native American stands before him (pp. 216–17). The appearance of Dr. Ergot, then, represents the advent of the scientific rationalist point

of view in the colony, in strong contrast to the religious faith of the original founders. That the doctor is presumptuous in his learning is clear enough from the mistakes he makes when trying to draw conclusions from the evidence of his senses, as witness his mistaken identification of the recaptured Whittal Ring as a Narragansett Indian. His errors, however, can always be rationalized away, and the simple inhabitants are duly impressed by his learning.

More serious, however, is the appearance of a new religious attitude in the person of the minister, the Reverend Meek Wolfe. Instead of the justice and charity displayed by the Heathcotes, Wolfe exhibits a spirit of fanaticism that leads the colony to perpetrate a gross injustice. Because the Heathcotes had treated Conanchet well—so well indeed that he comes to conclude that "there was much honesty in them" (p. 314)—the Indian stops the attack on the village and returns their lost daughter, who had become his wife, when he learns that they survived the fire and are still alive these twelve years later. At the instigation of Wolfe, however, who seems bent on unchristian revenge and will hear nothing of mercy, the colonists pursue the retreating Indians, aided by the treachery of an Indian deserter, and capture Conanchet. Though they do not kill him themselves, he is turned over to his deadly enemy, the Mohican Uncas, who executes him for them. Thus, the religion of the Heathcotes, who always sought justice and mercy, is perverted by the bigotry of the zealot, and the good that might have come from the honest treatment of the red men —a good clearly suggested by the return of the young Ruth and her half-breed child—is converted to evil.

The meaning that emerges from Cooper's use of contrast in *The Wept of Wish-ton-Wish* is thus a somber one. Though the closing chapter depicts a valley that has settled, in the ensuing century and a half, into peace and tranquillity, its pleasant physical state has been bought at the price of a great wrong. Through the series of physical contrasts, Cooper has developed the image of a peaceful and prosperous society, threatened, it is true, by the Indian incursions, but arising like the Phoenix from the ashes of its destruction to a new and better life. Through the change in the people, on the other hand, he clearly reveals the moral loss that accompanies the physical gain. Ironically, the Heathcotes' sense

of justice and honesty had been rewarded by their near destruction, whereas the arrogance and fanaticism of a Meek Wolfe leads eventually to prosperity and peace. The theme, moreover, has ramifications far beyond this Connecticut valley and may perhaps be applied to nineteenth-century America as well—an idea surely suggested by the inclusion of Dr. Ergot and the whole question of the rationalist point of view. In a sense, the valley of the Wish-ton-Wish may be seen as a microcosm in which the development of America is enacted in small—its original faith tarnished by the change and development that transforms it, despite its material prosperity, into something less than the original dream.

The theme of change that Cooper presents in *The Wept of Wish-ton-Wish* is thus related to that developed by Bryant in "An Indian at the Burial-Place of His Fathers" and by Irving in "Rip Van Winkle," in that all raise serious questions on the direction American life has taken. To be sure, Bryant's poem deals directly with a real problem in the contemporary world, whereas Irving's and Cooper's tales apply to that world only obliquely. Nonetheless, it is clear from these and many of their other writings that all three men were concerned with the question of change in nineteenth-century American life. Their concern, however, was not so much with the fact of change itself—which, in the normal course of events is obviously inevitable—nor solely with its contemporary aspects. Change is not only a central problem of human experience, but has its moral dimensions too, a fact which all three writers recognize in their treatments of the theme. They show the changes wrought in the world by passionate and violent men, and they try to suggest the spirit of humility proper to those whose lives are so brief and whose material achievements are so transient.

But although their themes are important ones, the devices they use to express them are not uniformly successful. To the twentieth-century taste, the use of the ruins of empire seems least effective. It was, at best, of limited value in expressing the meaning of change to an American audience that had no direct experience with actual ruins, and the attempt by Bryant and Cooper to create an American ruins of time must be judged a failure. Much more effective are the implied or actual contrasts that they include in their works: the use of the blasted tree or the durable aspects of physical na-

ture against which to measure the transience of human life. For Americans in the nineteenth century, physical nature was an ever-present reality and thus could serve effectively to suggest the appropriate themes. Best of all, however, at least in Irving and Cooper, is the device of contrasted landscapes. Placed in appropriate spots for thematic effect, these landscapes function well in the narrative mode of history or fiction. At times, indeed, they even serve as the structural basis for an entire piece and so express most effectively the problem of mutability and at least some aspects of its meaning.

2. Continuity

Although Bryant, Irving, and Cooper were acutely aware of the many and profound changes that they saw taking place around them, they did not accept the principle of mutability as the ultimate meaning of experience. Change, after all, was not random, but seemed to them to occur in one or the other of two ordered patterns, either of which could explain and reconcile the apparent flux of life. Change, for example, could obviously be seen as cyclical, as a process that always returns upon itself—a view that found ample justification in the regular cycles of change apparent in the natural world and in the cyclical theories of history to which many nineteenth-century thinkers subscribed. Change, however, could also be viewed as occurring in linear, rather than cyclical, time, that is, as moving toward some intelligible or even predictable end. The westward movement could thus be seen in terms of Manifest Destiny or some other variation of the providential view of history, and change in the physical or social order could be interpreted as progress toward some important goal.[1] What is significant in both of these concepts is not the different directions in which they move, but the basic agreement between them: that time has a meaningful direction and change is circumscribed by a principle of continuity and order.

Indeed, despite the contradiction that may seem to exist between them, both can appear in the works of a single artist. Thomas Cole provides a good example. His *Course of Empire* il-

lustrates quite well the cyclical theory of history, the five paintings in the series representing five stages in the growth and destruction of a great civilization that returns at last to a state roughly approximating its first rude beginnings. His *Voyage of Life*, on the other hand, suggests a concept of time that is better understood as linear. To be sure, the four paintings illustrate four stages in the life cycle of the human being, but this is not the main point of the series. The use of a stream as the central image of life suggests a linear flow to time, and the highlight in the distant sky in the last canvas symbolizes the goal—eternal life—toward which time is moving. Each of these concepts of time is perfectly appropriate to the theme of the series in which it appears, and the two are perhaps not so irreconcilable as they might at first seem to be. Viewed together, the series seem to imply that although in the mundane sphere, change occurs in a cyclical order, the thrust of time for the human soul is linear, moving toward an all-encompassing end.

Similar uses of time may be found in the works of Bryant, Irving, and Cooper. All three were deeply concerned with the problem of a mutable world, and, like their contemporaries, all sought meaning and order in the apparently endless process of change that they saw going on around them. This is not to say that all three agreed on the principles through which an ordering of change might best be understood. Bryant and Cooper were, as we might expect, more deeply philosophic in their approach to the problem of mutability than was the more socially oriented Irving, and they developed their themes more frequently than he in terms of a natural order. In this area, after all, individual differences in temperament and belief necessarily play an important role in forming the writer's opinion and shaping his mode of expression. All three, however, did agree on the seriousness of the problem and presented their materials in such a way as to suggest one or another of the two interpretations of time and change that were open to them. To a man, they affirmed that some principle of order transcends the apparent flux of life, that a principle of continuity gives meaning and direction to human experience.

The most pressing problem for Bryant was that of change in the physical world, and this aspect of the theme of mutability re-

ceives greatest emphasis in his works. The reason is simple. As a philosophic poet whose themes were derived from precise observation and description of the natural world, he had perforce to come to grips with the problem of a mutable earth, else the very basis for his themes would be unstable and untrustworthy. Understandably, then, he engages the problem of change most frequently at the physical level. It was, moreover, at this level that the simplest answer could be found. Even casual observation of the natural world reveals the cyclical nature of change. It is not surprising, then, to find the poet expressing his concept of order in terms of those natural processes which, though they are continually in motion, always describe an unvarying course and perpetually return to the point from which the change began. The cycle of the recurring seasons, the alternation of day and night, the phases of the moon, the rhythmic ebb and flow of the tides—all appear in his poems to express the essential concept of change within order.

Individual objects in nature also provided evidence for his view of an ordered world, for though all things change and die, continuity is assured in the survival of the type. In "The Dead Patriarch," for example, a poem which expresses well the concept of change in nature, Bryant ends with the affirmation of new life —"another sapling tree" (p. 397)—which may rise from the mould of the decaying forest giant and flourish as it had done. In "A Forest Hymn," he presents a similar idea through his depiction of succeeding generations of forest trees nourished by the remains of their forebears from which they grow.

> Lo! all grow old and die—but see again,
> How on the faltering footsteps of decay
> Youth presses—ever gay and beautiful youth
> In all its beautiful forms. These lofty trees
> Wave not less proudly that their ancestors
> Moulder beneath them. [p. 81]

Earth does not lose her charms. Despite the apparent changefulness of nature, the poet implies, there is a basic immutability in the order of the natural process, a triumph of life over death, of order over chaos.

The intimate relation that thus exists between change and or-

der finds explicit statement in a number of other poems, each dealing with some aspect of the mutable world, but expressing the theme in terms of a general principle everywhere operative in nature. Thus, in "The Evening Wind," Bryant describes a cooling breeze blown in from the sea to refresh the shore. In the natural course of events, however, it will return to the ocean whence it came, restored to its birthplace by "the circle of eternal change, / Which is the life of Nature" (p. 125). In a similar fashion, he uses the bubbling spring, in "The Fountain," as the symbol of a changing world that contains within itself the principle of unchanging order. Hence, the sage who gazes into its "self-replenished depth" can see "eternal order circumscribe / And bound the motions of eternal change" (p. 188). Implicit in both of these poems is the fact that life demands change and motion. Though order holds that change in check and turns it back upon itself, the cycle becomes, in effect, a part of the life. Change and order, then, are not contradictory principles, but two aspects of a single process that is best understood through the circle figures that the poet includes.

The belief in an ordered nature which Bryant expresses in these poems is no different from the view one might derive from simple observation of the natural scene, since it presupposes only natural causes for the events. Bryant was not content, however, to let the matter end there. Rather, he goes beyond the naturalistic description of the physical event to affirm his faith in the God who sustains the ordered cosmos and keeps the process within its appointed bounds. This was a crucial concern for Bryant, since his moral view of the world demanded an absolute order on which man could rely in learning proper conduct. Hence, in "A Forest Hymn," he affirms his belief in a beneficent Creator with these words:

> My heart is awed within me when I think
> Of the great miracle that still goes on,
> In silence, round me—the perpetual work
> Of thy creation, finished, yet renewed
> Forever. [pp. 80–81]

The passage is important for the image it presents of an active God who is still at work in nature renewing his creation, a concept that

affords the external world the unalterable base it must have if men are to rely upon it for moral truth.

"A Hymn of the Sea" provides further evidence for Bryant's view. In words that suggest the opening chapter of Genesis, he begins his poem with the image of a Deity still actively engaged in his creation. The God who made the world in the beginning still sustains it with his creative spirit and directs the natural processes to their normal ends. Thus, the poet writes:

> The sea is mighty, but a mightier sways
> His restless billows. Thou, whose hands have scooped
> His boundless gulfs and built his shore, thy breath,
> That moved in the beginning o'er his face,
> Moves o'er it evermore. The obedient waves
> To its strong motion roll, and rise and fall.
> Still from that realm of rain thy cloud goes up,
> As at the first, to water the great earth,
> And keep her valleys green. [p. 203]

Granted this view, change is not something to be deplored or feared, for in the last analysis it is only appearance. Behind the process lies the beneficent God, who orders the world as he will and who gives it its only permanence.

The reason for Bryant's emphasis on a divinely ordered world is explicitly presented at the end of "A Forest Hymn," where it provides an immutable basis for morality in men. This poem is a prayer, addressed to the God who reveals himself in nature and whom man may approach through the external scene. Man is weak, however, the prey of his passions, and although the poet may "reassure / [His] feeble virtue" in the forest (p. 81), many men do not. For these, God uses the forces of nature as instruments of his will, scares them with thunderbolt and tidal wave to still their pride and make them lay their strifes and follies aside. The poet, however, prays that he and those he loves may never

> need the wrath
> Of the mad unchained elements to teach
> Who rules them. Be it ours to meditate,
> In these calm shades, thy milder majesty,

> And to the beautiful order of thy works
> Learn to conform the order of our lives. [p. 82]

Here we find the ultimate reason for Bryant's affirmation of an ordered world. Without belief and trust in a divinely ordered nature, man would have no reliable natural means for approaching the Deity or for learning proper conduct. For the romantic poet, a major path to divine instruction would be closed.

Similar concepts appear in the works of both Irving and Cooper, though they seldom occupy so central a position as they do in Bryant's verse. As writers of history and fiction, Irving and Cooper could rely more heavily on narrative for the exposition of their themes, and neither had so explicit a philosophic purpose as did the poet. Their own religious views were different from those expressed in Bryant's verse, and in Cooper's novels in particular, the attitude toward God and nature that we find in Bryant is frequently placed in the mouths of some of the characters. Both Long Tom Coffin in *The Pilot* and Natty Bumppo in *The Deerslayer*, for example, see the hand of God as controlling the tempests and perceive his presence in the signs of nature. The hunter, Cooper writes, "loved the woods for their freshness, their sublime solitudes, their vastness, and the impress that they everywhere bore of the divine hand of their Creator," and he communed in spirit "with the infinite Source of all he saw, felt, and beheld" (p. 283). He specifically affirms, moreover, the cyclical concept of time when he tells Judith Hutter, late in the book, that " 'arth is an eternal round, the goodness of God bringing back the pleasant when we've had enough of the onpleasant" (p. 467).

Cooper has created in Coffin and Deerslayer a pair of fictional characters, and one must be careful in attributing to the author the views they express. Yet there is ample evidence to suggest that Cooper did indeed accept the basic view of nature that these men express. In his "Preface to the Leatherstocking Tales," where he speaks in his own voice, Cooper writes of his most famous character as if he were to be considered a kind of ideal, and there is no reason to believe that he has anything but approval for the hunter's attitude toward the natural scene and the God that he finds in it. Deerslayer is a man "who sees God in the forest; hears

Him in the winds; bows to Him in the firmament that o'ercanopies all; submits to his sway in a humble belief of his justice and mercy; in a word, a being who finds the impress of the Deity in all the works of nature, without any of the blots produced by the expedients, and passion, and mistakes of man" (p. vi). Though Cooper's own religious views went far beyond the simple faith presented here, they did not by any means contradict the belief in an ordered nature, sustained and controlled by God—a belief here affirmed in the character of Leatherstocking, but implicit also in the descriptive passages to be found in almost all of Cooper's novels.

This concept of an ordered world, moreover, is often seen as closely related to questions of human conduct. One need only recall the patterns of light and shadow that play across the Glimmerglass in *The Deerslayer* to recognize the recurring cycles of day and night, which, in their ordered progression, stand in such strong contrast to the disorder and violence caused by men in that book. Indeed, Cooper includes an explicit statement of his view in the opening paragraphs of the novel, just before the first characters are introduced. Whatever changes man may produce in the external scene, he writes, "the eternal round of the seasons is unbroken. Summer and winter, seed-time and harvest, return in their stated order with a sublime precision, affording to man one of the noblest of all the occasions he enjoys of proving the high powers of his far-reaching mind, in compassing the laws that control their exact uniformity, and in calculating their never-ending revolutions" (p. 3). The order of nature is clearly affirmed as a basic element in life, but men too often fail to perceive the lessons afforded them by the natural scene. Rather, they surrender to their passions, with the disastrous results detailed in the action of the novel.

In Washington Irving's works, such concepts appear only in scattered places and never play so important a role as they do in Bryant and Cooper. Yet even he occasionally includes a passage that suggests a cyclical ordering of time and change. In "The Catskill Mountains," for example, the chapter he contributed to *The Home Book of the Picturesque*, he not only celebrates the beauties of the American climate by taking the reader through the seasons—from winter to autumn—of a single year, but, like Bryant

and Cooper, even suggests a religious dimension to the ordered movement of time by concluding the passage with the words of the Psalmist: "surely we may say that in our climate 'the heavens declare the glory of God, and the firmament showeth forth his handy work.' "[2] In *The Sketch Book*, too, Crayon affirms the continuity of things in nature, despite the destruction of the individual, for he writes of "the great law of nature, which declares that all sublunary shapes of matter shall be limited in their duration, but which decrees, also, that their elements shall never perish. Generation after generation, both in animal and vegetable life, passes away, but the vital principle is transmitted to posterity, and the species continue to flourish" (2: 99).

Indeed, Irving includes a passage in "Wolfert Webber" that reminds one strongly of the sort of thing that Cooper does in *The Deerslayer*. As in Cooper's novel, the ordered cycle of nature serves as a point of contrast to the disorder caused by man. Webber destroys the soil of his garden by digging at night for gold that he has dreamed lies buried there. The more he digs, however, the poorer he grows, for the sand and gravel beneath are thrown to the surface, and the garden eventually becomes a barren waste.

> In the meantime the seasons gradually rolled on. The little frogs that had piped in the meadows in early spring, croaked as bull-frogs during the summer heats, and then sank into silence. The peach-tree budded, blossomed, and bore its fruit. The swallows and martins came, twittered about the roof, built their nests, reared their young, held their congress along the eaves, and then winged their flight in search of another spring. The caterpillar spun its winding-sheet, dangled in it from the great button-wood tree before the house; turned into a moth, fluttered with the last sunshine of summer, and disappeared; and finally the leaves of the button-wood tree turned yellow, then brown, then rustled one by one to the ground, and whirling about in little eddies of wind and dust, whispered that winter was at hand. [7: 408]

In contrast to the mad destruction that Wolfert Webber works in his garden—destruction that cannot be easily repaired—nature moves calmly through her cycle of ordered change, a cycle that will be repeated with every passing year.

Belief in an ordered world, moreover, afforded Bryant and Cooper the means for resolving the problem of geologic change, which plays an important role in some of their works. God, after all, is eternal, and the same Power who renews his creation in the recurring generations of forest trees guides and controls the geologic processes that have transformed the earth. Bryant is quite explicit on this point. In "A Hymn of the Sea," he follows a description of geologic change—the oceans eroding the shore and the land sinking beneath the waves—with a description of the creative processes that result from the active agency of God:

> Thou, meanwhile, afar
> In the green chambers of the middle sea,
> Where broadest spread the waters and the line
> Sinks deepest, while no eye beholds thy work,
> Creator! thou dost teach the coral-worm
> To lay his mighty reefs. . . .
>
> Thou bidd'st the fires
> That smoulder under ocean, heave on high
> The new-made mountains, and uplift their peaks,
> A place of refuge for the storm-driven bird.
> The birds and wafting billows plant the rifts
> With herb and tree; sweet fountains gush; sweet airs
> Ripple the living lakes that, fringed with flowers,
> Are gathered in the hollows. [p. 204]

Bryant relates the process to the original creation by including a biblical echo: "Thou dost look / On thy creation and pronounce it good" (p. 204). All change in the physical world has been ordered by the creative power of God.

Precisely the same idea is expressed in Cooper's *Crater*, when Mark Woolston survives an earthquake on his Pacific island and finds that the floor of the ocean has been raised to provide him with a whole new group of islands on which to live. Although Cooper sometimes uses the language of science to describe what has occurred—he speaks, for example, of internal fires and gases working beneath the surface—he also puts the event into a fundamentally religious context. Thus, as Mark surveys his new domain the following morning, he has confidence that the broad extent

of the change will guarantee its permanence, and he hopes "that what had thus been produced by the Providence of God would be permitted to remain, to answer His own benevolent purposes" (p. 165). Like Bryant, too, Cooper suggests the opening chapters of Genesis in his reference to the land as a "new creation" (p. 165), a new Eden, with Mark and his wife, Bridget, who eventually joins him in his island paradise, as a new Adam and Eve (p. 213). For Cooper, as for Bryant, then, the geologic changes occurring today in the transformation of the earth are ordered and directed by the will of God, who has controlled them from the beginning of time.

Such a conclusion is reinforced at the end of the book when a second convulsion occurs to destroy the islands and all who are living on them. No one survives to report the catastrophe, but Mark deduces what has occurred when, returning from a trip to America, he finds the single peak remaining above the water. Cooper himself makes the appropriate comment in the closing paragraphs of the novel. In a kind of summary comment on the events of the book, he writes: "For a time our efforts seem to create, and to adorn, and to perfect, until we forget our origin and destination, substituting self for that divine Hand which alone can unite the elements of worlds as they float in gases, equally from His mysterious laboratory, and scatter them again into thin air when the works of His hand cease to find favor in His view" (p. 481). In a final image, moreover, which expands the idea to cosmic proportions, Cooper pictures the entire earth as "a globe that floats, a point, in space, following a course pointed out by an invisible finger, and which will one day be suddenly struck out of its orbit, as it was originally put there, by the Hand that made it" (p. 482).

Yet if Bryant and Cooper fundamentally agree that all geologic change is ordered by the creative power of God, they see the movement of that process in somewhat different terms. Bryant's view in "A Hymn of the Sea" seems to entail a cyclical theory of time, for as one part of the earth is eaten away by the waves, other parts rise from the sea, presumably to take its place, and the process appears to go on in a never-ending cycle. Cooper's use of geology in *The Crater*, however, while also developed in cyclical terms in the rise and fall of Mark's dominion, seems to imply as

well a providential direction of events. Thus, like Cole's *Voyage of Life*, *The Crater* envisions time as both cyclical and linear, a view which Cooper himself explicitly states at the close of the next-to-last chapter in the book.

> Everything human is abused; and it would seem that the only period of tolerable condition is the transition state, when the new force is gathering to a head, and before the storm has time to break. In the meantime, the earth revolves, men are born, live their time, and die; communities are formed and are dissolved, dynasties appear and disappear; good contends with evil, and evil still has its day; the whole, however, advancing slowly but unerringly towards that great consummation, which was designed from the beginning, and which is as certain to arrive in the end, as that the sun sets at night and rises in the morning. The supreme folly of the hour is to imagine that perfection will come before its stated time.
>
> [p. 466]

Though change goes on within the world through a series of recurring cycles, the whole direction of cosmic time is linear. It moves from a point "in the beginning" to a divinely appointed end.

The concept of an ordered nature expressed in the works of the writers formed the philosophic basis for a similar concept of order in human society, where change was even more apparent than in the natural processes of the external world. In both the broad sweep of history and the more narrow range of contemporary society, time brought incessant change that the writers had of necessity to deal with if they were not to surrender completely to the vision of a disordered social world. It is not surprising, then, to find in all three men a deep concern with the problem of historical change, for this concept was an obvious corollary to their view of a mutable nature. All three, in one way or another, turned their attention to the writing of history. Irving and Cooper composed respectable historical studies, and Bryant provided at least the introduction to a multivolume work on the American past. In addition, all three turned at times to historical subjects in their imaginative writing in an attempt to come to grips with the problem of change in human history. To a man, moreover, they resolved the

question of social change in terms of both cyclical and linear time.

The cyclical theory of history found frequent expression in their prose and verse. In Bryant's "The Prairies," the poet wrote an imaginative account of the American past, stressing the successive cultures of Mound Builders and Indians, which, he conceived, had risen, flourished, and faded in the American West, to be succeeded at last by the civilization of the white man. In "The Ages," moreover, the Phi Beta Kappa poem he delivered at Harvard in 1821, he details the whole sweep of Western history. Beginning with the ancient civilizations that have left only their scattered relics strewn across the desert, he presents the rise and fall of both Greece and Rome and carries subsequent history down to the contemporary age. Implicit in the whole development is the concept of the cyclical theory of history. Civilizations rise and flourish, only to decay and be eventually succeeded by others which recapitulate the same process. At one level, then, Bryant reconciles the problem of historical change in terms of an ever-recurring cycle, a view that would seem to imply that history is simply the endless repetition of an inevitable social process.

Such a conclusion is justified in part by the analogy to nature that Bryant draws early in the poem. He begins "The Ages" with a serious question of the meaning of change in human life. When the good man dies, he writes, does goodness die with him? Will succeeding ages see a falling off in virtue? This view would seem to imply that a principle of deterioration operates in the historical process. Bryant does not accept this conclusion. Rather, drawing an analogy to the natural scene, he observes that nature, for all the change that it must undergo, does not seem to fade. Thus, he writes,

Look on this beautiful world, and read the truth
In her fair page; see, every season brings
New change, to her, of everlasting youth;
Still the green soil, with joyous living things,
Swarms, the wide air is full of joyous wings,
And myriads, still, are happy in the sleep
Of ocean's azure gulfs, and where he flings
The restless surge. Eternal Love doth keep,
In his complacent arms, the earth, the air, the deep. [p. 12]

If change in nature is ordered and controlled by the power of a beneficent God, so also, the logic of the analogy would have it, will change in the social world be contained by his will.

Bryant, however, does not end here. To do so would imply that history has no meaning but the recurring cycle itself, that time goes on in an ordered pattern without cumulative loss or gain. To Bryant's mind, the study of history should not lead one to this conclusion, for, he argues, many "cheerful omens" suggest that better days are coming.

> He who has tamed the elements, shall not live
> The slave of his own passions; he whose eye
> Unwinds the eternal dances of the sky,
> And in the abyss of brightness dares to span
> The sun's broad circle, rising yet more high,
> In God's magnificent works his will shall scan—
> And love and peace shall make their paradise with man. [p. 13]

Human reason, instilled in man by his Creator, will lead the race toward a Golden Age in the future. "Sit at the feet of History," Bryant goes on to say, and you will perceive the truth of this interpretation. You will learn of the gradual progress that has been made as successive cultures rise above the ones that went before. The light of reason leads men forward to truth, which, surviving the onslaughts of error, cannot be destroyed on earth. It remains undaunted after error has been put to flight.

The culmination of this process is, as one might expect, the United States of America. Here the white man supplants the Indian, the woods recede as "towns shoot up," and the earth is turned into farms. The march of civilization is now toward the western ocean, a process that Bryant sees, in this poem at least, as leading to good.

> Here the free spirit of mankind, at length,
> Throws its last fetters off; and who shall place
> A limit to the giant's unchained strength,
> Or curb his swiftness in the forward race?
> On, like the comet's way through infinite space,
> Stretches the long untravelled path of light,

Into the depths of ages; we may trace,
Afar, the brightening glory of its flight,
Till the receding rays are lost to human sight. [p. 20]

In Bryant's view, therefore, historical time must be seen as both cyclical and linear. Though the history of the past clearly indicates that all civilizations must perish—a view that sometimes gives pause to his own optimism about America's future[3]—nonetheless the broad movement of time is linear. Beginning at the dawn of history, time moves forward toward an ultimate goal of unlimited freedom and progress for all men.

Both of these views of history find occasional expression in the writings of Washington Irving, but they are never so fully and consistently developed as they are in Bryant's verse. Irving is more likely to drop an occasional sentence or paragraph expressing one or the other of these two concepts of time into the normal course of his narrative and then pass on without drawing the philosophical implications that are to be found in "The Ages." In *A History of New York*, for example, there is a brief—and rather conventional—statement of the ruins theme. Knickerbocker writes rather humorously of the strong emotions one should feel when contemplating the ruins of past empires, "the bosom of the melancholy inquirer [swelling] with sympathy" as he views the "kingdoms, principalities, and powers [that] have each had their rise, their progress, and their downfall—each in its turn has swayed a potent sceptre—each has returned to its primeval nothingness" (1: 449). Though Irving includes the passage to serve a satiric purpose—he immediately reduces the concept to travesty by juxtaposing the fall of Dutch New York—it does illustrate quite well his occasional use of the cyclical view of time.

A similar passage, however, that appears in *The Alhambra* is intended to serve a much more serious purpose. The rise and fall of Moorish Spain was a subject ready made for illustrating the cyclical theory of history, and Irving develops the idea early in the book. After describing in some detail the fine civilization that flourished for centuries in Moorish Spain, he records its defeat at the hands of the Christian Spaniards and ends with the following comment:

Never was the annihilation of a people more complete than that of the Morisco-Spaniards. Where are they? Ask the shores of Barbary and its desert places. The exiled remnant of their once powerful empire disappeared among the barbarians of Africa, and ceased to be a nation. They have not even left a distinct name behind them, though for nearly eight centuries they were a distinct people. The home of their adoption, and of their occupation for ages, refuses to acknowledge them, except as invaders and usurpers. A few broken monuments are all that remain to bear witness to their power and dominion, as solitary rocks, left far in the interior, bear testimony to the extent of some vast inundation. Such is the Alhambra. A Moslem pile in the midst of a Christian land; an Oriental palace amidst the Gothic edifices of the West; an elegant memento of a brave, intelligent, and graceful people, who conquered, ruled, flourished, and passed away. [15: 80]

Nowhere in Irving's work is there a better or more appropriate expression of the concept.

Irving occasionally treats more recent history in similar terms. Crayon pauses once in *The Sketch Book* to comment briefly on American-British friendship. Though American good will, he observes, may mean little to Britain now, the day may come when she will welcome it—"should those reverses overtake her, from which the proudest empires have not been exempt" (2: 71). This concept of a fading Britain is developed in somewhat different terms in the opening pages of *Bracebridge Hall*. Crayon has seen in Great Britain, he tells us, for the first time in his life, the "signs of national old age, and empire's decay," and he places this image in strong contrast to his memory of a youthful America, "where history was, in a manner, anticipation; where every thing in art was new and progressive, and pointed to the future rather than to the past; where, in short, the works of man gave no ideas but those of young existence, and prospective improvement" (6: 11). Clearly implied in these passages is the belief that England and the United States stand at a point in time when the cycle of change is leading Great Britain down to the common fate of all nations, while the United States is just about to embark on the early stages of the process.

In other treatments of the American scene, however, Irving suggests a view of time that might best be conceived as linear. He writes of the bees, in *A Tour of the Prairies*, as "heralds of civilization, steadfastly preceding it as it advanced from the Atlantic borders" (9: 50),[4] and he sees the early searchers for natural wealth, in *Astoria*, as "the pioneers and precursors of civilization." Plunging deep into the wilderness, they lay open the secrets of the country, "leading the way to remote regions of beauty and fertility that might have remained unexplored for ages, and beckoning after them the slow and pausing steps of agriculture and civilization" (8: 13). Such statements seem to reflect the nineteenth-century American view of Manifest Destiny, which would see the western expansion as, in a manner of speaking, ordained by God—a view which is probably reflected in the closing paragraphs of *Astoria*. "As one wave of emigration after another rolls into the vast regions of the west, and our settlements stretch towards the Rocky Mountains, the eager eyes of our pioneers will pry beyond, and they will become impatient of any barrier or impediment in the way of what they consider a grand outlet of our empire" (8: 500). Though opinions like these, strongly suggestive as they are of economic motivation, are a far cry from Bryant's vision of American destiny, they too imply, no less than the poet's views, a concept of time that is moving in the direction of a significant goal.

Much the same views of time and change appear in the novels of Fenimore Cooper, where they receive a treatment similar to that of both Bryant and Irving. In his "Introduction" to *The Heidenmauer*, for example, Cooper, like Bryant, presents the broad movement of history over an extended period. He begins with the time of the pagan domination of Germany, carries the process of historic change through the Roman occupation and subsequent barbarian assaults, and ends with the period of the Protestant Reformation, where his story begins (pp. xix–xx). Like Irving, too, he sometimes sees the history of European societies in specifically cyclical terms, describing the rise and fall of Venetian power in *The Bravo* in terms of organic growth and decay. "Communities," he writes, "like individuals, draw near their dissolution, inattentive to the symptoms of decay, until they are overtaken with that fate which finally overwhelms empires and their

power in the common lot of man" (p. 101). Indeed, he draws a specific analogy between the life of societies and the life of the individual human being. That both have lasted a long time, he writes, does not argue for their continued endurance, but rather for the likelihood that they will soon perish (pp. 288–89).

Like Irving, too, he sometimes compares the relative youth and age of American and European societies. At the beginning of *The Water-Witch*, for example, he observes that just as nature seems to have "given its periods to the stages of animal life, it has also set limits to all moral and political ascendency." Thus, while Florence, Venice, and Rome slip into the decay of age, "the youthful vigor of America is fast covering the wilds of the West with the happiest fruits of human industry" (p. 2). A similar idea appears in *Homeward Bound*, where a number of the characters discuss the question of the relative youth and age of Europe and the United States. Drawing their analogy from the seasons of the year, they see the current state of Italy as approximating that of summer—or perhaps even autumn—while that of the United States is equivalent to spring (pp. 286–87). Though all the characters do not agree completely with this interpretation—one sees America, for example, as old in its youth—the figure is an apt one for suggesting a cyclical view of time, in which youthful America is just embarking on a process which, by the logic of the analogy, should lead it at last to the same condition as the older societies of Europe.

That Cooper, like Bryant and Irving, did not consistently follow this logic to its conclusion is obvious from other of his novels. A nineteenth-century American, Cooper clung to the belief that his country would escape the fate of past civilizations. Thus, in a number of his works, he pictures time in America as moving in a linear pattern and American society as developing toward a divinely ordained end. *The Pioneers*, for example, despite the ambivalent attitude the book maintains toward the settlement of the wilderness, ends with as pointed a suggestion of Manifest Destiny as does Irving's *Astoria*, for when Leatherstocking disappears into the forest at the conclusion of the book, he is pictured as "the foremost in that band of pioneers who are opening the way for the march of the nation across the continent" (p. 477). To be

sure, the society of Templeton may seem to the modern reader to contain within itself the seeds of its own destruction, and the defeat of Leatherstocking, whose moral code is sounder than that of many of the settlers from whom he flees, would seem to give added weight to this view. Nonetheless, the conclusion of the book is unmistakable in its optimism concerning the future of American society.

The fundamental basis for Cooper's optimism is his providential vision of history. In *The Heidenmauer*, for example, just after describing the broad sweep of the past noted above, he turns his thoughts to the New World and wonders at "the long and mysterious concealment" that kept "so vast a portion of the earth as America, from the acquaintance of civilized man." He thinks of the progress in "religious and civil liberty" that has occurred since its discovery, ponders the effect its governing principles shall have on the Old World, and concludes with the thought of "all the immense results that were dependent on this inscrutable and grand movement of Providence" (p. xxi). A similar interpretation of American history appears as well in *Wyandotté*, where Cooper considers the movement toward Independence after the events of 1775 in similar terms. "It was, doubtless, one of the leading incidents of the great and mysterious scheme of Divine Providence for the government of the future destinies of man, that political separation should commence in this hemisphere at that particular juncture, to be carried out, ere the end of a century, to its final and natural conclusion" (p. 140). It was only to be expected, then, that Cooper should interpret the whole subsequent history of the United States in precisely this way.

The second preface (1851) that Cooper wrote for *The Path-finder* contains a clear statement of his belief. Noting the changes that have occurred in the Great Lakes region in the ninety-odd years since the time of his story, he interprets the fruits of change as "gifts of a most bountiful Providence" and firmly believes "that great results are intended to be produced by means of these wonderful changes" (p. v). He can thus look forward with confidence to the day "when the whole of that vast range of lakes will become the seat of empire, and fraught with all the interests of human society. A passing glimpse, even though it be in a work of

fiction, of what that vast region so lately was, may help to make up the sum of knowledge by which alone a just appreciation can be formed of the wonderful means by which Providence is clearing the way for the advancement of civilization across the whole American continent" (p. vi). In words that closely resemble the conclusion of *The Pioneers*, Cooper states his belief at the close of his life in a divinely ordered process directing American society toward an important, if as yet unrecognized, goal.

This concept received its most extended treatment in one of Cooper's late novels, *The Oak Openings* (1848). This tale of Michigan during the opening months of the War of 1812 depicts the struggle of a group of white men and women to survive alone on the frontier during an Indian uprising. The hero, Ben Boden, is a bee hunter, an occupation which suggests that he, like Leatherstocking, is a forerunner of the horde of settlers that will transform the continent, but although he is a resourceful frontiersman, he cannot survive by his powers alone. Rather, his success in escaping the Indians must be attributed to a totally unexpected—and providential—event, the conversion of Scalping Peter, an Indian leader who is deeply affected by the fact that a missionary, Parson Amen, prays for his tormentors with his dying breath. As a result of his experience, which is made to parallel the conversion of Saul in the Acts of the Apostles, Peter turns from his Indian ways, helps the white party escape from the other red men, and eventually becomes a practicing Christian. Indeed, many years later, Peter comes to see the whole settling of the continent as the will of God: " 'Arth belong to God," he says in the final chapter, "and He send whom He like to live on it. One time He send Injin; now He send pale-face. *His* 'arth, and He do what He please wid it" (p. 468).

Cooper did not deny that many wrongs had been committed by the white men in the course of this process. The violence that the settlers had done to both Indian and forest was too obvious to be denied. Yet Cooper's faith in the providential vision of history provided him with an answer. Though the evil that men do is everywhere apparent in the world, it is transmuted to good in "the inscrutable ways of Providence" (p. iv). For this reason, Cooper can look back over the history of the human race and still find cause for optimism. He sees

civilization, the arts, moral improvement, nay, Christianity itself, following the bloody train left by the conqueror's car, and good pouring in upon a nation by avenues that at first were teeming only with the approaches of seeming evils! In this way there is now reason to hope that America is about to pay the debt she owes to Africa; and in this way will the invasion of the forests and prairies and "openings" of the redmen be made to atone for itself by carrying with it the blessings of the gospel, and a juster view of the relations which man bears to his Creator. Possibly Mexico may derive lasting benefit from the hard lesson that she has so recently been made to endure. [p. 469]

Whatever evils have been committed in the course of the western movement—and Cooper was always ready to admit the genuine wrongs that had been inflicted upon the red man—the ultimate end toward which the United States is moving is a good one.

The agricultural society that Cooper depicts in the closing chapter of the book may therefore be viewed as an image of what that end might be. To be sure, he presents his description of Prairie Round as if it were a realistic picture of life in Michigan in 1848, but the vision of peace and abundance that he projects— an image that could hardly be predicted from the view of the scene in 1812—must surely be taken as a symbol of the providential goal toward which American society is moving. As one might expect in the late Cooper, the society is seen in strongly Christian terms, and the bountiful crops that fall under the blade of the harvesting machine may be interpreted as the gifts of a beneficent God. The settlers themselves live in harmony with one another, and the society is as close to projecting a social ideal as Cooper can make it. Behind this scene, he suggests, may lie decades of change, injustice, and out-and-out evil—much of which he had depicted in his many frontier novels—but time in America is moving toward its appointed end, the consummation of a process which will yield the prosperous and happy Christian society he describes on Prairie Round.

To affirm this view of American history, however, did not entail the acceptance or approval of everything that was happening in the contemporary social scene. Cooper had strong reservations about the changes that were occurring in his day and was fre-

quently critical of the direction American life seemed to be taking. Although these two views would appear to be contradictory, they are actually not at all difficult to reconcile, for each applies in a different order of being. Though Providence may indeed be ordering all things for an ultimate good, passionate and erring men may cause temporary evils in the interim. They will not change the ultimate goal toward which time is moving, for God can turn evil into good, but they can nonetheless cause disruption in the world and misery to men. This idea Cooper develops explicitly in his preface to *The Oak Openings*. The author himself believes "that the finger of Providence is pointing the way to all races and colors and nations, along the path that is to lead the East and the West alike to the great goal of human wants. Demons infest that path, and numerous and unhappy are the wanderings of millions who stray from its course; sometimes in reluctance to proceed; sometimes in an indiscreet haste to move faster than their fellows, and always in a forgetfulness of the great rules of conduct that have been handed down from above" (pp. iii–iv). Whatever these men may do, however, the goal toward which time is moving will not be altered.

It is for this reason that Cooper can maintain the providential view of history and still so vigorously criticize the specific faults he sees in contemporary American society. That he believed these faults were many and serious need hardly be mentioned. The despoliation of the landscape depicted in both *The Pioneers* and *The Prairie*, the disruption of social order presented in *Home as Found* and the Littlepage trilogy, and the general decay of fundamental principle illustrated in his late novels are all too widely known to need development here. What *is* necessary to emphasize, however, is that Cooper's faith in the ultimate goal of America did not die with these observations, but that he, like Bryant and Irving, had simply to come to grips with the problem of social change and reconcile it in terms of some fundamental principle of order. All three men are critical of the contemporary social scene and attack those attitudes which appeared to be driving American society in an unwanted direction. Each, however, approaches the problem in a different way and resolves it in terms of his own vision of an ordered world.

Of all three writers, Bryant is least concerned with the question

of change in contemporary society, yet even he occasionally expresses his abhorrence of what he saw going on in nineteenth-century American life. In "The Conjunction of Jupiter and Venus," for example, he condemns the "fraud and lust of gain" which characterize some of his countrymen (p. 113), and in "Autumn Woods," he abhors "the vain low strife / . . . the tug for wealth and power" in which many of his contemporaries engage (p. 69). In "The Crowded Street," one of his few poems describing the urban scene, he depicts the "keen son of trade, with eager brow" who lays his snares for the unwary and dreams of "golden fortunes" (p. 207), and the poet himself complains, at the conclusion of "Green River," that he is

> forced to drudge for the dregs of men,
> And scrawl strange words with the barbarous pen,
> And mingle among the jostling crowd,
> Where the sons of strife are subtle and loud. [p. 29]

Although Bryant does not treat the contemporary urban scene at any length in his verse, what he does include in poems like these reveals unmistakably his attitude toward those eager and ambitious business types who wrought such profound changes in nineteenth-century American society.

In the rural scene, too, Bryant is sometimes critical of changes that he saw taking place on the land. In "An Indian at the Burial-Place of His Fathers," the poet had raised the prospect of a despoiled landscape, as American settlers shear away the forests and clear the land for farms. A similar view appears near the end of "The Fountain," where Bryant depicts the potential effects that passionate or careless men may have on the land. Speculating on what the future holds for the spot where the fountain flows, Bryant writes:

> Is there no other change for thee, that lurks
> Among the future ages? Will not man
> Seek out strange arts to wither and deform
> The pleasant landscape which thou makest green? [p. 188]

This is not the only change that may occur in the course of time, but Bryant treats it as a real possibility. Should changes like these take place, moreover, throughout a significant part of the country,

Americans would incur the risk of themselves destroying the happy future for which their nation seemed destined.

Bryant in his verse seldom raised the question of an ultimate American failure. Generally optimistic about America's destiny, he only on occasion and by indirection suggested that the issue of American history might still remain in doubt. Thus, in "The Ages," a poem which sees America as the culmination of a long historical process moving in the direction of freedom, he includes a note of uncertainty in his final stanza: "But thou, my country, thou shalt never fall, / Save with thy children" (p. 21)—a note that implies at least the possibility that America can be destroyed if her citizens do not remain true to her basic principles. A similar question, though not explicitly stated, remains at the end of "The Prairies," for the logic of the poem, which shows the rise and fall of earlier cultures that have occupied the area, would seem to indicate that the society founded by American settlers might one day perish too. Indeed, in the final lines of "Earth," Bryant clearly suggests that the future may still be undecided. Addressing his "native land of Groves," he wonders if its record in the world will be fairer than that of Europe, and concludes:

> Fear, and friendly Hope,
> And Envy, watch the issue, while the lines,
> By which thou shalt be judged, are written down. [p. 163]

Yet, despite the disruptive forces set loose in American society by the evil passions of men, Bryant, like Cooper, can still remain optimistic about the future and see the flow of time as ordered by the divine purpose. The "keen son of trade" in "The Crowded Street" may pursue his materialistic goals, while others with fierce and stony faces may hurry on toward toil and strife. The street is filled with both the good and the evil, the kind and the harsh, all moving about in a constant stream of activity. But the vision of a mutable social world that the poet projects is not the ultimate meaning of the scene. Rather, Bryant ends his poem with a strong affirmation of a fundamental order that transcends the flux of the moment and gives the endless process its continuity and meaning.

> Each, where his tasks or pleasures call,
> They pass, and heed each other not.

There is who heeds, who holds them all,
 In His large love and boundless thought.

These struggling tides of life that seem
 In wayward, aimless course to tend,
Are eddies of the mighty stream
 That rolls to its appointed end. [p. 208]

Whatever the questions raised in his mind by the evils present in American life, Bryant is able to reconcile them in terms of the same providential view of history that we find expressed in Cooper's novels.

As writers of prose fiction, Irving and Cooper are much more concerned than Bryant with the problem of change in contemporary society, and they are less likely to develop the theme so explicitly as he in philosophic terms. The nature of fiction itself requires that much attention be given to the problems encountered by men in society, and stories and novels dealing with nineteenth-century issues could hardly avoid the problem of change in the social scene. In attempting to reconcile change with some principle of order, moreover, the writers frequently stressed the social values they saw in nineteenth-century life as principles by which the potentially radical changes might be circumscribed and contained. Thus, although Irving, in "Rip Van Winkle," and Cooper, in *The Wept of Wish-ton-Wish*, might use the principle of contrast to show what can befall a social organization in a relatively short period of time, they also suggest in some of their other works that change need not lead to such unhappy results. In these tales and novels they affirm the value of a principle of continuity that would not necessarily thwart completely the changes they saw occurring, but might order the inevitable flow of time in a proper direction toward an appropriate end.

That this principle of continuity must be firmly based in a stable social order is a fundamental assumption in the works of both these men, and Irving, in particular, includes in a number of his tales a strong affirmation of values that ought to assure such stability in a rapidly changing world. Indeed, in several of his stories, he presents the images of order and change in such a way as to make the theme unmistakable. Thus, in "Wolfert Webber," we find an island of order threatened by a rising tide of change.

The Webber farm has passed from father to son in an unbroken line of succession since the earliest days of Dutch settlement, and the solid family mansion, "the seat of government" of the farm, presents an "air of long-settled ease and security" (7: 394). These values contrast sharply with those of the rapidly growing city that spreads its suburbs across the countryside and eventually engulfs the Webber domain. The quiet lanes of the country are transformed into bustling city streets, the air and sunshine are cut off by surrounding houses, and the Webbers' metropolitan neighbors raid his cabbage garden. Rapid social change is clearly a threat to the established order of the Webber farm.

In "The Legend of Sleepy Hollow," too, Irving presents a similar contrast of change and order. Early in the story, the narrator compares the village of Sleepy Hollow to "those little nooks of still water which border a rapid stream; where we may see the straw and bubble riding quietly at anchor, or slowly revolving in their mimic harbor, undisturbed by the rush of the passing current." He has only unqualified praise for the social order that Sleepy Hollow represents, because, he writes, "it is in such little retired Dutch valleys . . . that population, manners, and customs, remain fixed; while the great torrent of migration and improvement, which is making such incessant changes in other parts of this restless country, sweeps by them unobserved" (2: 426). In both of these stories the Dutch pocket society represents a kind of stability and order that is threatened by the onrushing process of change which is transforming American society in so radical a way. Yet it is in these very societies that one can find the principles on which a reasonable continuity in American life might hopefully be based.

The farm and the person of Baltus Van Tassel in "The Legend of Sleepy Hollow" further exemplify these principles. The enormous abundance produced by the Van Tassel farm—the fields rich in ripening grain, the orchard heavy with fruit, the farmyard teeming with livestock, and the barn almost bursting "with the treasures of the farm"—is clearly a symbol of the wealth that can be produced in a stable society, while "the warm tenement of Van Tassel," surrounded by all this abundance, represents the humane values that such a society will encourage. The proprietor himself

is "a perfect picture of a thriving, contented, liberal-hearted farmer" who is "satisfied with his wealth, but not proud of it," and who piques himself on "the hearty abundance, rather than the style in which he lived" (2: 433–35). A truly hospitable man, old Baltus Van Tassel greets his guests on the day of the quilting party with warmth and good humor—"a shake of the hand, a slap on the shoulder, a loud laugh, and a pressing invitation to 'fall to, and help themselves' " making them welcome (2: 447). Both Van Tassel and his productive farm project the image of an ideal society where warmth, friendship, and hospitality are the values by which men live together in peace.

Opposed to this view is a system of value, typical of nineteenth-century American society, which will not tolerate such stability but demands the constant change of everything in the name of progress. In "The Legend of Sleepy Hollow," Ichabod Crane, the Connecticut Yankee who possesses all the unattractive traits that New Yorkers like Irving and Cooper attribute to the New England character,[5] is the representative of this attitude. The shrewd American go-getter who succeeds "by hook and by crook" (2: 429), Crane covets the wealth he sees on the Van Tassel farm and wants to make it his own by marrying Katrina Van Tassel, old Baltus's only child. Indeed, there is a strong suggestion in the story that Crane is attracted to the girl as much for "her vast expectations" (2: 433) as for her obvious personal charms, since she rises in his regard with his appreciation of her father's wealth (2: 435–36). That Ichabod Crane might inherit the Van Tassel farm is not, however, the most serious threat to the stable social order, but rather that he would not be content to leave it unchanged, even if he should possess it. As he gazes upon its wealth, his mind is filled with the thought that he might turn the farm into cash and invest the money "in immense tracts of wild land, and shingle palaces in the wilderness" (2: 435). The fever of speculation possesses him, and he even dreams of moving on with Katrina to "Kentucky, Tennessee, or the Lord knows where" (2: 435).

What Irving satirizes in the person of Ichabod Crane, therefore, is the rampant American materialism that, in the name of progress, converts everything into money and so destroys all other

values in a process of constant change. The warmth and hospitality of a Baltus Van Tassel cannot exist in a society whose only goal is money. Sleepy Hollow survives the onslaught of Ichabod Crane, for he is refused by Katrina Van Tassel and driven away by Brom Bones—only to succeed in a typically American manner elsewhere (2: 459). Wolfert Webber's farm, however, is not so fortunate, for Webber himself succumbs to dreams of gold, destroys his land by digging it up in search of an imagined treasure, and succeeds at last by dividing "his paternal lands . . . into building lots" and renting them out to tenants (7: 455). Webber grows wealthy, keeps a carriage, and alters his house to conform to current style, but it is at the expense of those values that made old Baltus Van Tassel so successful as a man. And as if to underscore what Webber has lost, Irving ends his story ironically with the powerful Webber "greatly honored and respected, insomuch that he was never known to tell a story without its being believed, nor to utter a joke without its being laughed at" (7: 456). He has bought the empty mockery of what Van Tassel had possessed in substance.

In both of these tales, the rapid change that besets American society is clearly related to the gross materialism that pervades American life. One seems to follow the other almost as a matter of course. To resist such change, therefore, American society would have to place its faith in other values than money—values that are typified by the kind of humane life that is lived in Sleepy Hollow, and which characterize Wolfert Webber's farm before he starts his search for gold. These are the values to be found in the long established family that settles once and for all on its comfortable acres, passes the land from father to son in unbroken succession, and warmly and hospitably shares the natural wealth it generates with all its neighbors. Such families, the stories seem to suggest, dwell in peace and contentment, for they set a natural limit to the wealth they possess and do not exhaust themselves with a constant striving for additional material advantage. They serve, moreover, an important social purpose, for they provide the basic stability, which, acting as a counterforce to the main thrust of American life, can restrain and order the process of change that is constantly at work in the world.

Irving develops this concept most fully in his treatment of

English society, where the long established social system seemed to confirm these theories. Thus, in *The Sketch Book*, Geoffrey Crayon discusses the moral value of the English landscape in terms that support the system of values affirmed in "Wolfert Webber" and "The Legend of Sleepy Hollow." English scenery, he writes, "is associated in the mind with ideas of order, of quiet, of sober well-established principles, of hoary usage and reverend custom. Every thing seems to be the growth of ages of regular and peaceful existence." He goes on to describe a number of objects in the landscape—the church with its Gothic tower, the parsonage, and the village—that suggest this conclusion, and ends with the observation that the "common features of English landscape evince a calm and settled security, a hereditary transmission of homebred virtues and local attachments, that speak deeply and touchingly for the moral character of the nation" (2: 83–84). These are exactly the qualities for which Sleepy Hollow stands and which are destroyed when Wolfert Webber converts his paternal farm into money and joins the American march toward materialism and progress. They are, moreover, just those qualities that can provide an ordered continuity to the sweep of time.

For such a system to succeed, however, the owners of the land must possess certain qualities of mind and soul that will assure the proper use of their heritage. In *Bracebridge Hall*, therefore, Geoffrey Crayon, a republican by birth, principles, and habits, does not value titled rank merely because it is titled. Rather, he accords respect to the gentleman landholder only when he possesses "a generous mind" and selflessly assumes the social responsibilities that his rank entails. Such a man can serve as a vital link between past and future. Through him, whatever had value in the past can be preserved and transmitted to future generations. "He lives with his ancestry, and he lives with his posterity. To both does he consider himself involved in deep responsibilities. As he has received much from those who have gone before, so he feels bound to transmit much to those who are to come after him. His domestic undertakings seem to imply a longer existence than those of ordinary men; none are so apt to build and plant for future centuries, as those noble-spirited men, who have received their heritages from foregone ages" (6: 95–96).

Crayon admits that theory and practice do not always coin-

cide, and he realizes too that some of the views he holds about English society are simply utopian. He confesses his disappointment, in *Bracebridge Hall*, on learning that the reality of English society is often far from the ideal. Extravagance and dissipation among the upper classes sometimes destroy their estates and turn too many of the landed gentry into "mere place-hunters, or shifting absentees." The court is infected with "importunate time-servers," and foreign hotels are crowded with English exiles who waste on "thankless strangers the wealth so hardly drained from their laborious peasantry" (6: 254). He realizes, too, that blind veneration of the past might lead one to ascribe an Arcadian quality to customs that were not "always so very loving and innocent as we are apt to fancy them" (6: 317), and he recognizes the folly of clinging to ancient ways in the face of real and inevitable improvements—like those of travel (6: 349–50). Such failures, however, do not invalidate the fundamental principle of order that lies at the heart of conservative society, a principle which could afford both England and the United States the continuity needed in a time of rapid and widespread change.

Though Cooper was never so friendly toward England as Irving clearly was in *The Sketch Book* and *Bracebridge Hall*, he espoused many of the same social theories on the value of landed gentlemen that are presented there.[6] The difference between the two men lay in their treatment of the aristocracy. Although Crayon depicts the evils created by those members of the landed gentry who were faithless to their social responsibilities, he nonetheless believes, as he writes in *Bracebridge Hall*, "that the great majority of the nobility and gentry in England are endowed with high notions of honor and independence" and will decide important questions in terms of principle rather than "party and power" (6: 256). But if Irving, through his persona, creates a favorable image of the British aristocracy, Cooper has little use for aristocrats at all, including those in England, because of the political power they could wield. Landed gentlemen in America, however—Cooper was always careful to note—were not really aristocrats in that they did not possess exclusive political power. Rather, they served only a social function as educated and civilized leaders who fulfilled their purpose by giving society the proper

direction and tone. Thus, although limited in the amount of political power they might wield, these men, by the weight of their virtue and intelligence, could direct social change toward desirable ends.[7]

Repeatedly in his novels, Cooper affirms the value of such a landed class. Judge Temple, in *The Pioneers*, their best known representative, is only one of a whole series of such honest land-holders who were to be entrusted in Cooper's social novels with the direction of society. Miles Wallingford, in *Afloat and Ashore* and *Miles Wallingford*, Captain Willoughby, in *Wyandotté*, and the three heroes of the Littlepage trilogy all serve essentially the same function in providing the social stability that will insure continuity to the progress of society. To be sure, they are not all equally successful. Miles Wallingford almost loses his family possessions in his attempt to make a fortune in trade, and Captain Willoughby's dreams are frustrated by the minor incident in the Revolutionary War that not only leads to his death, but effectively destroys the family estate he had wished to establish. Indeed, the Littlepage heroes must constantly defend themselves against re-peated threats to their possessions, and, by the final book in the series, are engaged in a struggle with the same kind of materialistic go-getter who threatens the peace and contentment of Irving's Sleepy Hollow. But whatever the differences we may observe among them, all these characters clearly represent the same social principles, and, if successful in their endeavors, could provide the element of continuity that Cooper saw as essential to rational social progress.

To develop this theme of ordered change in his books, Cooper employed a number of effective devices, the most obvious of which is the actual depiction of the changes that occur in a properly ordered society. Unlike Irving, who worked primarily through sketches, Cooper had ample room in his novels to present the growth and development of a fictional society presided over by one of his republican gentlemen. Such is the picture pre-sented in *Wyandotté* before the Hutted Knoll is besieged by a band of irregular partisans, and such is the kind of society that Mark Woolston founds in *The Crater*. On three occasions, however, Cooper developed his theme at such length as to require more than

a single novel for its completion. Thus, the society founded at Templeton at the close of the eighteenth century in *The Pioneers* is carried forward into the late 1830s in *Home as Found*, a novel which treats the descendants of Judge Temple, who still live in the town that Templeton has become. *Afloat and Ashore* and *Miles Wallingford* describe the adventures of the hero through two full-length novels, and the Littlepage trilogy details the history of a single family through a period of some ninety years.

Within this basic pattern, Cooper sometimes employed his descriptive technique to support the fundamental theme. The device of the landscape series, for example, served his purpose well, for successive views of the same location could reveal the kind of social progress his gentleman heroes could accomplish. Such is certainly the effect of the series of views of Captain Willoughby's land in the opening chapters of *Wyandotté*. When the captain acquires his patent in upstate New York, he has on his land a "little sylvan-looking lake" that lies like a jewel "embedded in the forest" and "glittering in the morning sun," a lake that was formed by a beaver dam that years before had been built across a small stream. But this body of water, some four hundred acres in size, was too great a luxury for a frontier settlement, and Willoughby breaks the dam to drain the lake for farming. Within a day, the lake is gone. "In its place, there remained an open expanse of wet mud, thickly covered with pools and the remains of beaver-houses, with a small river winding its way slowly through the slime" (p. 12). As in *The Pioneers*, the invasion of the virgin forest is initially destructive, and the captain himself almost mourns over what he has done.

Yet, though the change is a melancholy one, subsequent descriptions imply that it is both inevitable and necessary. A year later, we are told, the scene has changed for the better. "The few stumps and stubs which had disfigured the basin when it was first laid bare had all been drawn by oxen and burned" (p. 32). The irregular form renders the view picturesque, and winter wheat and grass are already growing on various parts of the area. By the time ten years have passed, the transformation is complete.

The site of the ancient pond was a miracle of rustic beauty. Everything like inequality or imperfection had disappeared,

the whole presenting a broad and picturesquely shaped basin, with outlines fashioned principally by nature, an artist that rarely fails in effect. The flat was divided into fields by low post-and-rail fences, the captain making it a law to banish all unruly animals from his estate. The barns and out-buildings were neatly made and judiciously placed, and the three or four roads, or lanes, that led to them, crossed the low-land in such graceful curves, as greatly to increase the beauty of the land- scape. Here and there a log cabin was visible, nearly buried in the forest, with a few necessary and neat appliances around it; the homes of laborers who had long dwelt in them, and who seemed content to pass their lives in the same place. [p. 50]

Though the loveliness of untouched nature has clearly been violated, the ugliness of the initial change has been transformed into another kind of beauty, one that affirms the preeminence of human values over natural ones.

The device of the landscape series could also be used to illustrate the principle of continuity through more than one novel, a purpose it serves in *The Pioneers* and *Home as Found*, where the concept of social continuity is expressed through the paired de- scriptions of Templeton drawn from about the same spot in both books. The view of her father's village that Elizabeth sees in the opening chapters of *The Pioneers* stresses the fact that Templeton is a new settlement and the expanse of forest is broken only here and there by a few new clearings. When her descendants view the same scene in *Home as Found*, comfortable dwellings dot the fields in every direction, the hills are cultivated, and meadows and pastures are an important part of the landscape. The valley is "verdant, peopled, wooded in places, though less abundant than the hills, and teeming with the signs of life" (p. 126). The village of Templeton, too, shows signs of change, but the change is healthy growth. It is not one of those towns "that shoot up in a day, under the unnatural efforts of speculation, or which, favored by peculiar advantages in the way of trade, becomes a precocious city while the stumps still stand in its streets; but a sober country town, that has advanced steadily *pari passu* with the surrounding country, and offers a fair specimen of the more regular advance- ment of the whole nation in its progress towards civilization" (p. 126). The Effingham family, who are largely responsible for

the settlement and growth of the region, have avoided the American propensity to strive for immediate material gain which Cooper, like Bryant and Irving, roundly condemned.

Indeed, Cooper goes on in a subsequent chapter to discuss at length the typical growth of an American settlement and the gradual separation of men into classes as cultivation, mental resources, and wealth mark some men off from those whose lives are spent in physical activity. As time moves on, the older settlers of a district begin to take pride in their forefathers and the traditions that have come down to them, and they begin to value their locality over all others because of the associations it has for them. These are the men on whom the stability of society will depend. Opposed to them are "the birds of passage"—as Cooper calls them (p. 165)—those who, like Ichabod Crane, restlessly move from place to place, see no value in what the more settled people hold most dear, and pose a constant threat of rapid change to the society. By 1838, Templeton is almost equally divided between these two classes of men, and the issue is still in doubt, but there is little question as to where Cooper's sympathies lie. Like Irving, he affirms the value of a society firmly based on the landed gentleman who assumes his social responsibilities and acts as a brake on the process of change that without him would be headlong and undirected. And to symbolize the continuity he maintains, Cooper shows the good effects wrought in the landscape by three generations of the Effingham family who possess just those qualities of heart and mind to fulfill their proper function in society.

The fullest and best expression of this theme in Cooper is undoubtedly the Littlepage trilogy, a series of books that Cooper wrote during the anti-rent war in New York in the 1840s and which is somewhat marred by the contemporary polemics which the third of the series contains. In these books Cooper develops fully his concept of change within order[8] by detailing the fortunes of the Littlepage family over a period of about ninety years, from the old French war of 1758 in *Satanstoe*, through the period just after the Revolution in *The Chainbearer*, and down to the contemporary age (1845) in *The Redskins*. This was obviously a time of rapid, radical change in the American consciousness as the

country moved from the status of separate colonies deferring to British opinion to that of a free nation proud of its independence and strength—a change that is clearly reflected in the characters and incidents in the books. At the same time, he is able to present through successive generations of the Littlepage family—six of which figure in one way or another in the novels—the principle of order that can meet the threat of rapid and sometimes violent change and keep it moving in the proper direction.

The threat of violent change is a constant one in all three books, for the plot in each is concerned with a struggle for control of the land. Corny Littlepage, in *Satanstoe*, not only takes part in Abercrombie's attempt to dislodge the invading French from Ticonderoga but also helps defend the Mordaunt patent at Ravensnest against Indian attack. His son, Mordaunt Littlepage, the owner of Ravensnest in *The Chainbearer*, acts as agent for his father and his father's friend Dirck Follock in helping to thwart the squatters who are cutting valuable timber on the Mooseridge patent. And Mordaunt's grandson, Hugh, returns from Europe in *The Redskins* during the anti-rent struggle of 1845 to confront the rebellious tenants at Ravensnest who are trying to force him to sell the land that they rent from him. Although all these threats are met and checked by the Littlepage heroes, the danger of violent change is an ever-recurring one, a fact well illustrated through some of the details that Cooper includes in the books. The bones of Mr. Traverse, the surveyor killed by the Indians in *Satanstoe*, are found by Mordaunt Littlepage just before he discovers the sawmill of the squatter Thousandacres in the woods, and the fire that the Indians set in their assault on Ravensnest in 1758 is repeated in the attempted arson by anti-rent Injins in 1845.

Not every change, of course, is so radical as these threatened ones. As Cooper wrote to Richard Bentley on January 22, 1845, he intended to show "the changes produced by time" on "the same family, the same localities, the same *things* generally" that appear in all three books.[9] The town of Albany, for example, described in detail in *Satanstoe*, is still very Dutch in 1758. Its two churches—one Dutch, one English—are important landmarks in the town, landmarks that are still there when Mordaunt arrives on his way to Ravensnest in 1784. By the time of *The Redskins*, however,

both are gone. The old Dutch stoops have vanished, the gabled houses are giving way to more modern buildings, and a "basin has changed the whole character of [the] once semi-sylvan, semi-commercial river." But Hugh's Uncle Ro, who observes these changes, does not consider them unfortunate. In his eyes, the change that has occurred in Albany is thoroughly respectable. It has none of the absurd pretension that he would find reprehensible, and it gives the growing town "an appearance of abundance and thrift that promise well" for the future (p. 74).

Albany also serves another function in the series. As an old Dutch town in *Satanstoe*, it represents the earliest phase in the development of York Colony. The English around Manhattan present a later stage in its settlement, and the wilderness lands of the Mordaunt and Littlepage families suggest its potential future. As the series develops, however, the Dutch become less important, and New England Yankees, who appear in small numbers in the earliest volume, assume an increasing importance in those that follow. Both Guert ten Eyck and Dirck Follock play a larger role in *Satanstoe* than does Jason Newcome, the Connecticut Yankee, but by the time we reach *The Redskins*, the Dutch are all but forgotten, and Seneca Newcome, Jason's descendant, has become an influential leader among the Ravensnest tenants. By 1845, the focus of attention has shifted away from New York City and Albany—the settings in much of the first two thirds of *Satanstoe* —and concentrates instead on the Ravensnest estate. In a very real sense, the Littlepage series depicts the gradual changes that occurred in New York in the nearly ninety years that the novels cover.[10]

As part of this historical process, the Littlepage family changes as the series develops. It becomes, for example, increasingly democratic. Herman Mordaunt, the original patentee at Ravensnest, is deeply impressed with the British aristocracy, and would have his daughter, Anneke, marry Bulstrode, the son of a baronet. But once she chooses Corny Littlepage to be her husband, the concept of aristocracy is dismissed from the series, and succeeding generations of Littlepages are firm supporters of republican principles. In each generation, the views of the son tend to be more democratic than those of his forebears, and both Mordaunt and Hugh

turn away from the wealthy girls of their class to marry women whose inherent worth more than makes up for their lack of wealth or social position. This increasingly democratic attitude on the part of the Littlepage family is well illustrated in a detail that appears in two of the books. Canopied pews for leading families in the congregation are much admired and accepted by Corny Littlepage in *Satanstoe* when he sees them in a church in Albany, and we learn in *The Redskins* that he had one constructed in the Episcopal church he built at Ravensnest in the 1780s. So much have attitudes changed by 1845, however, that the Littlepage family cares nothing for the distinction it represents, and Hugh is willing to have it removed from the church, provided he is not forced to do it by his rebellious tenants.

But if change is an important element in the Littlepage novels, there is nonetheless a principle of continuity apparent in all of them.[11] Though Cooper designed each book as a self-contained unit, he planned the novels as sequels in terms of the principles that inform them. "Every chronicle of manners has a certain value," he writes in the Preface to *Satanstoe*, and "when customs are connected with principles, in their origin, development, or end, such records have a double importance" (p. iii). In all three books, therefore, a heavy emphasis is laid on the need for sound principles on which to base society. Corny Littlepage admits, for example, "that there is such a thing as improvement" which "not only compels, but excuses changes," but he insists at the same time on the existence of "permanent principles" which endure no matter what external change may occur (p. 484). Mordaunt, his son, believes that society is based on "eternal and immutable" principles that, coming from God, may not be changed, but which must be applied for "the good of the human race" (p. 426). And the Littlepage men of 1845 believe that "the civilization of a community is to be measured by its consciousness of the existence of all principles of justice" (pp. 41–42), principles that cannot be altered by human means.

How these principles operate is made clear in *The Chainbearer*. When Mordaunt Littlepage arrives at Ravensnest for the first time, he tries to explain the white man's concept of property to Susquesus, an Onondaga Indian who figures significantly in all

three novels. In the course of the conversation, Mordaunt outlines the social theory that lies at the heart of the Littlepage series. In Mordaunt's view, the law can do no more than place "all men on a level, as to rights." Once having done so—once having established society on the basis of "certain great principles that are just in themselves," they "must be left to follow their own course." That these principles are right is insured by their ultimate source in God, and there is even a strong suggestion of a providential ordering of events in all the books. Mordaunt believes, moreover, that civilization depends on the rights of property and the rights of the owners to pass their possessions on to their children. These rights "must be established fairly, on some admitted rule; after which they are to remain inviolable" (pp. 113–14). The affluent and educated landowners, on their part, serve an important function in the community. They act as a civilizing force by providing a standard of manners and taste for the society as a whole.

The social relations envisioned here and the good which Cooper believes must derive from them is physically represented by the various estates that appear in all three books. Each provides a point of reference in terms of which change and continuity can be measured. Satanstoe and Lilacsbush, the properties of the Littlepage and Mordaunt families, are most important in the initial volume, where they are the homes of Corny and Anneke before their marriage. At this time, the Mooseridge and Ravensnest patents are remote areas which have only begun to be penetrated, and only Ravensnest is at all settled. By the time of the second novel, Corny and Anneke are living at Lilacsbush, Satanstoe has slipped into the background as the home of Corny's widowed mother, and the patents are ready to be developed. By the time of the third, Lilacsbush and Mooseridge have been sold, the latter in particular providing an alternative for those settlers who would prefer to own their own farms rather than rent. Satanstoe has been partially, and unsuccessfully, developed into town lots—a sign that even the Littlepage family can succumb to the vulgar desire for quick and immediate profit—and the center of family activity has been moved to Ravensnest, now the permanent home of the Littlepages. Since Ravensnest is the only one to be fully developed

throughout the series, it is there that we may see the principle of continuity most clearly at work.

When Corny Littlepage arrives at Ravensnest in 1758, he finds a very rude settlement. A few small clearings have been made in the forest where some fifteen or twenty families, induced to settle there by the liberal terms granted by Herman Mordaunt, are trying to establish themselves. "The whole of the open space," Corny observes in his description of the patent, is "more or less disfigured by stumps, dead and girdled trees, charred stubs, log-heaps, brush, and all the other unseemly accompaniments of the first eight or ten years of the existence of a new settlement" (p. 424). But rude as Ravensnest is, Herman Mordaunt fears that the hard-earned advantages that have been gained over the wilderness may be lost if his settlers take alarm at the incursion of the French army into the colony or at the probability of Indian attack. He has come to the patent, therefore, to reassure his people and hold them on the estate. When the Indian attack does come, he gathers the tenants into the fortress-like house he has built "with a view to defence," and which has "served for some time as a sort of rallying point to the families of the tenantry, in the event of an Indian alarm" (p. 326).

The description of Ravensnest in *Satanstoe*, therefore, resembles the frontier settlements in *The Pioneers* and *Wyandotté*, but in this book, there is a difference. Herman Mordaunt stresses the expense to which the landlord must go to lure families to his farms, expenses that cannot be recovered for several generations because of the low rents he must charge to make his land attractive to settlers in a country where land is abundant. Important too in this book is the interest the landlord takes in the welfare of his tenants and the leadership Herman Mordaunt exercises in directing the defense against the Indians. Since Corny and Anneke are also present on the patent in its time of trouble, they share the dangers that the tenants face, and Corny takes part in the defense of an estate which, though he does not yet know it, will one day pass to their son. The whole of the initial treatment of Ravensnest, therefore, is designed to establish the relation of the landlord to his land and to the tenants who occupy it, a relationship that, the Littlepage novels insist, will form the basis for a stable social order.

A considerably different Ravensnest greets the eyes of Mordaunt Littlepage when he first sees the patent in 1784. A quarter of a century has passed, and although little has been done to the patent during the Revolutionary War, it is much improved over what his father had seen. As we might expect from other of Cooper's landscape descriptions in series, "the stumps [have] nearly all disappeared from the fields," and although the virgin forest still impinges on the settlement, "giving a wild and solemn setting to the rural picture," the land is "dotted with cottages and barns, . . . beautified by flourishing orchards, and garnished with broad meadows, or enriched by fields, in which the corn [is] waving under the currents of a light summer air" (pp. 117–18). Roads wind through the settlement, which now includes a growing hamlet, and pass on into the forest where other settlements are beginning to spring up. The policies established by Herman Mordaunt have begun to bear fruit, a principle of continuity has been established, and Mordaunt Littlepage can begin to look forward to a flourishing estate.

One detail in the landscape, however, betrays the ravages of time. The fortresslike house has begun to decay with the passage of years. It looks somber and dark to Mordaunt's eyes when he first catches sight of it from a distance. Indeed, it is "barely to be distinguished by its form and chimneys, from any other pile of logs" (p. 121). Though the building looks considerably better when seen up close, it serves as a kind of yardstick to measure the degree of change that has come into the landscape over a period of time. But this is not the only function it serves. Because the landlord should live on his estate to provide the proper civilizing influence on the community, Mordaunt's father determines to build a permanent house on the site of the old one, a house that by its very situation will establish a link with the past while Mordaunt and his family maintain a relationship with the tenants that should work to the benefit of both in the future. Mordaunt marries soon thereafter, and although the new house is not described in this book—except for the detail that it is to be of stone—we learn that it was completed in due course and that Mordaunt and his bride were able to occupy it by Christmas 1785.

In the ensuing sixty years, Ravensnest continues to grow and

develop. When Hugh comes home from Europe in 1845, he finds a beautiful community that should be a model of stability and peace. As he drives through his estate, he sees "a picture of rural abundance, mingled with rural comfort" (p. 214). A thousand acres of fertile bottomland provide fine crops of hay and corn for both Hugh and his tenants, and there is even a pastoral note in the landscape in the thousand sheep that feed "on the lawns, along the slopes, and particularly on the distant heights" (p. 163). The patent has come a long way since the days of Herman Mordaunt, and its current prosperity clearly suggests that the policies which he established and the social order that he helped to create have indeed provided the machinery by which the natural process of change has been directed to productive ends. The house, in particular, symbolizes this principle well. Built on the site of the square logged one that had stood for half a century, it has itself endured for sixty years, basically the same though added to on a plan that conformed to the shape of the original structure. It thus embodies the process of ordered change that has gone on for over a century.

That the estate is under violent attack by Hugh's rebellious tenants does not, in Cooper's view, invalidate the principle on which it has been established. Because they wish to alter the laws of society in such a way that they stand to profit from them, the tenants are viewed simply as advocates of radical change for selfish ends. Indeed, should their principles prevail, the book suggests, there would be nothing to keep the order of society from being overturned in each generation, since those at the bottom of the social scale would repeatedly seek to overthrow those at the top. To remove the landlords, moreover, would be to destroy the civilizing influence they represent. In their place would rise a new moneyed class with none of the manners or graces of the Littlepage gentlemen, and the natural result would be the vulgarization of American life. In treating the history of the Littlepage family and their developing estate, therefore, Cooper is affirming that principle of continuity which, to his mind, is best capable of controlling the process of social change and directing it to the most fruitful ends.

The rich and forceful development that Cooper gives the

theme of continuity in his Littlepage novels is unique among the writers, and with good reason. Only he felt impelled to defend a social order under serious threat of destruction, and he lent the full force of his talent to its support. Though Irving affirms quite similar views in some of the societies he presents in his tales and sketches, he treats the theme more covertly in his depiction of threatened Dutch villages or in his description of British society, and Bryant does not develop this facet of the subject at all. Yet individual differences among the writers on any single aspect of the theme of continuity are not so important as the fact that none of them was content to accept an utterly mutable world. Though each was profoundly aware of the process of change at work in all aspects of the physical and social spheres, they sought appropriate means to affirm a fundamental principle of order in terms of which that basic process might be controlled. In developing the theme of continuity, therefore, each turns to that aspect of the external world that concerns him most and develops the theme through the use of that material.

The broadly philosophic aspects of the theme receive their fullest treatment in Bryant's poems. As a poet of nature, Bryant was intimately involved with the problem of change in the natural world, for his theory of knowledge and his ethics both depended ultimately upon the concept of an ordered cosmos. Similar views appear in Cooper, who also affirms his belief in an ordered universe, and even in Irving, too, in the occasional use he makes of natural cycles in his works. The providential view of history appears most strongly in Cooper, especially in his later novels, though Bryant uses it too, not only in a poem like "The Ages," where one might naturally expect it, but also in "The Crowded Street," where this vision of history is used to reconcile the problem of social change with a larger principle of order. The social aspects of the theme, however, are most fully treated in Irving and Cooper, with the novelist, in particular, making extended and significant use of the principle of social continuity in some of his most important works. Whatever the means they use, therefore, all three writers affirm their belief in a fundamentally ordered world. Though change may indeed be inevitable, it is circumscribed and bound by a principle of continuity that gives it direction and meaning.

IV. Conclusion

To treat the various elements of the pictorial style in isolation—necessary though it may be for the purposes of analysis and comparison—inevitably incurs the danger of oversimplification, since time and space do not exist for anyone as separable entities. Rather, man's experience in the world must always be seen in terms of his simultaneous relationship to both. To communicate the fullness of that experience, therefore, the artist must somehow suggest the dual relation in which man stands to his environment, located in space but changing in time with a world that itself is involved in a similar process of change. Both the writers and painters in early nineteenth-century America clearly recognized this problem, else painters like Cole and Durand would not have sought to instill a temporal element in their canvases, nor would the writers have been so concerned with depicting the effects of change in their fundamentally spatial views. Hence, to understand most fully the depth of their thematic meaning and to estimate most accurately the artistic success of their technique, we must consider now the means by which they were able to suggest the intimate relation of space and time in their works.

In this matter, the painters faced the most serious artistic problem, for the very nature of their medium militated against their success. The spatial dimension of their imagined worlds could easily be depicted through the usual painterly means of composition, detail, light, and color, and in general the painters were successful in projecting their great moral theme of man's relation to nature and to nature's God. But when they turned to the temporal aspects of experience, they were compelled to use either the generally unsatisfactory device of the landscape series or to try somehow to suggest the passage of time in a single picture. Contrasted pairs of canvases like Durand's *Morning of Life* and *The Evening of Life* or Cole's *Departure* and *Return*, and vast landscape series like Cole's *Course of Empire* and *The Voyage of Life* solved the problem, though perhaps not very suc-

cessfully, by juxtaposing contrasted spatial compositions. Each of the paintings freezes a moment in time, and the viewer must pass from one to the other noting the changes in composition, detail, and mood to perceive the temporal relation of contrast or continuity through which the passage of time is suggested.

To express a temporal dimension in a single landscape is much more difficult and had to be handled through the use of detail. The blasted tree or ruined monument could, of course, suggest the desired effect, and each became a part of the landscape convention. At times, however, artists found other means to express this aspect of their themes. In *The Lackawanna Valley*, for example, George Inness includes in his composition a roundhouse, railroad train, cutover land, and standing woods—all set in a spacious landscape—to suggest the same ongoing process of change in American society that Bryant, Irving, and Cooper treat in their works.[1] And in *Westward the Course of Empire Takes Its Way*, Immanuel Leutze projects a feeling of movement in time through the gesticulating figures that sprawl across the foreground of the picture, while the highlight in the background sky, seen through a gap in the range of mountains, suggests the ultimate goal toward which the process of westward migration is moving.[2] At best, however, such attempts are only partially successful, for painting is a spatial form, and, whatever devices the artists may use to suggest the passage of time, the concept of space always dominates the composition.

The writers, on the other hand, who had at their disposal the suggestive power of language, were much more successful in projecting a world that exists in both space and time and in relating it to man. They could turn as they pleased to either the narrative or descriptive mode in their writing, and even in those passages of prose and verse which seem to have primarily a narrative or descriptive function, they could suggest the other dimension through the judicious use of even a phrase or a sentence. Less limited for this reason than their painter friends, they could devise almost endless means through which to suggest the dual dimensions of space and time. Because they could also broaden or narrow their angle of vision at will, the writers were able to focus more sharply on man and his significance in the space-time re-

lation, moving back and forth—as the painters could not—between the expansive view of the landscape and the sharp focus on character. The painter, trapped in a spatial medium, must always present the human race as dwarfed by an expansive world. The writers, in other words, had by the very nature of their medium much more flexibility in the expression of their themes.

One need only turn to specific works by Bryant, Irving, and Cooper to observe their success in expressing their meaning through the use of the space-time relation. In the first two sections of *The Sketch Book*, for example—"The Author's Account of Himself" and "The Voyage"—Irving uses the narrative mode to introduce his persona, Geoffrey Crayon, to the reader and to describe in general terms his experience up to the time of his arrival in England. Within this basically temporal pattern, however, Irving includes a large number of spatial details to give the whole unit a serious philosophical dimension. Consider the first paragraph in the book, which sets the tone for the passage.

> I was always fond of visiting new scenes, and observing strange characters and manners. Even when a mere child I began my travels, and made many tours of discovery into foreign parts and unknown regions of my native city, to the frequent alarm of my parents, and the emolument of the town-crier. As I grew into boyhood, I extended the range of my observations. My holiday afternoons were spent in rambles about the surrounding country. I made myself familiar with all its places famous in history and fable. I knew every spot where a murder or robbery had been committed, or a ghost seen. I visited the neighboring villages, and added greatly to my stock of knowledge, by noting their habits and customs, and conversing with their sages and great men. I even journeyed one long summer's day to the summit of the most distant hill, whence I stretched my eye over many a mile of terra incognita, and was astonished to find how vast a globe I inhabited. [2: 9]

The paragraph moves firmly forward in time, enlarging the spatial dimension as it proceeds, to suggest—in a mode that prefigures Whitman—the growth and development of the child and the expansion of his consciousness as he becomes increasingly aware of the spacious world he inhabits.

Succeeding paragraphs carry the concept forward. As time progresses, Crayon turns to books for knowledge, but his "rambling propensity" continuing, he absorbs the scenery of his native country, an experience that is presented in terms of an expansive landscape. Thus, he writes of the charms of nature that have been lavished upon America:

> Her mighty lakes, like oceans of liquid silver; her mountains, with their bright aerial tints; her valleys, teeming with wild fertility; her tremendous cataracts, thundering in their solitudes; her boundless plains, waving with spontaneous verdure; her broad deep rivers, rolling in solemn silence to the ocean; her trackless forests, where vegetation puts forth all its magnificence; her skies, kindling with the magic of summer clouds and glorious sunshine:—no, never need an American look beyond his own country for the sublime and beautiful of natural scenery. [2: 9–10]

This is the usual kind of expansive landscape description we expect to find in the works of these writers. Yet much of the significance of the passage lies not in what is included, but in what is left out. Developed exclusively in spatial terms, it implies the absence of a temporal dimension in the American landscape. It has no history.

That dimension can best be supplied by a contemplation of Europe. Though America is "full of youthful promise," it is the European past alone that can supply the sense of time to balance the spatial elements he has just been describing. Hence, in the following paragraph, he writes of Europe: "Her very ruins told the history of times gone by, and every mouldering stone was a chronicle. I longed to wander over the scenes of renowned achievement—to tread, as it were, in the footsteps of antiquity—to loiter about the ruined castle—to meditate on the falling tower—to escape, in short, from the common-place realities of the present, and lose myself among the shadowy grandeurs of the past" (2: 10–11). In these two passages Irving projects a world of interrelated space and time in which the individual's growth and development are contingent upon his increasing awareness of both dimensions of experience. From this point of view, the voyage

to Europe becomes almost a necessity to insure that this growth will continue.

"The Voyage," the first chapter of *The Sketch Book* proper, describes the trip across the Atlantic in very similar terms. Once again the movement is basically narrative, but Irving employs a number of spatial details to impress on the reader the great discontinuity Crayon feels on leaving America and traveling to Europe. "In traveling by land," he writes, "there is a continuity of scene, and a connected succession of persons and incidents, that carry on the story of life, and lessen the effect of absence and separation" (2: 13). "The vast space of waters" over which he sails, however, "is like a blank page in existence" (2: 13), and cuts one off at once "from the secure anchorage of settled life. . . . It interposes a gulf, not merely imaginary, but real, between us and our homes—a gulf subject to tempest, and fear, and uncertainty, rendering distance palpable, and return precarious" (2: 14). The voyage, therefore, in space and time, has a psychological as well as physical meaning. The persona introduced in the preceding sketch sees the discontinuity as a serious threat, cut off as he is from the settled and the known—a threat that is well represented by the images of shipwreck and storm that Irving includes.

Thus, despite the numerous details of space and time through which they are developed, the primary concern of both these sketches is the relationship of those elements to man—a fact clearly revealed at the very end of "The Voyage," when, all the terrors weathered, the persona lands in England and a whole new world opens before him. Irving is most insistent that we perceive this fact, for he narrows his focus sharply in the final paragraph to the narrator himself: "All now was hurry and bustle. The meetings of acquaintances—the greetings of friends—the consultations of men of business. I alone was solitary and idle. I had no friend to meet, no cheering to receive. I stepped upon the land of my forefathers —but felt that I was a stranger in the land" (2: 20). The growth and development described in "The Author's Account of Himself" were accomplished gradually through his experience in space and time. The ocean voyage, however, creates a discontinuity in his life that acts as a kind of threat to his personality, and the speaker,

acutely aware of his aloneness, must begin again to establish himself in a space-time relation. Read in these terms, the sketches clearly show how Irving used the descriptive style to treat an important psychological state with considerable subtlety.[3]

Other passages in Irving are equally effective in using space and time for artistic purposes. Consider, for example, the first edition of *The Alhambra* (1832). It begins, like *The Sketch Book*, with a journey that leads the reader's imagination first across "the immense plains of the Castiles and La Mancha, extending as far as the eye can reach," and then into the "vast sierras or chains of mountains" in Granada, where "Moorish battlements" and "ruined watch-towers" recall "the chivalrous days of Christian and Moslem warfare" and "the romantic struggle for the conquest of Granada."[4] Part of Irving's purpose here is to suggest the picturesque quality of romantic Spain; part is to set the Alhambra in the appropriate spatial and temporal context before the reader approaches the tales and sketches in the main body of the work. The latter purpose is made clear toward the end of the chapter when the journey ends on "the beautiful Vega of Granada" and the travelers view "the old Moorish capital in the distance, dominated by the ruddy towers of the Alhambra, while far above it the snowy summits of the Sierra Nevada [shine] like silver" (1: 38). Thus, before the reader is finally introduced to the building itself, Irving places it in a broad context of both space and time.

This effect is reinforced by a pair of chapters that Irving introduces shortly after this point. One, "The Tower of Comares," is developed primarily through the descriptive mode, and the other, "Reflections on the Moslem Domination of Spain," stresses the temporal. Yet even the former involves a movement in time, for Irving uses the device of an imaginary trip to the summit of the tower to provide a point of view for the description. Thus, as the early morning sun begins to rise, he invites the reader to accompany him to the terraced roof of the tower, to approach the battlements, and to look below. He moves to each side of the tower in turn, and when the sun, mounting higher in the heavens, begins to pour the full force of its rays upon the roof, he invites the reader to abandon the tower: to descend and refresh himself

at the fountain of the lions. Irving deliberately avoids the creation of a static, set piece of description. He keeps before the reader a sense of movement throughout the passage, and suggests thereby the constant and inexorable passage of time.

The description itself, on the other hand, is one of the most breathtaking that Irving ever drew and clearly suggests an expansive universe in which his viewers are dwarfed by comparison. From three of the sides of the tower, the landscape stretches away in vast prospects. The northern side reveals "a giddy height" with a deep glen below leading out into "the valley of the Darro" (1: 63); the west presents the prospect of a range of mountains off in the distance studded with "warrior towns" (1: 65); the south overlooks the broad and luxuriant Vega, beyond which rises a range of snowy mountains "shining like a white summer cloud on the blue sky." Irving dwells at length on these mountains, which dominate all Andalusia, and which may be seen by "the Spanish mariner on the deck of his bark, far, far off, on the bosom of the blue Mediterranean, [who] watches them with a pensive eye, thinks of delightful Granada, and chants in low voice some old romance about the Moors" (1: 67–68). Irving extends his landscape beyond the visual limitations of the tower and, by introducing the reference to the Moors, prepares for the temporal development of the ensuing chapter.

If the tower chapter ends on a temporal note, the following one begins with the spatial. The sun has set "behind the purple mountains of Alhama," and "the Vega, covered with a slight sultry vapour that caught the setting ray, [seems] spread out in the distance like a golden sea" (1: 69). Irving's thoughts, however, turn to the past, and he recounts in narrative fashion the conquest of Gothic Spain by the Moslem inundation that swept into Europe from Africa. He deliberately invokes a sense of the long reach of time since that remote day, for he writes, "Generation after generation, century after century had passed away, and still they maintained possession of the land" (1: 72). Yet, he concludes, in a passage that illustrates well his use of cyclical time, their power and dominion were destroyed, and only a few broken monuments remain to recall "a brave, intelligent and graceful people, who

conquered, ruled, and passed away" (1: 74). This chapter, coming immediately after the spatially developed description from the Tower of Comares, helps place the Alhambra firmly in the appropriate space-time context. Taken together, the chapters set both the scene and the mood for what is to follow in the main part of the book.

In the 1850 revision that Irving made of *The Alhambra*, this time-space pattern is considerably altered. To be sure, the book still begins with "The Journey," in which images of both space and time are presented much as they are in the earlier edition, but in doubling the length of the chapter, he includes more details of his actual journey through Spain. Thereafter, Irving rearranges his sketches in such a way that the spatial and temporal chapters are reversed and are no longer juxtaposed. Now he elects to stress first the dimension of time, imbeds his reflections on the Moorish past in a chapter on the Hall of the Ambassadors, follows it with chapters on the founder and the finisher of the Alhambra that had appeared toward the end of the earlier edition, and even includes a Gothic chapter on some mysterious chambers before he presents an altered version of the panorama from the Tower of Comares. One can argue, of course, that a space-time pattern is still present in the book, but in making his revisions and rearrangements so general, Irving obscured a pattern that was clear and effective in the 1832 edition.

In the earlier version of *The Alhambra*, as in *The Sketch Book*, the stylistic achievement of Irving is of considerable significance. Beneath the simple charm and grace of expression for which he is so often praised is an artistic sophistication not often conceded to him as a writer. Beneath the surface smoothness, there sometimes lurks a richness of associations that the contemporary aesthetic demanded and which suggests a vision of reality that is both complex and significant. Well aware of the condition of man as a mutable being living in a constantly changing world of enormous space and inexorably moving time, he sought to express the nature of that reality in some of his tales and sketches. Not all of his works are equally successful in suggesting the complex effects that we find in the best of his prose, for many of his works fall far short of this achievement. Too often he writes the simple and

straightforward narrative we find in *The Conquest of Granada*, and he sometimes stooped, as he did in *Astoria*, to out-and-out paraphrase of historical sources. A man should be judged, however, on the basis of his best and most original work, and for Irving, this will surely include the descriptive style he shaped to his artistic ends in works like *The Sketch Book* and the first edition of *The Alhambra*.[5]

The descriptive style, however, is a suitable vehicle for expressing philosophical and moral themes far beyond any of those developed in Irving's works. The reaches of space and time that dwarf the human observer have significance for the human race that they cannot afford to ignore: the relative size of man in relation to that of the cosmos suggests at the same time his position before the God who transcends it, and awareness of this relation should enable the human being to still his feelings of pride and develop an appropriate spirit of humility. These aspects of the pictorial mode, though generally avoided by Irving, receive full and explicit development in the works of Bryant and Cooper. Both evoke in their poems and novels a reach of space that is astronomical in its proportions and a stretch of time that can only be measured on a geologic scale. Both, too, develop their descriptions in such a way that images of time and space appear together to suggest the intimate connection between them, and both—like Irving—develop this space-time continuum specifically in terms of man, who must find his place in the world, both physically and morally, in relation to the immense universe in which he finds himself.

So important is this concept in Bryant's verse that most of his major poems stress the enormous dimensions of the universe he envisions. Consider, for example, the middle section of "Thanatopsis." This part of the poem, designed to reconcile the reader to the thought of death, places the concept of individual mortality in a context of such vast space and time as truly to suggest the universality of death. He begins the section with a temporal image, reminding the reader that at his death, he will "lie down / With patriarchs of the infant world," and with "hoary seers of ages past." He then turns immediately to a spatial development, describing,

the hills
Rock-ribbed and ancient as the sun,—the vales
Stretching in pensive quietness between;
The venerable woods—rivers that move
In majesty, and the complaining brooks
That make the meadows green. [p. 22]

By juxtaposing the temporal and spatial images in this way, Bryant suggests the breadth of the time-space dimension necessary for the development of his theme.

The spatial images, however, as so far developed, are not of the same order as the temporal. Bryant has evoked a range of time stretching back to the dawn of history, but has described a generalized scene that could simply be western Massachusetts. One suspects that this choice was deliberate, for in the lines that immediately follow, the scene suddenly expands to enormous proportions, almost as if Bryant, determined to impress the reader with the breadth of his vision, forces him to participate in an enlarging awareness of space. Thus, he expands the description first to continental size with the suggestion that surrounding all this pleasant landscape lies "old Ocean's gray and melancholy waste," and then enlarges the dimensions further to include the entire cosmos.

The golden sun,
The planets, all the infinite host of heaven,
Are shining on the sad abodes of death,
Through the still lapse of ages. [p. 22]

Thus, he evokes an image of space of truly vast proportions and closes with an image of time that enlarges upon the one with which he began. Indeed, even the rhythm of the final line suggests the glacial movement of cosmic time.

Other poems by Bryant make use of similar devices to project their quite different themes. "To a Waterfowl," for example, clearly suggests an enormously spacious world both in the "rosy depths" of sky and "the desert and illimitable air" against which the bird is seen, and in "the abyss of heaven" which swallows up his form in the last stanza. Yet the poem also contains a clear, if somewhat underplayed, movement in time. From the very first

word—"whither"—we are made aware that the bird is not stationary, but moves constantly through the enormous reaches of space that Bryant suggests with his spatial diction. Each stanza, moreover, also contains language that denotes movement and the passage of time. The cycle of life is suggested in the day-long flight of the bird that shall soon pass into darkness, and in the annual migration of waterfowl "from zone to zone," a word that must surely be read in its geographical meaning. The poem is a complex texture of spatial and temporal images that suggest the nature of reality as perceived by the poet, and it focuses at the close on the meaning of that reality to the human observer—faith that the God who guides the waterfowl will also lead the poet's steps aright (pp. 26–27). Though less explicit, certainly, than "Thanatopsis," this poem too is developed in terms of the complex relations of space and time.

"A Forest Hymn" provides yet another example of Bryant's use of space and time in the development of his moral themes. The size of the trees in the virgin forest set the scale for the human observer, for the poet, standing beside the "immovable stem" of a "mighty oak" feels "almost annihilated" by the comparison (p. 80). The temporal dimension, on the other hand, is suggested by "the century-living crow" that, born in the tops of the trees, "grew old and died / Among their branches" (p. 79). Beyond these points for measurement, however, the mind perceives a scale that far transcends the human, for man, in the presence of these woods, feels his spirit bowed "with the thought of boundless power / And inaccessible majesty" (p. 79). Contemplation of the natural scene, especially in the space-time dimension, turns the observer's thoughts toward the Deity, whose "grandeur, strength, and grace" are suggested by the similar qualities the poet perceives in the forest giants, and whose eternity is suggested by the recurring cycle of ever-renewing life to be seen in successive generations of forest trees (pp. 80–81). And with this perception comes the spirit of humility that the poet always sees as the appropriate end of man's contemplation of God's wonderful works in nature.

The best example of Bryant's use of the technique, however, is probably "The Prairies," for in this poem the concepts of space

and time firmly control both structure and meaning. From the very first lines of the poem, where words like "boundless," "encircling vastness," and "far away" suggest the dominant effect, Bryant develops his vision of an enormously spacious world. Like many another writer of the time, he compares the prairie to the open sea and suggests both size and movement in the patterns of light and shadow he describes as wind and cloud sweep over the prairies to make the surface roll and fluctuate like waves on the ocean (p. 130). As in "Thanatopsis," he expands his vision to continental proportions by including in his description of the Illinois prairies the winds that have played

> Among the palms of Mexico and vines
> Of Texas, and have crisped the limpid brooks
> That from the fountains of Sonora glide
> Into the calm Pacific. [p. 131]

Indeed, he even employs a single detail in "the prairie-hawk that, poised on high, / Flaps his broad wings, yet moves not" (p. 131) to intensify, as in the "Waterfowl," the infinite reaches of space.

All of this is preparation for the middle section of the poem that develops the temporal aspects of the theme. This enormous space has been the stage on which has been enacted a drama of vast proportions, beginning in the distant past

> while yet the Greek
> Was hewing the Pentelicus to forms
> Of symmetry, and rearing on its rock
> The glittering Parthenon [p. 131]

and projecting forward into the future, when, he foresees, an "advancing multitude" will "fill these deserts" (p. 133). Within this sweep of time, innumerable changes have occurred. Mound Builders have yielded to Indians, and they in turn to the white men. Beaver and bison have gone, the bee, forerunner of the white men in the movement across the continent, has already arrived, and the herds of cattle that will one day graze on the prairies are still to come. The breathtaking sweep of time that Bryant envisions here is the temporal counterpart of the broad reaches of space he evokes in the opening section. Together, they project a vision of reality truly majestic in its vast dimensions.

Most important, however, is the significance of this vision for man. Bryant was deeply affected by his view of the Illinois prairies, and this poem is the result of that experience. His "heart swells" and his sight dilates, he tells us, as he observes "the encircling vastness" (p. 130), and his thoughts are turned toward the God who has

> smoothed these verdant swells, and sown their slopes
> With herbage, planted them with island groves,
> And hedged them round with forests. [p. 131]

Contemplation of space, therefore, as in "A Forest Hymn," turns the mind of the observer to the greatness of God, who has performed such magnificent works. Contemplation of time, on the other hand, makes one aware of the mutability of all terrestrial things. "Thus change the forms of being," Bryant writes,

> thus arise
> Races of living things, glorious in strength,
> And perish, as the quickening breath of God
> Fills them, or is withdrawn. [p. 132]

The evocation of space and time thus suggests the infinity and eternity of God, the Creator, and brings home to the observer his own smallness in relation to so great a Being. This awareness of self as existing in an enormous world of space and time is especially emphasized in the closing lines of the poem, when the poet's imaginative vision is swept away and he becomes aware once again that he is "in the wilderness alone" (p. 133).

Not all Bryant's poems reveal so clearly the fundamental nature of his view of reality nor the philosophical implications that his vision had for him. At times he would simply concentrate on one small aspect of the natural world, as in poems like "The Yellow Violet" or "To the Fringed Gentian," and develop his theme through the analogy he perceived between the natural phenomenon and the truths of the moral world. At times, too, he would turn to allegory, as he did in "The Flood of Years" or "Waiting by the Gate," to develop his themes. But many of his poems—and these are among his best ones—evoke the sense of space and time that we have examined here. In these, Bryant reveals his cosmic view and the moral vision of life he derived from

it. For him, the natural world must be seen as existing in vast reaches of both space and time. The thinking man must perceive this fact, approach his Creator with deep humility, still his violent passions, and arrange his life in accord with the rational order he perceives in the natural world. In such a universe, Bryant insists, concern with self is the rankest form of pride and desire for material gain the sheerest folly.

Closely related themes developed in much the same manner appear in the works of Fenimore Cooper, for the novelist, like the poet, was deeply concerned with the meaning of space and time, and developed his novels with close attention to both the spatial and temporal dimensions of his fictive world. Beginning with *The Spy* in 1821, he probed the meaning of the American past at all stages of his writing career and wrote two fine series of books to examine the meaning of change in the American experience. From *The Pioneers* (1823) to *The Sea Lions* (1849), moreover, he developed his view of an expansive nature and examined in detail the relation of man to the spacious world in which he must live and act. In none of these works can the spatial and temporal aspects be completely separated, though in any given book Cooper may indeed emphasize one over the other. In most, the two function together to express the basic environment in which the actions of men take on their moral significance. Such use of time and space together is most obvious, perhaps, in a book like *The Crater*, where Cooper creates an enormous stage on which to portray the rise and fall of a whole society. But a similar handling of the devices, more subtly treated, may also be found in other, and better, novels.

Consider, for example, his use of space and time in the first three Leatherstocking tales, all written in the 1820s and providing a unified series complete in itself, even without the two that were written later. Cooper's deep concern with the space-time dimension is clearly revealed in his own characterization of two of these books. *The Pioneers*, he tells us on the title page, is "a descriptive tale," and much of the meaning of the novel is embodied in the spatially developed scenes through which the story is presented. *The Last of the Mohicans*, on the other hand, is a narrative—a historical account of one aspect of the old French war of 1757—

and develops its theme in terms of the swiftly moving action which gives the tale its characteristic movement and tone. Neither book, of course, is adequately described by these phrases. Descriptive though it may be, *The Pioneers* has much to say as well on the meaning of time, and *The Last of the Mohicans*, though primarily a narrative, is also deeply concerned with the meaning of space. Although each may emphasize a different aspect of the space-time relation, the books can be properly understood only if we see each of them in terms of both dimensions of experience.

When all three novels are read in sequence, moreover, the importance of the space-time relation becomes immediately apparent. The mere fact that Cooper developed the books as a series reveals his concern with the meaning of time, but that meaning is controlled to a considerable extent by the spatial development in each of the books. The temporal pattern is quite obvious. The action of the tales spans a period of nearly half a century, a time of enormous change in the country. When the series begins in *The Last of the Mohicans* in 1757, the American colonies are still the pawns of European monarchs who struggle for their possession, the white settlers are just beginning to move inland from the eastern seaboard, and the Indian tribes still pose a serious threat to the penetration of the wilderness. By 1805, when the action of *The Prairie* takes place, a free America has thrust its boundaries across the Mississippi River, the continent is all but conquered as Lewis and Clark move up the Missouri toward the Pacific Ocean, and the doom of the red men is sealed with the appearance of the whites on the Great Plains. Seen from this point of view, the three novels would seem to develop a concept of time as continuity, with the ultimate goal the establishment of white Americans everywhere on the continent.

The conclusion of each of the books gives added weight to this interpretation. At the end of *The Last of the Mohicans*, Tamenund, the aged chief, laments that the white men "are masters of the earth," that he has in his own lifetime seen a strong and happy tribe vanish with the last of its members (p. 423). *The Pioneers* ends on an even more strongly positive note, with Leatherstocking, quite unintentionally, opening a path through the wilderness for "the march of the nation across the continent" (p. 477), and

although *The Prairie* concludes the series with the death of Leatherstocking, the other characters are disposed of in such a way as to suggest a basically affirmative theme. Ishmael Bush and his tribe are turned back from their westward movement, and both Paul Hover and Captain Middleton not only settle down with their families but rise in the social scale to such a degree that both become important men in their communities. Hover's children, in particular, rise well above the social level from which their parents issued. The subsequent history of these major characters reads, in other words, much like a celebration of the American dream.

Yet the spatial development in each of these books seriously qualifies such optimistic conclusions. Each of the novels begins with an extended physical description of the landscape which not only sets the appropriate tone for the novel itself but also contributes to the overall meaning of the series. *The Last of the Mohicans*, for example, is dominated by the almost impenetrable forest—the dense wilderness that the opposing armies must enter before they can contest the ownership of the continent, and the tenuousness of their hold is clearly revealed by the lack of control they can actually exert over the landscape itself or their Indian allies. Whole armies are swallowed up by the wilderness, the Canada Indians throw off all restraint to massacre the surrendering British, and even Hawkeye himself must rely on his Indian allies to extricate the white characters from their difficulties at the end of the book. From the very beginning of the novel, the forest is a living presence that dominates the action and defines the possibilities open to the white intruders, who, as in Bryant's poems, are all but annihilated by the enormous wilderness they have entered.

In *The Pioneers*, on the other hand, the opening chapters reveal a landscape that is rapidly becoming domesticated. Though the forest still encircles the village of Templeton in 1793, such inroads have been made upon it that clearings now dot the landscape, the wooded hills give way to farms, and a thriving community is growing on the shores of the lake. Far from being dominated by their environment, men now seem to control it. Everywhere we turn in the novel, we find evidence of the havoc men have been working among the trees. Stumps and stubs stand

in the yards and fields of the villagers, and blazing fires consume the fallen giants—in the fireplaces of the village houses, in Billy Kirby's clearings, even in the conflagration that rages across the mountain near the close of the book. The relation of man to space seems to have changed as we move from book to book. No longer feeling so overwhelmed by the immensity of their environment, men have begun to assume that they can control it and in their pride show no concern over the senseless destruction they work in the landscape. Only Leatherstocking preserves the old sense of the spatial relationship in his extended description of the expansive landscape he recalls from his earlier experience deep in the Catskills.

The final book in the series carries this development to its logical conclusion. *The Prairie* begins with a somber description of a denuded landscape, the arid plains stretching away in every direction unbroken by forest or grove. The axes of the settlers are felling the trees all across the country, and the end result, Cooper implies, could well be the barren desert in which the action of the novel takes place. Indeed, in the great debate between Dr. Bat and the trapper, the old frontiersman draws a parallel between this American landscape and the deserts of the East where ruins of past empires decay amid lands that had once supported whole civilizations. The spatial development in all three books suggests, therefore, that the meaning of time may not be so happy a one as some elements in the books imply. The ruthless despoliation of nature begun in *The Pioneers* may lead the country to eventual destruction, and the awareness of human smallness and frailty, sensed in *The Last of the Mohicans* but lost by most of the settlers in *The Pioneers*, may return with a vengeance when men see once again their own insignificance in the vast and denuded nature that they once had thought they could dominate.

Read in these terms, the first three Leatherstocking tales come to a rather ambivalent conclusion. Though Cooper holds out hope that the American occupation of the continent will lead to good, he nonetheless maintains some serious reservations about the ultimate destiny of the nation. Such a conclusion was perhaps inevitable considering his view of the basic nature of man. Like Bryant, he saw the human race as fallen and contemporary men

as the victims of their pride and passions. By their very nature, then, such men fall prey to temptation and commit the follies and crimes that characterize the settlers of Templeton and such lawless men as Ishmael Bush. Should these men, moreover, assume a dominant role in society, the eventual result of their actions would be the barren landscape of *The Prairie*. But Cooper, like Bryant, did not despair of men. If sometimes selfish and willful, they could also be humble and just. The problem was to insure that men would develop the positive side of their nature, see themselves in the proper relation to God and the external world, and create thereby the kind of just society that would result from appropriately humble men.

To emphasize the need for such humility in men, Cooper, like Bryant, used the pictorial style to depict the human being in his true relation to his environment. Consistently in the Leatherstocking tales, for example, Cooper stresses the immensity of the world in which his characters move. From this point of view, the vast forest of *The Last of the Mohicans* serves the same thematic purpose as the denuded plains of *The Prairie*, in that both reveal the smallness and frailty of men, and if *The Pioneers* presents the reader with a domesticated landscape, Leatherstocking's view from deep in the Catskills reestablishes the expansive landscape that Cooper needs for this aspect of his theme. The last two Leatherstocking tales, moreover, maintain the same dimensions. *The Pathfinder* begins with a view of the forest wilderness that relates its vastness to both "the expanse of the ocean" and "the illimitable void" of space (p. 1), and *The Deerslayer* opens with a description that suggests the vast reaches of both space and time. Cooper discusses the sense of remoteness that the American past acquires from the frequent changes that have occurred in the national scene, and he stresses the enormous size of the forest that stretches at the time of his story from the Atlantic settlements to the Mississippi (pp. 1-3).

Descriptions like these serve the same purpose in Cooper's novels as they do in Bryant's poems, for they are designed to fill the human being with a sense of his own insufficiency and to convince him of the need to still his pride and passion before the God who created so vast a cosmos. That many men fail to perceive

or to understand this relation is a major theme in Cooper's novels, for many of his characters are unaffected by the grandeur of their surroundings. The gradual breaking of a glorious dawn in *The Deerslayer*, a view that should soothe the passions and temper the ferocity of men, leaves Tom Hutter and Harry March untouched by "that calm delight which the spectacle is wont to bring when the thoughts are just, and the aspirations pure" (pp. 331–32), and men like Ishmael Bush in *The Prairie* are unaffected by the enormous landscape through which they move. Indeed, even the settlers of Templeton, who are surely less culpable than Hutter, March, or Bush, are filled with a selfish pride that has not been altered by their experience in the virgin wilderness. They are like Bryant's prideful men who need the elemental violence of nature to teach them who rules the cosmos.

Other men, like Leatherstocking, do indeed acquire the proper attitude toward the external scene, toward God, and toward their fellow men, an attitude that is gained through perception of one's relation to his natural environment. Throughout the Leatherstocking tales, the hero stands in strong contrast to the willful and greedy men who see all problems in terms of self and who seem to care little about the consequences of their actions. Though he shares the common frailty of all human beings, Leatherstocking understands better than most his relation to the God he sees in forest and sky and hears in the winds. Like the poet in "A Forest Hymn," he has learned to conform his life to the order he perceives in the external world and to bend his will to that of the transcendent God, who is at work in nature. Because he has developed this fundamentally religious view, Leatherstocking respects the natural world, refuses to destroy wantonly the life that he finds in the woods and streams, and even takes his first human life, in *The Deerslayer*, only after allowing his adversary the opportunity to go his way unharmed.

Such use of space and time to express his basically moral themes appears at all stages of Cooper's career, but assumes added importance in some of his later works. Deeply concerned that his readers understand his meaning and keenly aware that American society was moving in a direction that he could not approve of, Cooper turned in his later novels to increasingly violent aspects of

the natural scene in order to emphasize the need for humility in the national character. Such works as *The Crater* and *The Sea Lions* represent the extremes to which he would go, submitting his characters to Pacific earthquakes and the rigors of an antarctic winter to make them see their proper relation to the God who rules the cosmos. Increasingly, too, he gave his moral themes a specifically Christian meaning, for he uses the nighttime vastness of the antarctic sky to lead Roswell Gardiner, the unitarian hero of *The Sea Lions*, back to trinitarian orthodoxy. This use of space, however, marks no real departure from his earlier practice, any more than his handling of time in the Littlepage novels and *The Oak Openings* represents any fundamental change from that to be found in his earlier series. In all these works, the meaning of space and time is the same, for they all express the moral view that he stressed throughout his writing career.

Examples from the works of Bryant, Irving, and Cooper illustrating their use of the space-time dimension could be multiplied much further, for the device was a basic one in many of their poems and stories. Living at a time when a strong visual sense was almost a prerequisite for the creation of literary art, all three developed a pictorial style as their characteristic mode of expression. This style requires the reader to "see" the views that the writer puts before him, to perceive the relation of men to surrounding space, and to understand the function of the many details and the various lights and shadows with which the basic descriptions are filled. It is a style that relies heavily on the suggestive quality of language for the communication of its meaning, whether it is developing the spatial dimension that defines the position of man in the cosmos, or the temporal one that seeks to explain the meaning of time and change in human life. In either event, it is one that must be seriously studied by the critic of American literature if he is to understand the basic themes of Bryant, Irving, and Cooper, and to estimate justly their success as literary artists.

It can help us understand, too, the works of succeeding writers, for the next generation of American authors continued to use many of the same kinds of visual imagery to suggest related concepts of space and time. In Nathaniel Hawthorne, for example, the precise counterpart of the view from an eminence appears in the vast

panoramic scene described from Donatello's tower in Chapter 28 of *The Marble Faun*. The expansive landscape that greets the eyes of Kenyon and Donatello as they look across the wide Umbrian valley reminds one of Irving's view from the Tower of Comares in *The Alhambra*, and the many varied details that Hawthorne includes are much like those to be found in the typical landscape description. The different kinds of weather that are apparent in the valley—the bright sunshine contrasted with the ominous darkness of the approaching thunderstorm—recalls the scene depicted in Thomas Cole's *Oxbow*, and we even learn that the state of mind of the observers controls the meaning—or lack of it—that each perceives in the scene. The landscape that Hawthorne draws in this 1860 novel is thus the direct descendant of the views we have seen depicted in the works of the artists who preceded him.[6]

Nor is this the only landscape that Hawthorne paints. An additional example is provided by the final scene in "Ethan Brand," where, after Brand's suicide at night, Bartram and Little Joe awaken to a glorious dawn. Though the valley lies in deepest shadow, the mountain tops are touched with gold, and a brilliant radiance invests the sky. Hawthorne even suggests a religious interpretation, for the village, surrounded by hills, looks as if it rests in the hands of a protecting Providence, and earth is joined to heaven by the mists that link the darkened valley to the brilliance of the upper atmosphere. The strong chiaroscuro with which the scene is composed is obviously well within the tradition of the pictorial mode. So too is the skillful use of light and shadow to be found in a number of tales by both Hawthorne and Poe. The uncertain light of dancing flames in such stories as "Young Goodman Brown," "My Kinsman, Major Molineux," "The Man of the Crowd," or "The Masque of the Red Death" recalls the use that Cooper made of flickering torches in the nighttime scenes of *The Bravo*, or the flames of the forest campfires that create a Salvator-like effect in his frontier tales.

Examples could be multiplied further of the writers' use of descriptive techniques, from Poe's serious handling of the picturesque in "The Domain of Arnheim" and "Landor's Cottage"[7] to Melville's ironic treatment in his landscape description in *Pierre*, but enough has been said to indicate the spatial devices to be

found in the writers of the American Renaissance. The visual image also served them well in developing themes on the concept of time. *The House of the Seven Gables,* for example, contains important images that suggest both linear and cyclical time. The street that passes before the Pyncheon house seems to suggest, like the railroad on which Clifford and Hepzibah flee, a linear direction to time—a chance for progressive movement that stands in strong contrast to the eddy of life that turns on itself in the ancient house. But the water-cart and omnibus that pass at intervals suggest, like the railroad train itself, a recurring pattern of movement that would seem to be cyclical. The Pyncheon family, too, appears to have come full circle when Jaffrey Pyncheon, who resembles so closely the old colonel, dies in the same manner as his ancestor to bring the family back to the point at which it began.

An equally ambiguous concept of time appears in *A Week on the Concord and Merrimack Rivers,* for the two informing images of the book also point to different kinds of movement in time. That rivers have often been used as conventional images of passing time and forward progress is obvious enough, and Thoreau specifically points to this interpretation at the end of his initial chapter, where he views the Concord River in precisely these terms. But a week—like the year he employs as one of the major structural devices in *Walden*—is part of a cyclical movement that continually repeats itself, a point that is of great significance in the developing theme of the book. The trip that Thoreau describes is, in effect, a circular one, for the journey is to the source, the hills from which the Merrimack River flows, that he may return refreshed in spirit and mind to the place from which he had begun a few days before. A cycle has thus been completed, yet the narrator has, at the same time, moved forward in his journey of self-discovery to a point beyond his place of departure. The whole of Thoreau's book turns on the concept of a dual movement in time, an idea with which we are quite familiar from our study of his immediate predecessors.

Perhaps the most striking relation among these men, however, is that to be found between Bryant and Whitman. Of all the American poets of the nineteenth century, only they had imaginations that were at all similar,[8] a fact that soon becomes apparent when certain aspects of their works are compared. One need only

place Bryant's "The Prairies" beside Whitman's "On the Prairies at Night," or compare their many images drawn from the stars and the reach of cosmic space to understand the effect of the spatial dimension on their essentially religious visions of reality. A similar vision of time as a vast continuous stream appears in poems like Bryant's "The Ages" or "The Prairies" and in Whitman's "Starting from Paumanok" with similar effect. To be sure, the younger poet develops a view of man and nature that the philosophically more conservative Bryant would not have accepted, for Whitman's view of the developing self as ultimately divine bears no relation to the view of man we find in Bryant's poems. Nonetheless, the sense of cosmic vastness is the same in both poets and links them firmly in the development of nineteenth-century American verse.[9]

To observe these similarities is not to suggest that the two generations of writers are essentially the same. Though they use a number of descriptive techniques that resemble those of their predecessors, the later writers developed a romantic theory of perception well beyond anything found in the works of the earlier men and moved, because of it, more firmly in the direction of literary symbolism. Seen in this context, Bryant, Irving, and Cooper are important forerunners of the group of symbolic artists who soon succeeded them. They form the bridge by which the psychological and aesthetic theories of the late eighteenth century passed over into the full-blown romanticism of the next generation, and they even supplied their successors with a mode of expression that could be adapted to their own needs. Yet one could hardly defend an extended study of these three writers if this were the only—or even the primary—claim they had to our attention. Bryant, Irving, and Cooper are important in their own right as a group of serious artists who developed a pictorial style especially well suited to the themes they wished to express.

The proper understanding of this characteristic mode of expression, therefore, would seem to be absolutely essential if the critic is to interpret accurately the themes to be found in the works of these three writers and to estimate justly their artistic success. The proper proportioning of means to ends would seem to be an important criterion in the evaluation of any artistic work. Hence, the critic who approaches a Bryant poem, an Irving sketch, or a

Cooper novel should ask himself if the mode of expression in all its manifestations does indeed function effectively in suggesting the moral or intellectual theme that emerges from the texture of the work. Not all the poems and tales, of course, will be found to be equally successful, for like other literary artists, Bryant, Irving, and Cooper had both their triumphs and their disasters. At their best, however, they did manage to shape their pictorial style in such a way as to express significant themes with the effectiveness one expects in any successful literary work. The pictorial mode may seem old-fashioned and not to the twentieth-century taste, but to our first generation of American romantic artists, it was indeed an appropriate means for expressing those moral and intellectual themes that were of the utmost concern to the developing American nation.

Notes

I. Introduction

1 An extended treatment of the visual in the major writers of the mid-nineteenth century can be found in F. O. Matthiessen, *American Renaissance: Art and Expression in the Age of Emerson and Whitman* (New York, 1941). On symbolism, see Charles Feidelson, Jr., *Symbolism and American Literature* (Chicago, 1953).

2 William Cullen Bryant, *Prose Writings*, ed. Parke Godwin (New York, 1884), 2: 340.

3 See William Charvat, *The Origins of American Critical Thought, 1810–1835* (Philadelphia, 1936), pp. 27–58; Terence Martin, *The Instructed Vision: Scottish Common Sense Philosophy and the Origins of American Fiction*, Indiana University Humanities Series, No. 48 (Bloomington, 1961), esp. pp. 3–54.

4 Tremaine McDowell, "Cullen Bryant Prepares for College," *South Atlantic Quarterly* 30 (1931): 132.

5 Stanley T. Williams, *The Life of Washington Irving* (New York, 1935), 1:120.

6 *North American Review* 1 (1815):195; 7 (1818): 6, 10, 20. In his bibliography, Charvat lists an even earlier notice of Alison's *Essays on Taste* in *General Repository and Review* in 1813. See *Origins of American Critical Thought*, p. 209.

7 Compare Bryant, *Prose Writings*, 1:5–6, and Archibald Alison, *Essays on the Nature and Principles of Taste* (Hartford, Conn., 1821), pp. 87–88; hereafter cited as *Essays on Taste*. This similarity is discussed briefly in Donald A. Ringe, "Painting as Poem in the Hudson River Aesthetic," *American Quarterly* 12 (1960): 74–75. See also William P. Hudson, "Archibald Alison and William Cullen Bryant," *American Literature* 12 (1940): 59–68. Cole mentions Alison explicitly in his "Notes on Art," December 12, 1829. See Louis L. Noble, *The Life and Works of Thomas Cole*, ed. Elliot S. Vesell (Cambridge, Mass., 1964), pp. 81–82.

8 Stewart, *Collected Works*, ed. Sir William Hamilton (Edinburgh, 1854–1855), 2:117. Part 1 of the *Elements*, from which this quotation is taken, was first published in 1792; part 2 in 1814.

9 Alison, *Essays on Taste*, p. 110.

10 Ibid., pp. 18–27.

11 Although this conclusion is implicit in Alison's initial argument, the explicit statement of this principle can be found later in the book. See ibid., pp. 117–18, 443, 447. For a good discussion of this important question in Alison, see Walter J. Hipple, *The Beautiful, the Sublime, and the Picturesque in Eighteenth-Century British Aesthetic Theory* (Carbondale, Ill., 1957), pp. 168–69.

12 Alison, *Essays on Taste*, pp. 18, 26–27.

13 Ibid., pp. 112, 117.

14 Ibid., p. 173. Compare Stewart, *Collected Works*, 2:431–32. Stewart even

includes the senses of smell and taste, as well as of sight and hearing, in his discussion.

¹⁵ Alison, *Essays on Taste*, pp. 81–82.

¹⁶ Ibid., pp. 82–87. The quotation can be found on p. 87.

¹⁷ Ibid., pp. 87–88.

¹⁸ James Fenimore Cooper, "American and European Scenery Compared," in *The Home Book of the Picturesque: or, American Scenery, Art, and Literature,* with an Introduction by Motley F. Deakin, Scholars' Facsimiles and Reprints (Gainesville, Fla., 1967), p. 51.

¹⁹ Bayard Taylor, "The Scenery of Pennsylvania," in ibid., p. 95.

²⁰ Cooper, "American and European Scenery Compared," in ibid., pp. 52, 69.

²¹ Washington Irving, "The Catskill Mountains," in ibid., pp. 72–74.

²² William Cullen Bryant, "The Valley of the Housatonic," in ibid., pp. 156–57.

²³ Henry T. Tuckerman, "Over the Mountains, or the Western Pioneer," in ibid., pp. 115–16.

²⁴ Susan Fenimore Cooper, "A Dissolving View," in ibid., pp. 79–80.

²⁵ James Fenimore Cooper, "American and European Scenery Compared," p. 67.

²⁶ Irving, "The Catskill Mountains," p. 71.

²⁷ Bryant, "The Valley of the Housatonic," p. 158.

²⁸ Washington Irving, *Works*, Author's Revised Edition (New York, 1856), 6:94–95. Hereafter, unless otherwise noted, all citations of Irving's works will be from this edition.

²⁹ James Fenimore Cooper, *The Heidenmauer*, Mohawk Edition (New York, 1896), pp. 379–80. Hereafter, all citations of Cooper's novels will be from this edition.

³⁰ William Cullen Bryant, *Poetical Works*, Roslyn Edition (New York, 1903), pp. 50–53. Hereafter, all citations of Bryant's poems will be from this edition.

³¹ The most recent and most detailed treatment of this relation is James T. Callow, *Kindred Spirits: Knickerbocker Writers and American Artists, 1807–1855* (Chapel Hill, N.C., 1967).

³² Alison, *Essays on Taste*, p. 86.

³³ Stewart, "On the Beautiful," in *Collected Works*, 5:235–36.

³⁴ Stewart, *Collected Works*, 2:439.

³⁵ *Lectures on Art, and Poems* (New York, 1850), p. 101.

³⁶ Quoted in Noble, *Life and Works of Thomas Cole*, p. 266.

³⁷ William Cullen Bryant, *Orations and Addresses* (New York, 1873), p. 25; *The Letters and Journals of James Fenimore Cooper*, ed. James Franklin Beard (Cambridge, Mass., 1960–1968), 5:397.

³⁸ Bryant, *Orations and Addresses*, p. 37.

II. Space

1. The Expanse of Nature

¹ For the development of the concept of the sublime in eighteenth-century critical theory, see Samuel H. Monk, *The Sublime: A Study of Critical Theories in Eighteenth-Century England* (Ann Arbor, Mich., 1960).

[2] For a discussion of the "Aesthetics of the Infinite" as it developed in England, see Marjorie Hope Nicolson, *Mountain Gloom and Mountain Glory: The Development of the Aesthetics of the Infinite* (Ithaca, N.Y., 1959).

[3] The descriptive techniques of British and American writers have never been adequately compared, though a beginning has been made with Scott and Cooper. See Donald Davie, *The Heyday of Sir Walter Scott* (New York, 1961), pp. 103–4, 132–33; and George Dekker, *James Fenimore Cooper: The Novelist* (London, 1967), pp. 61–62.

[4] For a discussion of the influence of space on the American consciousness, see Howard Mumford Jones, *O Strange New World; American Culture: The Formative Years* (New York, 1964), pp. 386–89.

[5] For Mackenzie, see his *Voyages from Montreal, on the River St. Laurence, through the Continent of North America to the Frozen and Pacific Oceans; in the Years 1789 and 1793* (London, 1801), pp. 68–69. Compare pp. lxxxv–lxxxvi. For Bartram and the other travelers, see below.

[6] John Filson, *The Discovery, Settlement and Present State of Kentucke*, with an Introduction by William H. Masterson (New York, 1962), pp. 54–55, 57–58. Dates in the text to this and succeeding travel volumes are those of the first editions, even where later ones have been used for quotation.

[7] Gilbert Imlay, *A Topographical Description of the Western Territory of North America*, 2d ed. (London, 1793), pp. 51–52.

[8] Thaddeus Mason Harris, *The Journal of a Tour into the Territory Northwest of the Alleghany Mountains*, reprinted in *Early Western Travels, 1748–1846*, ed. Reuben Gold Thwaites (Cleveland, Ohio, 1904), 3:322–23; hereafter cited as Thwaites.

[9] Fortescue Cuming, *Sketches of a Tour to the Western Country*, reprinted in Thwaites, 4:226–27.

[10] Alison, *Essays on Taste*, pp. 457–58.

[11] Harris, *Journal of a Tour*, in Thwaites, 3:368.

[12] Ibid., 3:366.

[13] Cuming, *Sketches of a Tour*, in Thwaites, 4:346.

[14] H. M. Brackenridge, *Journal of a Voyage up the River Missouri: Performed in Eighteen Hundred and Eleven*, reprinted in Thwaites, 6:109–10.

[15] Harris, *Journal of a Tour*, in Thwaites, 3:326, 359.

[16] Estwick Evans, *A Pedestrious Tour, of Four Thousand Miles, through the Western States and Territories, during the Winter and Spring of 1818*, reprinted in Thwaites, 8:202, 316–17, 175.

[17] Thomas Jefferson, *Notes on the State of Virginia*, ed. William Peden (Chapel Hill, N.C., 1955), pp. 19–20. For a discussion of this passage and its relation to American landscape painting, see Jones, *O Strange New World*, pp. 358–60. Jones makes a special point of its painterly quality, p. 359.

[18] William Bartram, *Travels*, ed. Francis Harper (New Haven, Conn., 1958), pp. li, 121. For a full discussion of Bartram's philosophy and the artistry of his landscape descriptions, see N. Bryllion Fagin, *William Bartram: Interpreter of the American Landscape* (Baltimore, Md., 1933). Fagin comments upon the painterly quality of Bartram's style, pp. 104–10.

[19] Bartram, *Travels*, p. 223.

[20] See, for example, the discussion of the sublime effect of both height and horizontal extent in Dugald Stewart, "On the Sublime," in *Collected Works*, 5:305–7.

[21] Howard Mumford Jones, "Prose and Pictures: James Fenimore Cooper," *Tulane Studies in English* 3 (1952):139–43.

[22] Donald A. Ringe, "Kindred Spirits: Bryant and Cole," *American Quarterly* 6 (1954):240–43.

[23] For a discussion of this concept, see Ringe, "Painting as Poem in the Hudson River Aesthetic," pp. 73–74.

[24] See also *Works*, 10:54, 159.

[25] For reproductions of these paintings, see Noble, *The Life and Works of Thomas Cole*, plates 16–19.

[26] Thomas Philbrick, *James Fenimore Cooper and the Development of American Sea Fiction* (Cambridge, Mass., 1961), pp. 71–72.

[27] Ibid., pp. 68–70.

[28] Compare Thomas Cole's statement: "After all, beauty is in the mind. A scene is rather an index to feelings and associations." Quoted in Noble, *The Life and Works of Thomas Cole*, p. 145.

[29] For reproductions of these paintings, see ibid., plates 6, 10. A reproduction of *The Oxbow* appears in this volume.

[30] Bryant, *Prose Writings*, 1:5–6. Although Bryant is discussing poetry in these pages, what he says about language may be applied as well to prose. Compare Alison's views in the passage quoted above pp. 7–8.

[31] Bryant's intention is clear from a correction he made in the text of the poem after it had appeared in the *Christian Examiner*. He wrote to William Ware, the editor of that journal, on September 27, 1842: "I made a blunder in the 'Hymn of the Sea' which surprised me when I perceived it.

'The long wave rolling from the *Arctic* pole
 To break upon Japan—'

is not what I meant; it does not give space enough for my wave, nor does it place my new continent or new islands in the widest and loneliest part of the ocean. I meant the Southern or Antarctic pole, and by what strange inattention to the meaning of the word I came to write Arctic I am sure I cannot tell. I corrected the error and published the poem in the 'Evening Post,' as extracted from the 'Christian Examiner.' It has been in most of the newspapers since, but I perceive they copied from my copy." Quoted in Parke Godwin, *A Biography of William Cullen Bryant, with Extracts from His Private Correspondence* (New York, 1883), 1:391.

[32] Compare Philbrick's discussion of Irving's use of the sea in *James Fenimore Cooper*, pp. 39–40.

[33] Even here, however, Irving merely repeats a concept that he found in one of his sources.

[34] Philbrick, *James Fenimore Cooper*, pp. 66–68.

[35] So numerous are these passages that citation is not practical. Suffice it to say that they appear in Bryant's "The Prairies," Irving's *Tour of the Prairies* and *Astoria*, and Cooper's *Prairie*, *The Pathfinder*, and *Satanstoe*. A half-century earlier Bartram had used the same figure (*Travels*, pp. 147, 212), and it appears in the works of other travelers, too. See also Dorothy Ann Dondore, *The Prairie and the Making of Middle America: Four Centuries of Description* (Cedar Rapids, Iowa, 1926), p. 220; Philbrick, *James Fenimore Cooper*, pp. 66–67.

[36] Quoted in Pierre [M.] Irving, *The Life and Letters of Washington Irving*

(London, 1862–1864), pp. 458–59. For a discussion of this passage in Irving's letter, see William L. Hedges, *Washington Irving: An American Study, 1802–1832* (Baltimore, Md., 1965), p. 117.

[37] For reproductions of the two versions Cole painted, see *Letters and Journals of James Fenimore Cooper*, 5: plate 12. One version is included in this volume.

[38] Bryant, *Prose Writings*, 2:22.

[39] Quoted in Godwin, *A Biography of William Cullen Bryant*, 1:286.

[40] Quoted in Noble, *The Life and Works of Thomas Cole*, p. 219.

2. The Precise Detail

[1] Quoted in Noble, *The Life and Works of Thomas Cole*, pp. 82–83.

[2] Asher B. Durand, "Letters on Landscape Painting," *The Crayon* 1 (1855):145.

[3] *Letters and Journals of James Fenimore Cooper*, 2:240.

[4] *A Letter to His Countrymen*, reprinted in part in Robert E. Spiller, *James Fenimore Cooper: Representative Selections* (New York, 1936), p. 294; *The Bravo*, p. iii. For a discussion of the use of detail in both Cooper and Cole, see James Franklin Beard, "Cooper and His Artistic Contemporaries," *James Fenimore Cooper: A Re-Appraisal* (Cooperstown, N.Y., 1954), pp. 488–91.

[5] See the Preface to *Lionel Lincoln* that Cooper wrote for the London 1832 edition, quoted in Arvid Shulenberger, *Cooper's Theory of Fiction: His Prefaces and Their Relation to His Novels* (Lawrence, Kans., 1955), p. 27.

[6] E. Soteris Muszynska-Wallace, "The Sources of *The Prairie*," *American Literature* 21 (1949):191–200.

[7] David P. French, "James Fenimore Cooper and Fort William Henry," *American Literature* 32 (1960):28–38; Thomas Philbrick, "The Sources of Cooper's Knowledge of Fort William Henry," *American Literature* 36 (1964):209–14.

[8] Quoted in Godwin, *A Biography of William Cullen Bryant*, 1:281–82.

[9] Quoted in Noble, *The Life and Works of Thomas Cole*, p. 251.

[10] For Hogarth's discussion of the "line of beauty," see William Hogarth, *The Analysis of Beauty* (Oxford, 1955), esp. pp. 54–56.

[11] For this aspect of the picturesque, see Uvedale Price, *On the Picturesque*, ed. Sir Thomas Dick Lauder (Edinburgh, 1842), pp. 82, 90. A good discussion of Price and the picturesque may be found in Hipple, *The Sublime, the Beautiful, and the Picturesque*, pp. 202–23.

[12] Jonathan Carver, *Three Years Travels through the Interior Parts of North America* (Philadelphia, 1796), p. 44. Carver's authorship of the book has been seriously questioned. See Edward Gaylord Bourne, "The Travels of Jonathan Carver," *The American Historical Review* 11 (1906):287–302. For our purposes, however, the question of authorship is not important, for the descriptive technique remains the same, whoever might have written the book.

[13] Brackenridge, *Journal of a Voyage*, in Thwaites, 6:34, 89, 78.

[14] Bartram, *Travels*, p. 219.

[15] François Michaux, *Travels to the West of the Alleghany Mountains*, reprinted in Thwaites, 3:181.

[16] Bartram, *Travels*, p. 249.

[17] Cuming, *Sketches of a Tour*, in Thwaites, 4:236.

[18] Brackenridge, *Journal of a Voyage*, in Thwaites, 6:108.

[19] Price, *On the Picturesque*, pp. 82, 90.

[20] Bartram, *Travels*, pp. 110, 58. Bartram was writing, of course, before

Price's work on the picturesque appeared. His descriptions nonetheless illustrate the appropriate qualities.

21 Cuming, *Sketches of a Tour*, in Thwaites, 4:221.

22 John Bradbury, *Travels in the Interior of America, in the Years 1809, 1810, and 1811*, reprinted in Thwaites, 5:193–94.

23 Carver, *Three Years Travels*, p. 34.

24 Harris, *Journal of a Tour*, in Thwaites, 3:321.

25 Washington Irving, *Journals and Notebooks, vol. 1, 1803–1806*, ed. Nathalia Wright (Madison, Wis., 1969), pp. 401, 62. This is the initial volume of the projected edition of *The Complete Works of Washington Irving*.

26 Quoted in Noble, *The Life and Works of Thomas Cole*, p. 83.

27 William Cullen Bryant, *Letters of a Traveller; or, Notes of Things Seen in Europe and America* (New York, 1850), p. 238.

28 For Cole, see Noble, *The Life and Works of Thomas Cole*, p. 63; for Allston, see his *Lectures on Art*, pp. 152–53.

29 This volume includes a reproduction of Durand's painting.

30 According to Christopher Hussey, the Bay of Naples presents a naturally unified view, "perfectly composed and balanced." See *The Picturesque: Studies in a Point of View* (London, 1927), p. 85. In his opinion, "the Bay of Naples might be dubbed the parent of all Ideal Landscape."

31 Bryant, *Prose Writings*, 1:19.

32 An exception is Joel Porte, who discusses the beheading incident in *The Prairie*. See *The Romance in America: Studies in Cooper, Poe, Hawthorne, Melville, and James* (Middletown, Conn., 1969), pp. 5–6.

33 An interesting analogue to this scene may be found in John Singleton Copley's painting, *Watson and the Shark*, reproduced in Virgil Barker, *American Painting: History and Interpretation* (New York, 1950), p. 215.

34 Herman Melville, *Moby-Dick; or, The Whale*, ed. Luther S. Mansfield and Howard P. Vincent (New York, 1952), p. 36.

35 For a full discussion of this theme, see Donald A. Ringe, "New York and New England: Irving's Criticism of American Society," *American Literature* 38 (1967):455–67.

36 Compare the discussion of fire imagery in Thomas Philbrick, "Cooper's *The Pioneers*: Origins and Structure," *PMLA* 79 (1964):590–91, and in Davie, *Heyday of Sir Walter Scott*, pp. 136–38.

3. Light and Shadow

1 *The Crayon* 1:209, 66–67.

2 Quoted in Noble, *The Life and Works of Thomas Cole*, pp. 46–47, 206, 118.

3 For a reproduction of this painting, see Esther I. Seaver, *Thomas Cole: One Hundred Years Later*, exhibition catalogue (Hartford, Conn., 1948), plate 15.

4 For a reproduction of this painting, see Frederick A. Sweet, *The Hudson River School and the Early American Landscape Tradition*, exhibition catalogue (Chicago, 1945), p. 48.

5 For a color reproduction of this painting, see ibid., frontispiece.

6 For a reproduction of this painting, see Noble, *The Life and Works of Thomas Cole*, plate 7.

7 See Donald A. Ringe, "Bryant's Criticism of the Fine Arts," *College Art Journal* 17 (1957):43–54.

[8] Bryant, *Letters of a Traveller*, pp. 167, 209.

[9] Bryant, *Orations and Addresses*, pp. 21, 19. For a reproduction of Cole's *Ruins of Aqueducts in the Campagna di Roma*, see Ringe, "Painting as Poem in the Hudson River Aesthetic," Fig. 1. I have not been able to locate a published reproduction of *The Sunset on the Arno.*

[10] Elizabeth W. Manwaring, *Italian Landscape in Eighteenth Century England* (New York, 1925), esp. pp. 102–7, 212–17.

[11] Bartram, *Travels*, pp. 64, 94.

[12] Harris, *Journal of a Tour*, in Thwaites, 3:365–67, 322–23.

[13] James Flint, *Letters from America*, reprinted in Thwaites, 9:125, 28, 245, 261.

[14] For a reproduction of this painting, see Sweet, *The Hudson River School*, p. 56.

[15] This volume includes a reproduction of this painting.

[16] Quoted in Noble, *The Life and Works of Thomas Cole*, pp. 129–30. For reproductions of the paintings, see ibid., plates 11–15.

[17] Compare Hedges, *Washington Irving*, p. 133.

[18] Quoted in Noble, *The Life and Works of Thomas Cole*, pp. 141–42.

[19] For a reproduction of this painting, see ibid., plate 24.

[20] This volume includes reproductions of *The Morning of Life, Departure,* and *Return.*

[21] Henry Nash Smith, *Virgin Land: The American West as Symbol and Myth* (New York, 1957), p. 258.

[22] See Marius Bewley, *The Eccentric Design: Form in the Classic American Novel* (New York, 1959), p. 112, and Richard Chase, *The American Novel and Its Tradition* (Garden City, N.Y., 1957), pp. 60–61. Both relate the scene of the trapper's death to that of his first dramatic appearance.

[23] See Beard, "Cooper and His Artistic Contemporaries," p. 124. Beard writes of the "religious awe and aspiration" that are implicit in these two great scenes, as in much Hudson River painting. Charles A. Brady, too, discusses the contrasting deaths of White and the trapper, in "Myth-Maker and Christian Romancer," in *American Classics Reconsidered: A Christian Appraisal*, ed. Harold C. Gardiner (New York, 1958), p. 88.

[24] Compare Bewley, *The Eccentric Design*, p. 91. Bewley covers some of these points, but sees in the Glimmerglass "that equilibrium in nature which is the serene and indifferent resolution of all violence and blood." See also David Brion Davis, "The Deerslayer, A Democratic Knight of the Wilderness," in *Twelve Original Essays on Great American Novels*, ed. Charles Shapiro (Detroit, 1958), p. 11.

[25] See Yvor Winters, *Maule's Curse* (Norfolk, Conn., 1938), p. 34. Winters also writes of the "symbolic value of the moonlit water" in this chapter, and of the "fragments of action discernible upon it."

III. Time

1. Contrast

[1] William Cullen Bryant, *Letters of a Traveller, Second Series* (New York, 1859), p. 148. The omitted words are "as actively in Spain as elsewhere." Thus, although writing specifically of Spain, Bryant clearly implies that rapid change is universal in the contemporary world.

² Bryant, *Prose Writings*, 2:322.

³ Pierre [M.] Irving, *Life and Letters of Washington Irving*, pp. 560, 563.

⁴ For a discussion of Bryant's interest in geology, see Donald A. Ringe, "William Cullen Bryant and the Science of Geology," *American Literature* 26 (1955):507–14.

⁵ Tremaine McDowell, "Cullen Bryant at Williams College," *New England Quarterly* 1 (1928):456–57.

⁶ See, for example, Oliver W. Larkin, *Art and Life in America* (New York, 1949), p. 202. Larkin writes that Thomas Cole was "probably familiar with Volney's *Ruins.*"

⁷ William Cullen Bryant, "Review of Henry Pickering, *The Ruins of Paestum* and *Athens, and Other Poems*," *North American Review* 19 (1824):44–45.

⁸ Bryant, *Letters of a Traveller*, pp. 11–12.

⁹ Quoted in Noble, *The Life and Works of Thomas Cole*, p. 225.

¹⁰ Bryant, *Letters of a Traveller*, pp. 296–97, 103–4.

¹¹ William Cullen Bryant and Sydney Howard Gay, *A Popular History of the United States* (New York, 1878), 1:xx–xxi. Bryant wrote the Introduction, from which these words were taken. For Cole's interest in the Mound Builders, see his "Essay on American Scenery," *The American Monthly Magazine*, n.s. 1 (1836):11. For a discussion of contemporary archeological opinion on the Mound Builders and of Bryant's—and others'—use of the material, see Curtis Dahl, "Mound-Builders, Mormons, and William Cullen Bryant," *New England Quarterly* 34 (1961):178–90.

¹² "Journal of David Taitt's Travels from Pensacola, West Florida, to and through the Country of the Upper and Lower Creeks, 1772," in *Travels in the American Colonies*, ed. Newton D. Mereness (New York, 1916), p. 504.

¹³ Bartram, *Travels*, p. 232.

¹⁴ Ibid., p. 25.

¹⁵ Harris, *Journal of a Tour*, in Thwaites, 3:362.

¹⁶ Bryant, *Prose Writings*, 2:22.

¹⁷ For reproductions of these four paintings, see Sweet, *The Hudson River School*, pp. 68, 46, 29, 53.

¹⁸ Quoted in Noble, *The Life and Works of Thomas Cole*, pp. 237–38.

¹⁹ Ibid., pp. 96–97.

²⁰ This volume includes a reproduction of this painting.

²¹ *Salmagundi; or, the Whim-Whams and Opinions of Launcelot Langstaff, Esq. and Others*, No. 15 (Oct. 1, 1807):310. *Salmagundi* is the combined work of Washington Irving, William Irving, and James Kirke Paulding. Though it is practically impossible to isolate each man's contribution, Stanley T. Williams suspects the influence of Washington Irving in this passage. See *The Life of Washington Irving*, 2:272.

²² The quotations are taken from Cole's own description of the pictures. See Noble, *The Life and Works of Thomas Cole*, p. 182.

²³ Cole included the details for precisely this purpose. See ibid., pp. 129, 182.

2. Continuity

¹ For the eighteenth-century background of these views, see Stow Persons, "The Cyclical Theory of History in Eighteenth Century America," *American Quarterly* 6 (1954):147–63.

[2] Irving, "The Catskill Mountains," p. 75.

[3] See p. 186.

[4] The bee as a herald of advancing settlement appears elsewhere in nineteenth-century American literature. See Bradbury, *Travels*, in Thwaites, 5:57–59, for a statement of the theory. Compare Bartram, *Travels*, pp. 261–62. For literary use of the idea, see Bryant, *Poetical Works*, p. 133. Cooper uses bee hunters as characters in two of his novels: *The Prairie* (Paul Hover) and *The Oak Openings* (Ben Boden).

[5] See Ringe, "New York and New England: Irving's Criticism of American Society," pp. 456–60.

[6] For a discussion of the gentleman in American literature, see Edwin H. Cady, *The Gentleman in America: A Literary Study in American Culture* (Syracuse, N.Y., 1949).

[7] For Cooper's social theories, see *The American Democrat: or, Hints on the Social and Civic Relations of the United States of America*, with Introductions by H. L. Mencken and Robert E. Spiller (New York, 1956), esp. pp. 85–96.

[8] Compare James T. Callow, who sees the principle of contrast as the basic one in these novels. See *Kindred Spirits*, pp. 158–61.

[9] *Letters and Journals of James Fenimore Cooper*, 5:7.

[10] A quite different view of the stages of cultural development may be found in Kay Seymour House, *Cooper's Americans* (Columbus, Ohio, 1965), pp. 149–50.

[11] For a full discussion of the question developed more specifically in terms of the characters and their social attitudes, see Donald A. Ringe, "Cooper's Littlepage Novels: Change and Stability in American Society," *American Literature* 32 (1960):280–90.

IV. CONCLUSION

[1] For a reproduction of this painting, see Leo Marx, *The Machine in the Garden: Technology and the Pastoral Ideal in America* (New York, 1967), plate 2.

[2] This picture exists in two forms: the waterglass fresco over the west staircase of the House wing of the United States Capitol in Washington, D.C., and the oil sketch in the National Collection of Fine Arts in Washington. The fresco is reproduced in Barker, *American Painting*, p. 467; the sketch is reproduced in Edgar P. Richardson, *American Romantic Painting* (New York, 1944), plate 145. Barker discusses the gesticulating figures, p. 469.

[3] Compare Hedges's analysis of these sketches, *Washington Irving*, pp. 130–31.

[4] The quotations in this and the ensuing three paragraphs are from the first edition of *The Alhambra: A Series of Tales and Sketches of the Moors and Spaniards* (Philadelphia, 1832). For the quotations printed here, see 1:15, 19–20. Other citations in my text in these four paragraphs are to this edition.

[5] Compare Hedges, who thinks the revision of *The Alhambra* superior. See *Washington Irving*, p. 266.

[6] Hawthorne's use of the picturesque tradition has been the subject of a number of articles by Leo B. Levy. See, for example, "Hawthorne and the Sublime," *American Literature* 37 (1966):391–402.

[7] Important discussions of these works may be found in Robert D. Jacobs, "Poe's Earthly Paradise," *American Quarterly* 12 (1960):404–13, and Jeffrey A.

Hess, "Sources and Aesthetics of Poe's Landscape Fiction," *American Quarterly* 22 (1970):177–89.

[8] W. E. Leonard, "Bryant," *Cambridge History of American Literature* 1:271.

[9] A more extended discussion of this relation may be found in Donald A. Ringe, "Bryant and Whitman: A Study in Artistic Affinities," *Boston University Studies in English* 2 (1956):85–94.

Index